

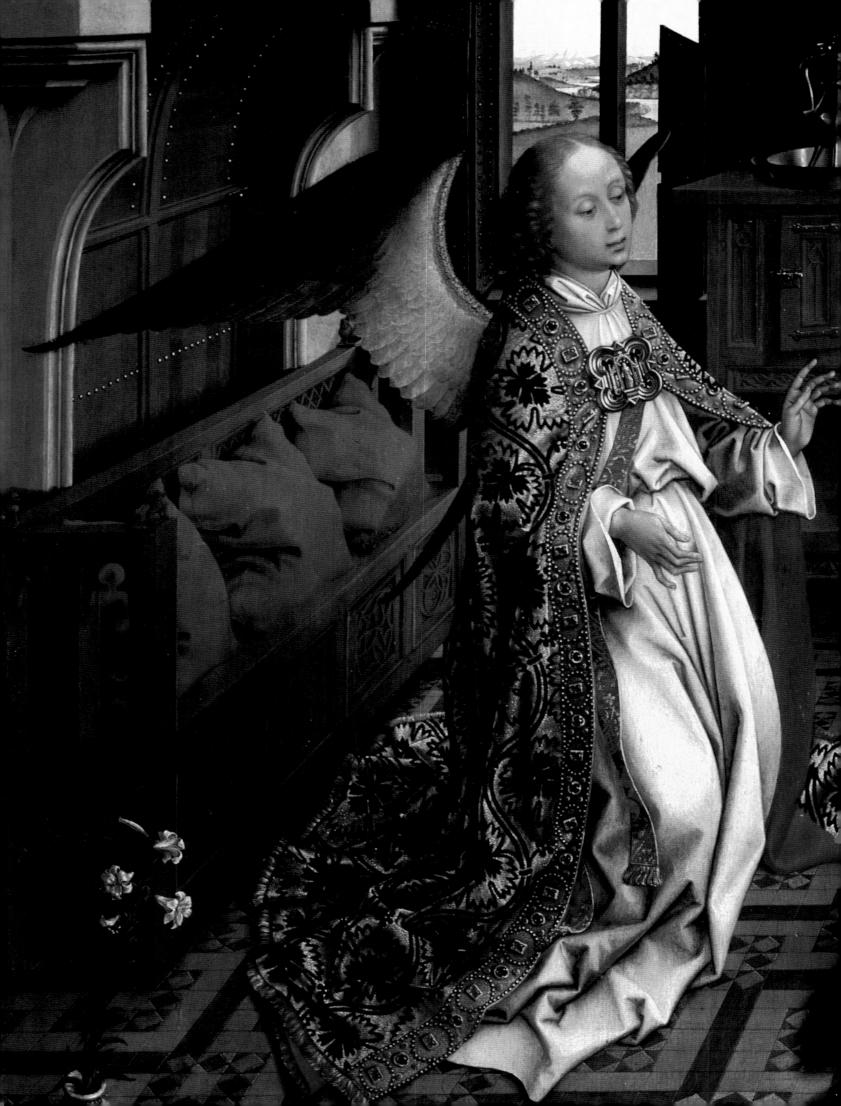

ANGELS IN ART

NANCY GRUBB

A R T A B R A S A DIVISION OF ABBEVILLE PUBLISHING GROUP NEW YORK LONDON PARIS

TO MY GRANDMOTHER, IRMA QUANZ CHESTER, WITH LOVE AND THE HAPPIEST OF MEMORIES

FRONT COVER: Detail of Lorenzo Lotto, Madonna and Child with Saints Catherine and James, 1533. See page 132. BACK COVER: Interior of the dome of the Baptistery, mid-13th century. See pages 54-55. HALF-TITLE PAGE: Detail of Giotto (1266/67-1337), The Flight into Egypt, c. 1305-13. See page 86. FRONTISPIECE: Detail of Rogier van der Weyden, The Annunciation, c. 1435. See page 34. RIGHT: Sandro Botticelli (1445-1510), The Angel of the Annunciation, c. 1495-98. Tempera on canvas, 175% x 51% in. (45 x 13 cm). Pushkin State Museum of Fine Arts, Moscow. OPPOSITE: Detail of Bernardino Lanino (1512-1583), Madonna and Child with Saints, n.d. Oil on wood, 89³/₄ x 52 in. (228 x 132 cm), overall. Pinacoteca di Brera, Milan.

EDITORS: Nancy Grubb and Mary Christian DESIGNER: Tania Garcia PRODUCTION EDITOR: Owen Dugan PRODUCTION MANAGER: LOU Bilka PHOTO RESEARCHER: Kim Sullivan

Copyright © 1995 Abbeville Press. All rights reserved under international copyright conventions. No part of this book may be reproduced or utilized in any form or by any means, electronic or mechanical, including photocopying, recording, or by any information storage and retrieval system, without permission in writing from the publisher. Inquiries should be addressed to Abbeville Publishing Group, 488 Madison Avenue, New York, N.Y. 10022. The text of this book was set in Bembo. Printed and bound in Hong Kong. Excerpts from *The Divine Comedy* by Dante, translated by Thomas G. Bergin, translation copyright © 1969 by Grossman Publishers, Inc. Used by permission of Viking Penguin, a division of Penguin Books USA Inc.

First edition

10 9 8 7 6 5 4 3 2 1

Library of Congress Cataloging-in-Publication Data Grubb, Nancy. Angels in art / Nancy Grubb. p. cm. Includes index. ISBN 0-89660-062-9 I. Angels in art. 2. Christian art and symbolism. I. Title. N8090.G78 1995 704.9'4864—dc20 95-30680

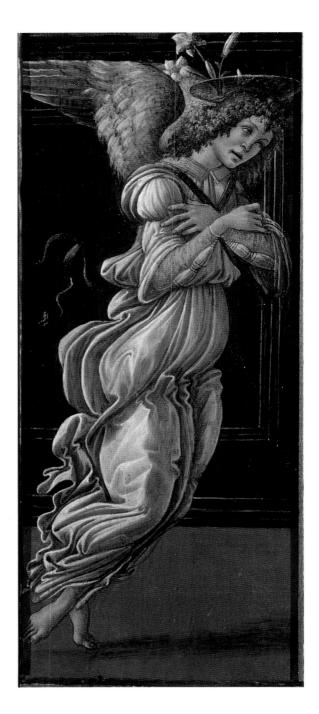

C O N T E N T S

INTRODUCTION	7
ANGEL PORTRAITS	13
HEAVENLY MESSENGERS	29
HOSTS OF ANGELS	49
CHERUBS	71
PATTERNS OF FLIGHT	85
BATTLES OF GOOD AND EVIL	103
GUARDIAN ANGELS AND COMPANIONS	125
INDEX OF ILLUSTRATIONS	143

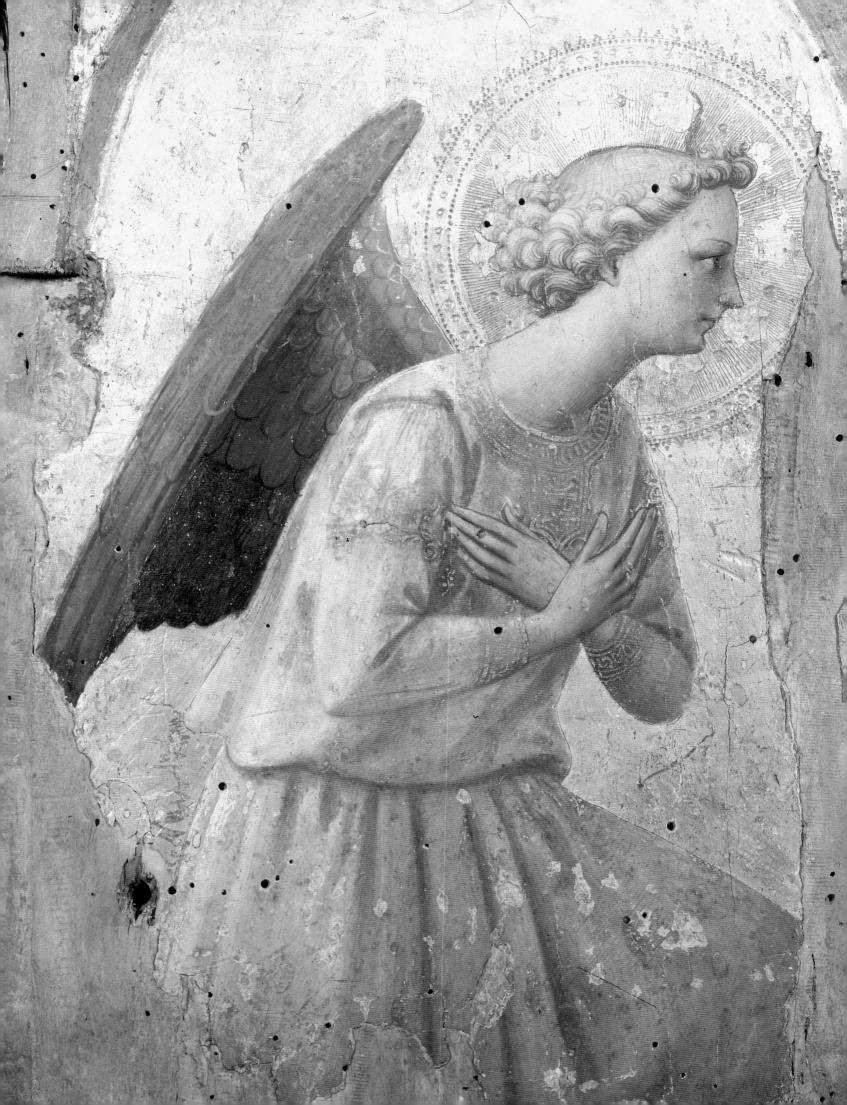

INTRODUCTION

I saw a myriad host

Of angels, festive all, with wings unfurled, Each one distinct in brightness and in kind. Dante, Paradiso, canto 31

heologians, mystics, and poets have argued for centuries over what angels look like and even whether they can be seen at all. Thomas Aquinas, writing about angels with a philosopher's precision during the thirteenth century, declared them to be pure intellect and hence without any physical form. But for artists, angels must be made visible, and the conventions for depicting them have evolved as art and society have changed over the millennia.

Images of winged beings—man, woman, and beast—can be found in many ancient cultures. Some of the most familiar of these "proto-angels" are the monumental winged figures on Assyrian palaces, wall paintings of various Greco-Roman spirits (page 8), and particularly the goddess of Victory portrayed in classical sculpture (page 8). In some cases the differences between such prototypes and the later Judeo-Christian angels are greater than the similarities. The lightly draped Victories, for example, are all unabashedly female, whereas angels were predominantly envisioned as asexual, androgynous, or male until the nineteenth century.

Angels come in many categories, and much confusion has developed regarding the names, functions, and characteristics of the different types. One often-cited source is Dionysius the Areopagite's *Celestial Hierarchy*, written about A.D. 500, in which he identifies nine orders of angels. These can be grouped into three ranks (or choirs) in descending order of power: (I) seraphim, cherubim, and ophanim (also known as thrones and often portrayed as flaming wheels); (2) dominions, powers, and authorities; and (3) principalities, archangels, and angels. Thomas Aquinas later illuminated this three-part hierarchy by assigning each rank a certain relationship to God and man. The first rank is dedicated to face-to-face worship of God; the second rank to knowing God through contemplation of the universe; and the third to human affairs. Within that third rank, the principalities watch over nations; the archangels interact with humans in extraordinary circumstances; and the angels function as guardians to individuals.

Artists—especially in the Middle Ages, when angels were newly popular in art and before certain visual conventions had been established—often found more explicit guidance from such written reports of angels than from the work of other artists, to which they had

7

[○] TUDIO OF FRA ANGELICO. Detail of Adoration of an Angel, 1st part of 15th century. Tempera on wood, 14⁵/₂ x 9¹/₂ in. (37 x 23 cm), overall. Musée du Louvre, Paris.

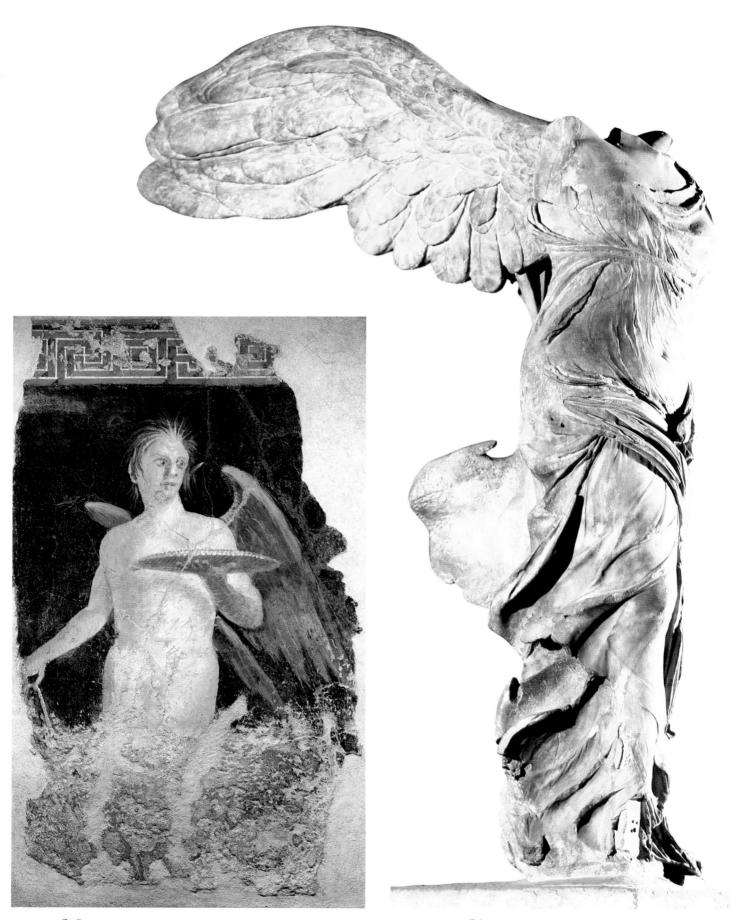

Dinged Spirit. Roman, 3d quarter of 1st century B.C.
 From the villa of Publius Fannius Sinistor, Pompeii.
 Painted mural, 49⁵/₈ x 28 in. (126 x 71 cm). Musée du Louvre, Paris.

She Winged Victory of Samothrace, c. 190 B.C. Marble and limestone, height: 129 in. (328 cm). Musée du Louvre, Paris.

limited access. Vivid descriptions of angels appear in the Old and New Testaments but are even more plentiful in the traditional Legends of the Saints and in the Apocrypha (ancient religious texts accepted by the early church fathers and the Roman Catholic church as Holy Scripture but ultimately excluded from both the Hebrew and the Protestant canons). Particularly notable for their elaborate details are the biblical Book of Revelation and the noncanonical Book of the Secrets of Enoch (believed to be a compilation of texts written by several authors during the last two centuries B.C.). The latter is said to chronicle the patriarch Enoch's observations of heaven, where he encountered

> the archangels who are above angels...and the angels who are appointed over seasons and years, the angels who are over rivers and sea, and who are over the fruits of the earth, and the angels who are over every grass, giving food to all, to every living thing, and the angels who write all the souls of men...; in their midst are six Phoenixes and six Cherubim and six six-winged ones continually with one voice singing one voice. (The Secrets of Enoch 19:3)

Although many incidents from the Bible and the Apocrypha were originally known primarily to literate and learned monks, certain episodes eventually became familiar to all worshipers, and these scenes became essential elements first of church decoration and illuminated manuscripts, then later of freestanding works of art. Some of these subjects provided especially apt occasions for painting angels, such as the Sacrifice of Isaac, Daniel in the Lions' Den, the Annunciation, the Nativity, the Resurrection of Christ, the Assumption of the Virgin, and the Last Judgment. Angels also play a prominent role in Islamic scripture, and artists who belonged to the Shiite branch of Islam, which did not prohibit the representation of human form, depicted angels in scenes such as the *Ascension of Mohammed on Buraq, His Mule, Guided by the Angel Gabriel* (page 130).

Dante's *Divine Comedy* (c. 1308–21) and, much later, John Milton's *Paradise Lost* (1667) also conjured up elaborate visions of angels (and fallen angels) that became part of the vernacular and inspired generations of artists. By the time the Romantic poet Lord Byron wrote his satiric *Vision of Judgment* (1821), about the arrival of King George III in heaven, angels had become nearly a cliché:

'Twas the archangel Michael; all men know

The make of angels and archangels, since There's scarce a scribbler has not one to show,

From the fiends' leader to the angels' prince;

There also are some altar-pieces, though

I really can't say that they much evince One's inner notions of immortal spirits;

But let the connoisseurs explain their merits.

Conventions for portraying angels were slow to develop and, once established, were slow to change. Certain elements became codified, offering an easy way to identify the named angels in any given scene. For example, the archangel Gabriel carries a staff or a lily when making his annunciatory visit to the Virgin Mary but a trumpet when heralding the Last Judgment;

Michael almost invariably brandishes a sword with which to battle the forces of evil.

Angel imagery has steadily progressed over the centuries from the ethereal to the fleshy, paralleling Western culture's progression from faith in the unseen to reliance on direct observation and documentation. Even the early Florentine artist Giotto, who was such a pivotal figure in the transition from the medieval to the modern, still portrayed many of his angels as only quasiphysical, with their lower halves delineated more as disembodied suggestions of flight than as flesh and blood. (See the angel in the section on Joachim's dream in the Arena Chapel, page 87.) As Renaissance artists became increasingly dedicated to depicting the natural world accurately, angels became more and more three-dimensional—no longer the flat, almost translucent creatures of medieval art. Compare, for example, Simone Martini's four-teenth-century *Annunciation* (page 30) with the fifteenth-century one by Filippo Lippi (page 36), noting how the angels are situated in their surroundings.

Medieval angels were frequently placed flat against an unmodulated surface that was often painted gold to signify heavenly light. Starting in the Renaissance, angels were shown in more detailed and more convincingly familiar backgrounds, such as the Virgin Mary's bookfilled bedroom or a grassy, flower-bedecked paradise. By the Baroque period, angels had become not only recognizably human but even sensual, with their wings and bodies painted or sculpted in caressingly explicit detail.

After the eighteenth century, it seemed that the less wholeheartedly people believed in angels, the more believably they were portrayed. The trend toward this paradoxically realistic depiction of angels eventually became a source of contention between the nineteenthcentury Realist Gustave Courbet and the proto-Impressionist Edouard Manet regarding the

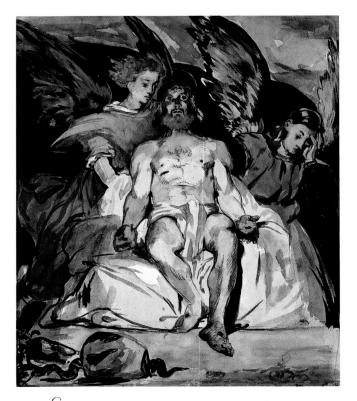

Graphite, watercolor, gouache, and pen and india ink on paper, 12⁵/₈ x 10⁵/₈ in. (32 x 27 cm). Musée d'Orsay, Paris; Gift of Mme. Emile Zola, 1925.

latter's painting *Christ with Angels* (page 10). Courbet was known for his fierce advocacy of uncompromising realism in art. "Art in painting consists only of representations of objects visible and tangible to the artist," he wrote. "An *abstract* object, not visible, not existing, is not within the realm of painting." Given this unyielding stance, it is not surprising that Courbet greeted Manet's painting of Christ and the angels with scorn, despite the fact that its unromanticized corpse and unidealized angels had scandalized contemporary critics.

As their colleague Pierre-Auguste Renoir recounted, Courbet mockingly asked Manet, "So you have seen angels then and know that they have backsides?" Edgar Degas later added: "Courbet said that never having seen angels, he did not know whether they had backsides and that, given their size, the wings Manet gave them could not have carried them. But I don't give a d—— about any of this."

By the time such irreverent comments could be made, the potential for sincere renditions of angels in the traditional mode had nearly vanished. What prevailed instead were winged figures—no longer really angels—that stood for something other than purely heavenly beings in allegories such as Jean-Auguste-Dominique Ingres's *Victoria* (below) and Augustus Saint-Gaudens's *Charity* (page 25).

Yet even in the late twentieth century, people continue to express faith in angels, and artists continue to portray them, as shown by Keith Haring's hovering cartoonlike being (page 26), Dorothea Tanning's surreal angelic landscape (page 142), and Komar and Melamid's radiant archangel for a church in New Jersey (page 43). These and other contemporary images communicate a sense of continuity with tradition and a spirit of aesthetic conviction that suggest that the angel may remain an eternal element in art.

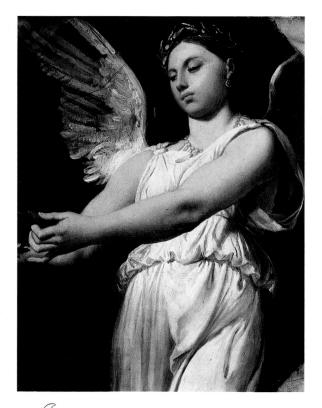

JEAN-AUGUSTE-DOMINIQUE INGRES (1780–1867).
 Victoria, detail of The Apotheosis of Homer, 1827.
 Oil on canvas. Musée Bonnat, Bayonne, France.

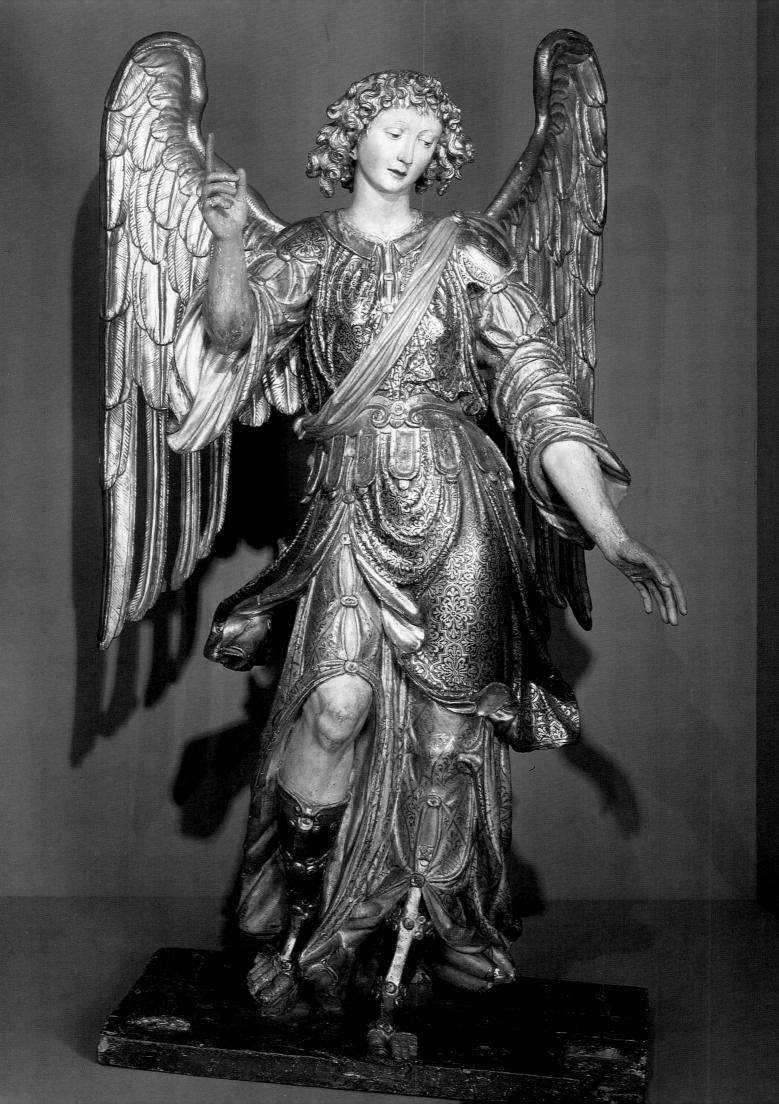

ANGEL PORTRAITS

And I saw another mighty angel come down from heaven, clothed with a cloud: and a rainbow was upon his head, and his face was as it were the sun, and his feet as pillars of fire. Revelation 10:1

Of ost angels are nameless, identified in art only by attributes such as color, clothing, or wing configuration. John Milton, in book 6 of *Paradise Lost*, suggests that angels preferred such anonymity:

Angels, contented with their fame in Heaven, Seek not the praise of men.

Early Christian images of angels are so idealized that the result is a generic type rather than an individualized portrait. They usually are clad in simple robes of one or two colors, with their wings providing the only elements of decoration. But even from the beginning, a few angels were singled out for special treatment. They had names—the most familiar and the most frequently portrayed being the archangels Gabriel, Michael, and Raphael. (Gabriel and Michael are the only two angels mentioned by name in the Protestant Bible; Raphael makes an appearance in the apocryphal Book of Tobit.) They were often lavishly costumed, with princely or ecclesiastical garb that grew more and more ornate as the centuries progressed. And they played major roles in scenes illustrating familiar stories from the Bible or from the Apocrypha.

Gabriel was the bearer of tidings both good and bad: he brought Mary news of Christ's impending birth, but he also announced the end of the world. Considered to be one of the seven angels of the Apocalypse (although not identified as such in the Book of Revelation), he sometimes holds the trumpet with which he is to sound the arrival of the final days.

Michael—often dressed in armor and bearing an unsheathed sword—was a warrior angel who led the battle against Satan. Known in the Old Testament and elsewhere as the prince of angels, he is shown as a formidable adversary. Joan of Arc declared that it was Michael who called her to do battle for France. In scenes of the Day of Judgment, he may also carry the scales of justice, with which he weighs souls to determine if they will go to heaven or to hell.

> Archangel Raphael, Naples, Italy, late 16th century. Polychromed wood, 70 x 39³/₈ in. (177.8 x 100 cm). Los Angeles County Museum of Art; Purchased with funds given by Anna Bing Arnold.

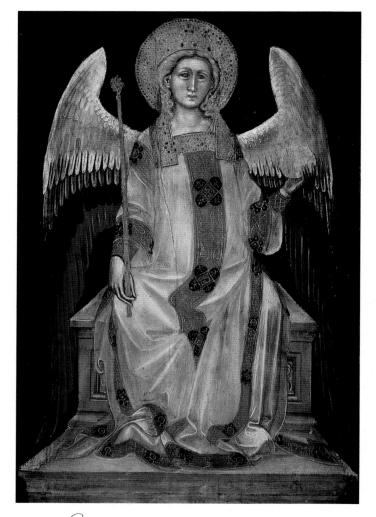

GUARIENTO DI ARPO (c. 1338–1377). Angel, 1354. Panel, 35³/₈ x 22³/₈ in. (90 x 57 cm). Musei Civici, Padua, Italy.

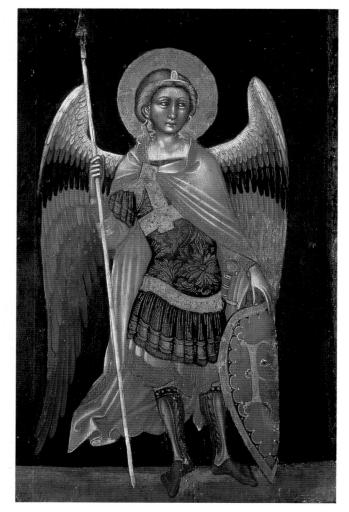

GUARIENTO DI ARPO (c. 1338–1377). Angel, 1354. Panel, 35³/₈ x 19³/₄ in. (90 x 50 cm). Musei Civici, Padua, Italy.

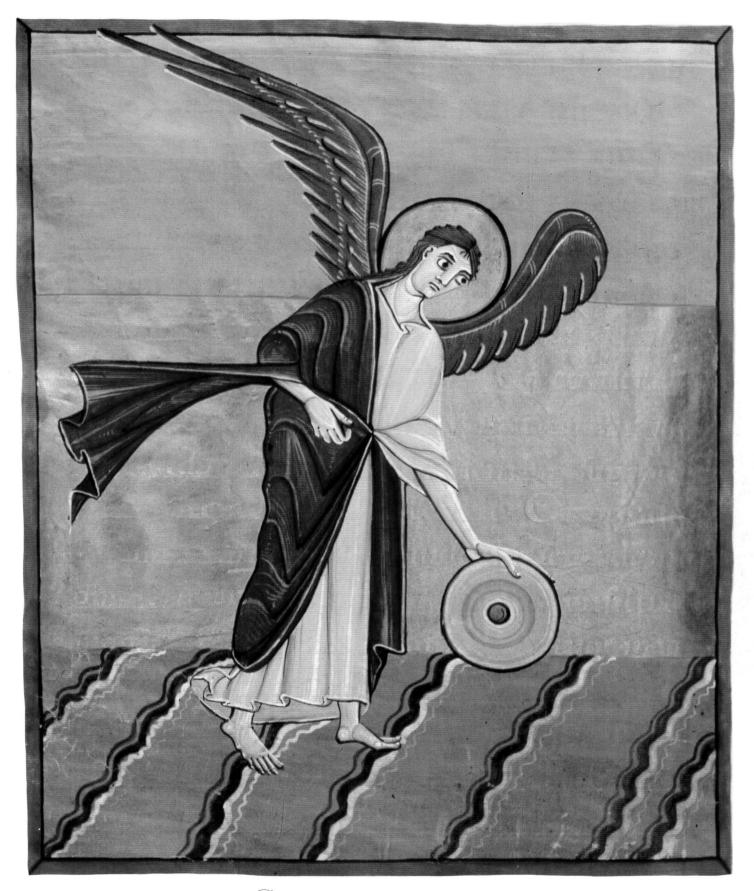

Angel with Millstone, c. 1020. Illuminated manuscript, 11½ x 8 in. (29.5 x 20.4 cm). Staatsbibliothek, Bamberg, Germany.

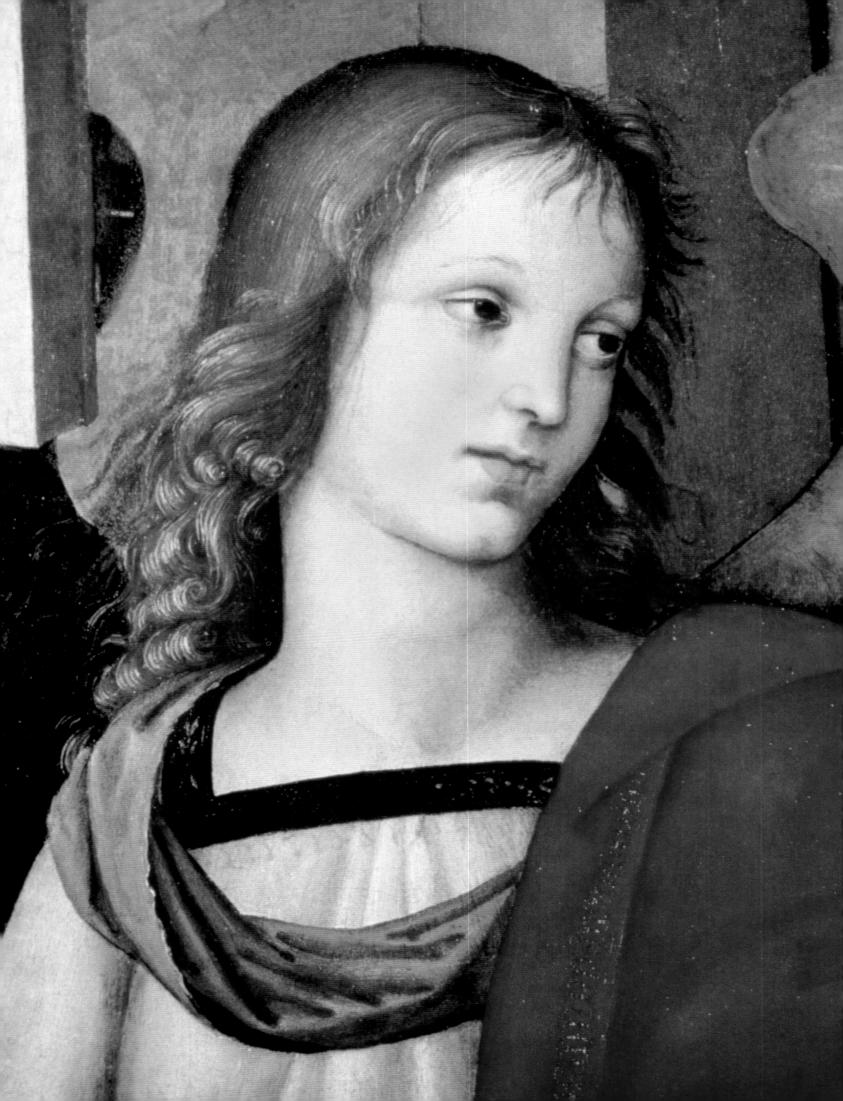

RIGHT

Angels, c. 1180. Stained glass. Chartres Cathedral, Chartres, France.

OPPOSITE

RAPHAEL (1483–1520). Detail of *The Saint Nicholas Altarpiece*, c. 1500–1501.

Oil on wood, 12[%] x 10[%] in. (32 x 27 cm), overall. Pinacoteca Civica Tosio-Martinengo, Brescia, Italy.

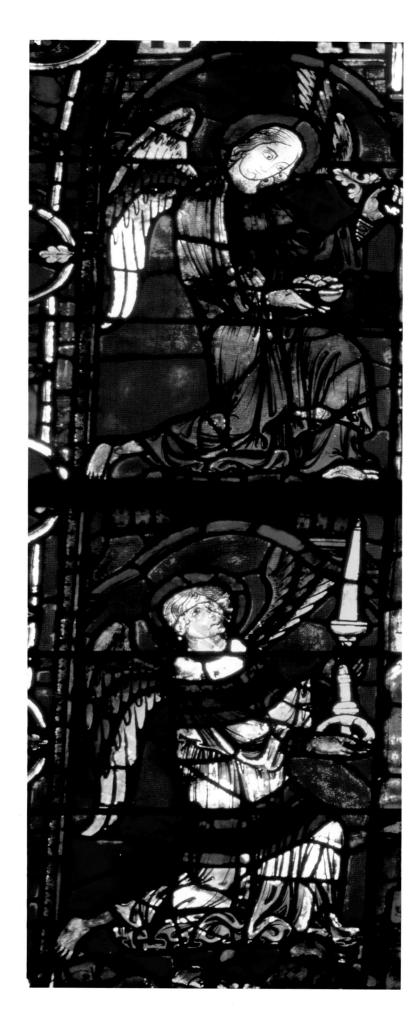

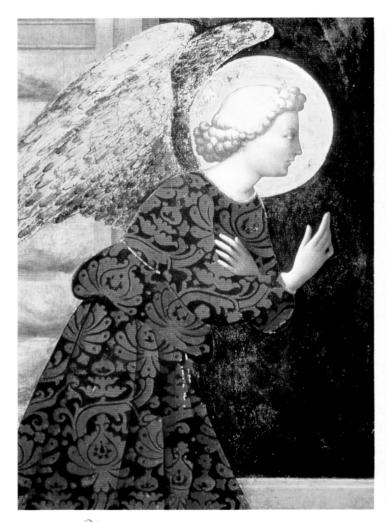

MASOLINO DA PANICALE (c. 1383/84-1447?). Archangel Gabriel, c. 1432. Tempera on wood, 30 x 22⁵/₈ in. (76 x 57 cm). National Gallery of Art, Washington, D.C.; Samuel H. Kress Collection.

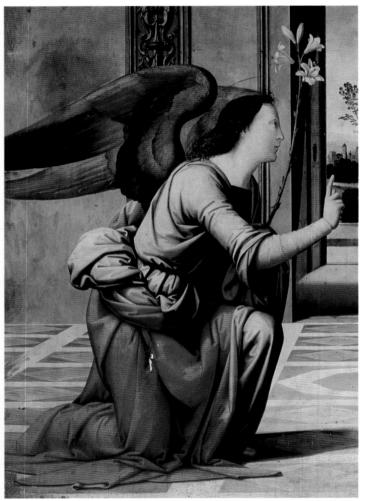

BENVENUTO DI GIOVANNI GUASTA (1436–1518). Detail of *The Annunciation*, 1466. Tempera on wood, 71¹/₄ x 88¹/₄ in. (181 x 224 cm), overall. Pinacoteca Comunale, Volterra, Italy.

JACOPO DA PONTORMO (1494–1556). Detail of *The Annunciation*, 1527–28. Fresco, 145 x 66 in. (368 x 168 cm), overall. Capponi Chapel, Santa Felicita, Florence.

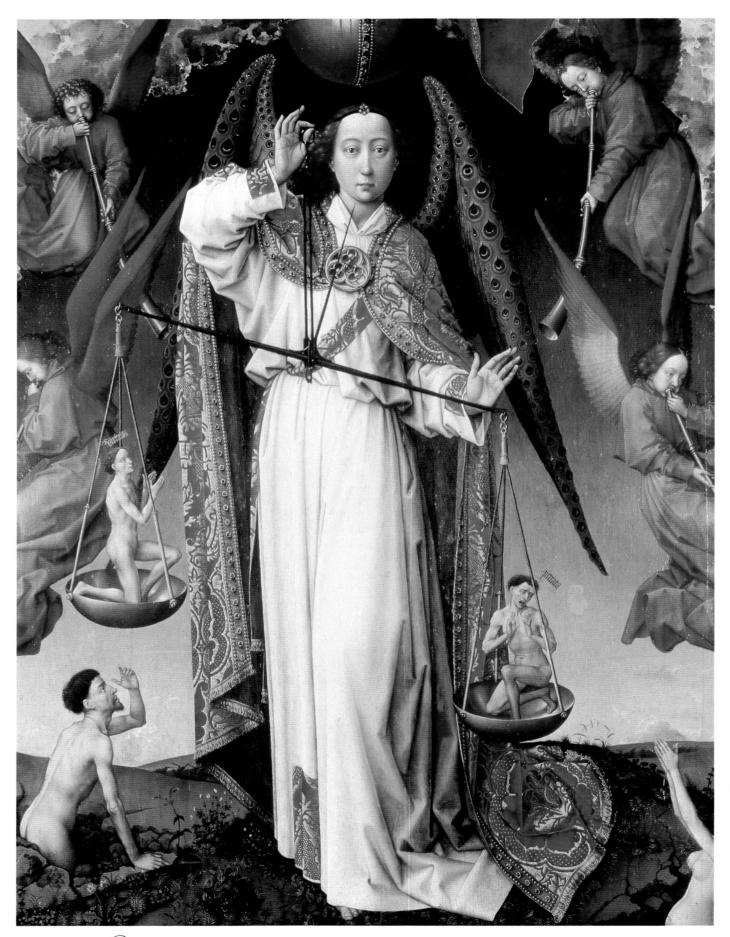

ROGIER VAN DER WEYDEN (1399/1400–1464). Saint Michael Weighing Souls, detail of The Last Judgment, 1443. Oil on wood, 39^{3/4} x 55 in. (100 x 140 cm), overall. Musée de l'Hôtel-Dieu, Beaune, France.

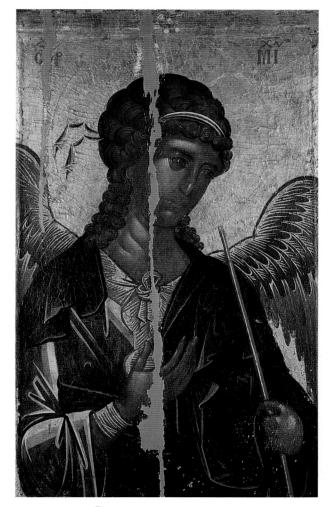

Archangel Michael, 14th century. Icon. Serbisches Kloater Hilander, Berg Athos, Greece.

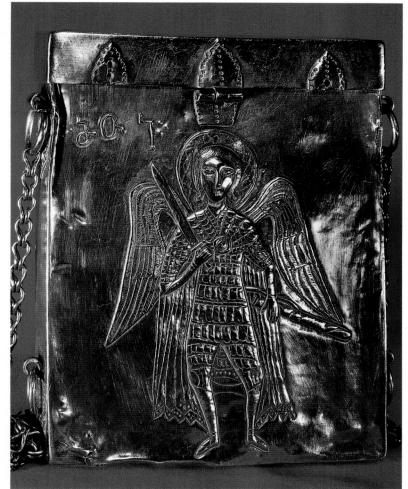

Silver, approximately 7⁷/₈ x 5⁷/₈ in. (20 x 15 cm). Musée Arménien de France, Paris.

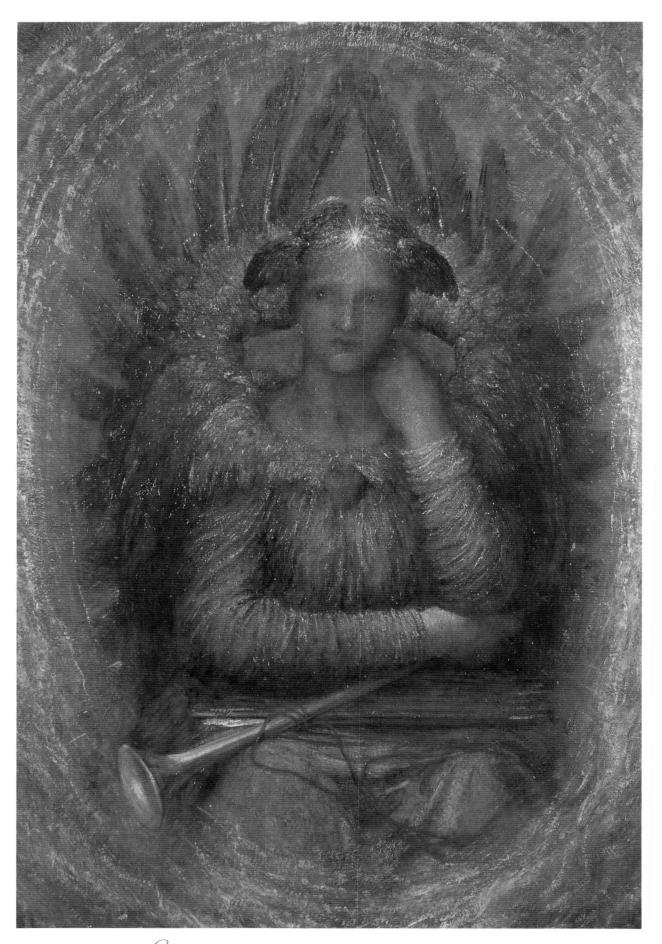

George Frederic Watts (1817–1904). Dweller in the Innermost, c. 1885–86. Oil on canvas, $41\frac{34}{4} \ge 27\frac{1}{2}$ in. (106 ≥ 69.8 cm). Tate Gallery, London.

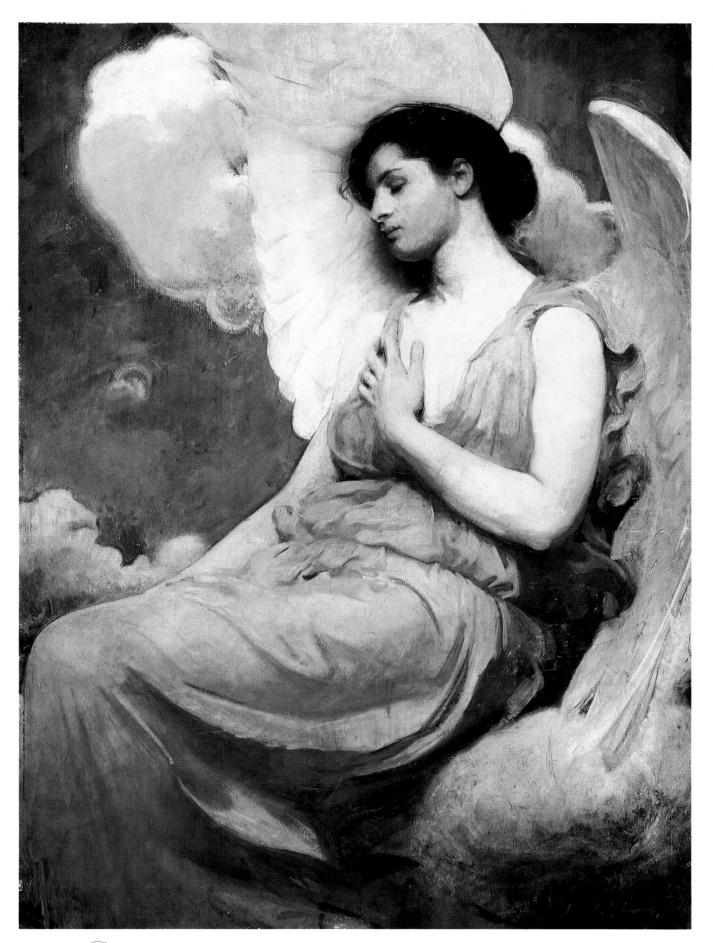

BBOTT HANDERSON THAYER (1849–1921). *Winged Figure*, 1889. Oil on canvas, 51½ x 37¼ in. (131 x 96 cm). The Art Institute of Chicago; Simeon B. Williams Fund, 1947.

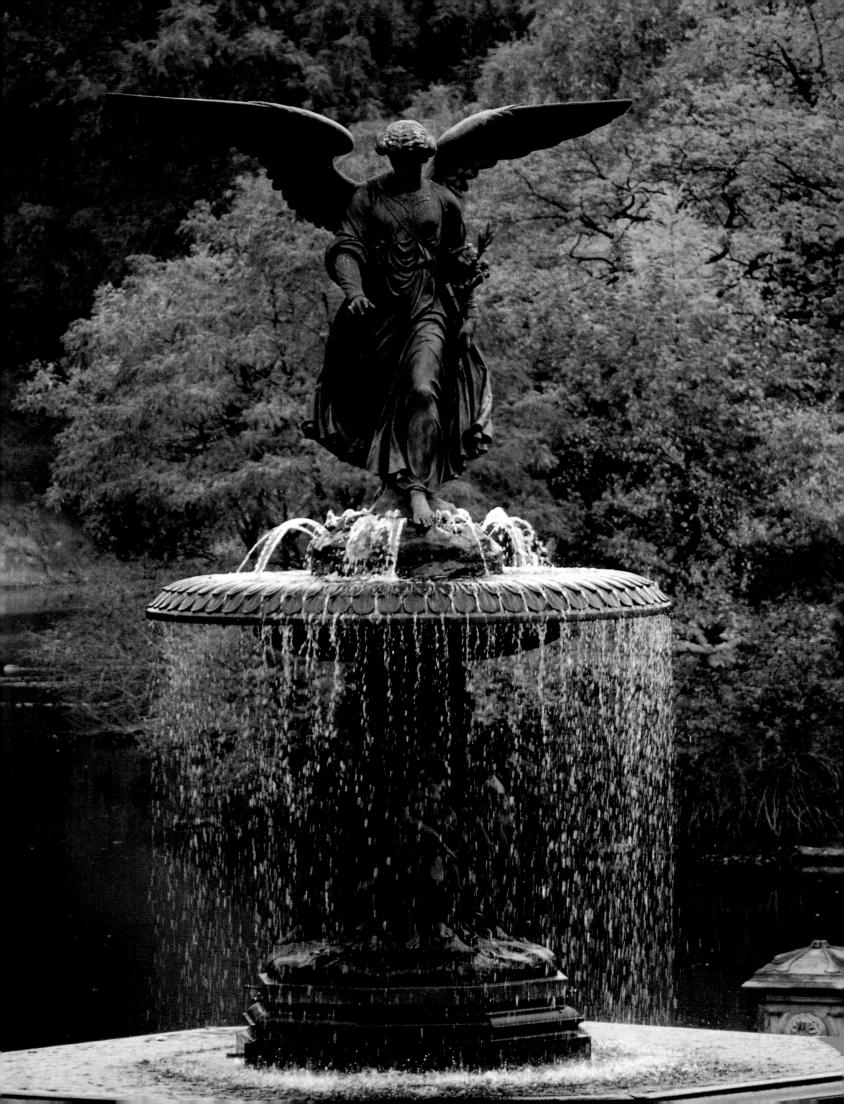

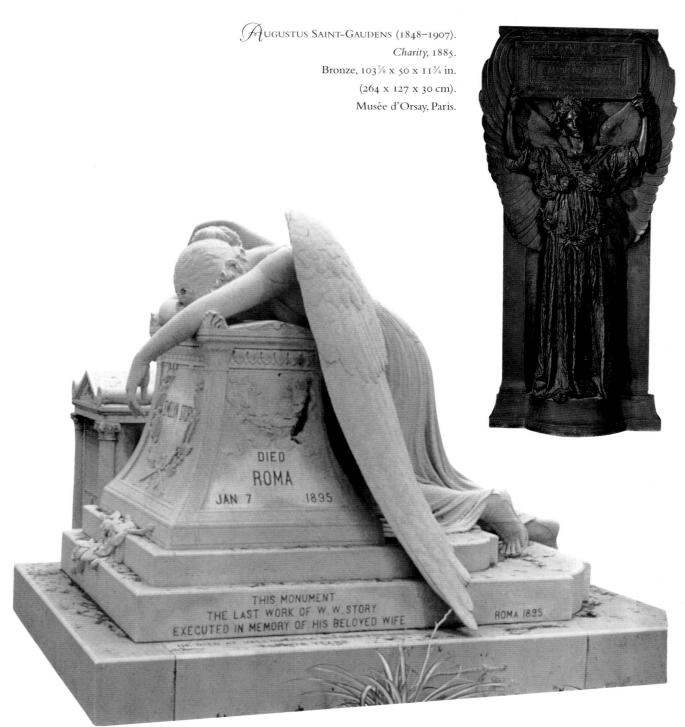

Detection Wetmore Story (1819–1895). *Angel of Grief,* 1905. Protestant Cemetery, Rome.

CMMA STEBBINS (1815–1882). Angel of the Waters, constructed 1868, unveiled 1873. Bronze, height of angel: 94^{1/2} in. (240 cm). Central Park, New York.

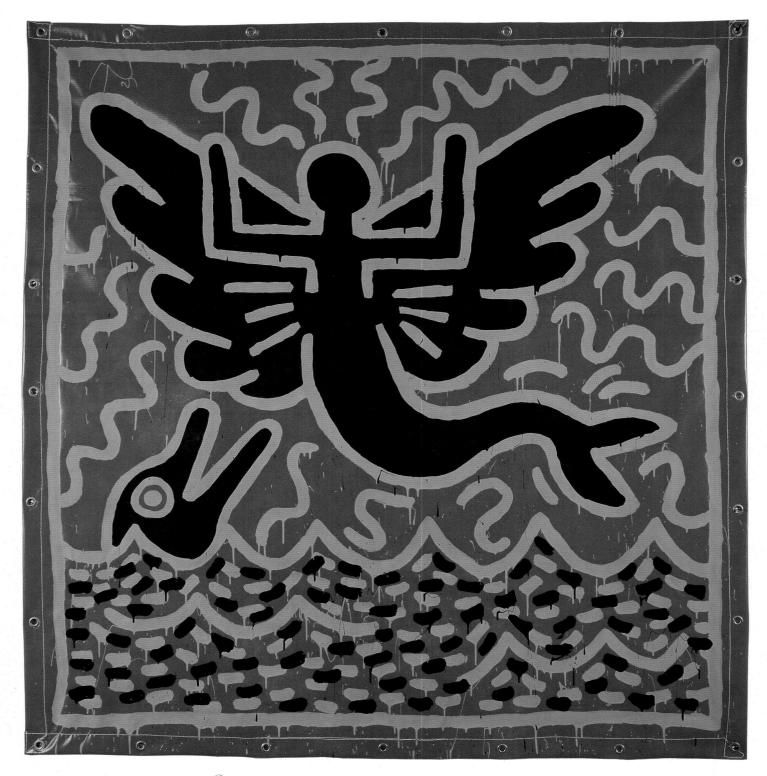

HARING (1958–1990). Untitled, 1982. Vinyl ink on vinyl tarp, 72 x 72 in. (182.8 x 182.8 cm). Private collection, Berlin.

FRED SMITH (1886–1976). Angel, 1950–68. Glass-covered concrete. Fred Smith's Wisconsin Concrete Park, Phillips.

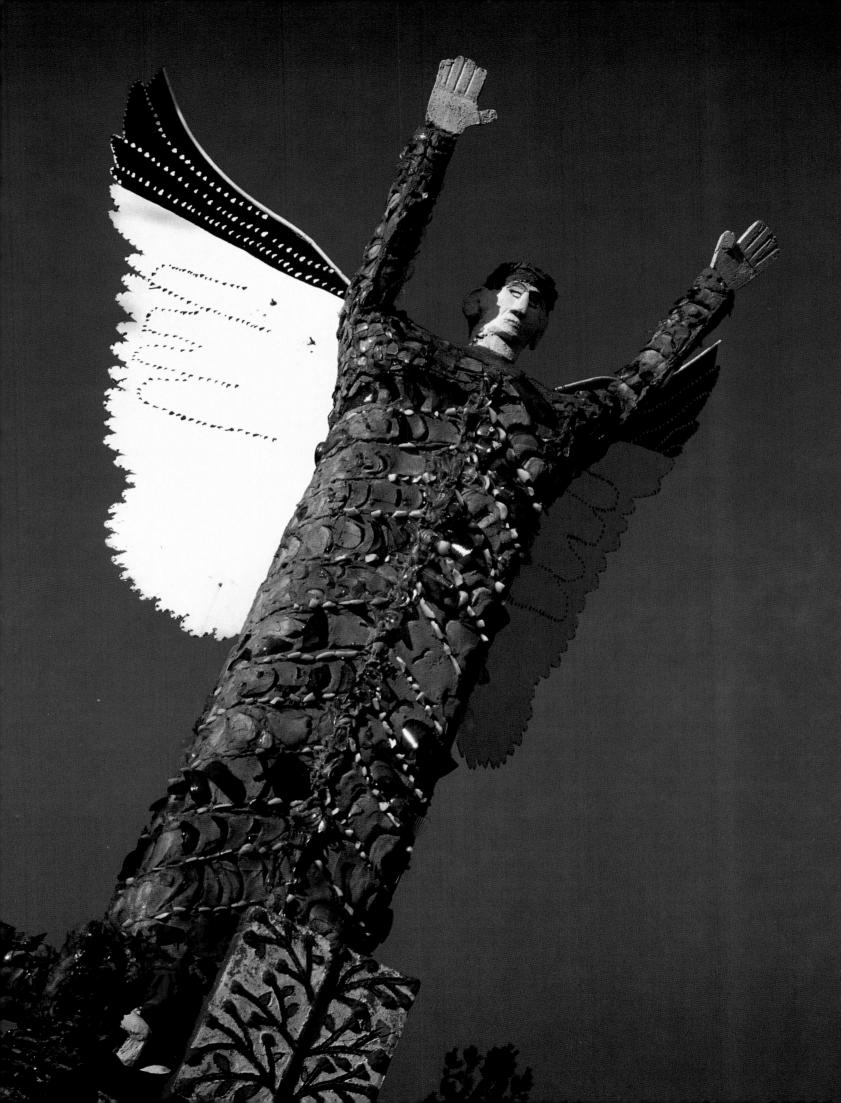

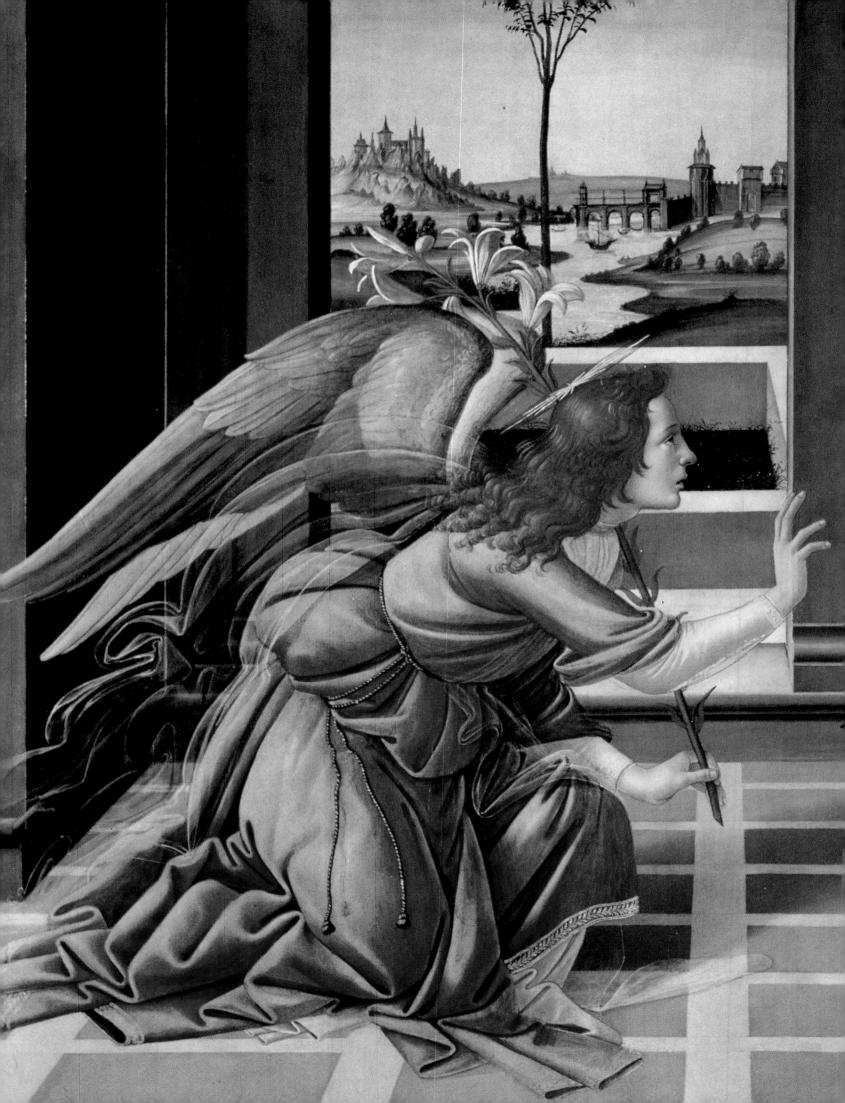

HEAVENLY MESSENGERS

Behold, I bring you good tidings of great joy.

Luke 2:10

ngels are first and foremost messengers; in fact, the word *angel* is derived from the Greek word for messenger. One of the most frequently painted scenes in Christian art—particularly favored during the Renaissance—is the Annunciation. As chronicled in the Gospel of Luke, it was Gabriel who announced to the Virgin Mary that she would give birth to the child of God. In many Annunciations a ribbonlike banner unfurls, emblazoned with the words *Ecce ancilla domini* ("Behold the handmaid of the Lord"), taken from Luke's account.

The moment portrayed is Mary's conception by means of the Holy Spirit, which is often depicted as a beam of light streaming down from a dove. The beam frequently is directed toward her ear, embodying the medieval idea that Mary conceived through that route. Portrayals of her response to Gabriel's news became increasingly human over the centuries, progressing from the early images of a shy young woman expressing either mild surprise or calm acceptance to the decidedly alarmed maiden in Dante Gabriel Rossetti's *Ecce Ancilla Domini!* (page 42).

Gabriel is often shown as a sweet-faced, almost feminine youth with intricately feathered wings, as in the images of the Annunciation by Fra Angelico (pages 32–33) and Rogier van der Weyden (page 34). Sometimes he hovers just above the ground—as in the Rossetti painting, where he is wingless, with flames around his feet—but more often he kneels in motionless silence, holding out a staff or a lily, the latter a symbol of the Virgin's purity.

The Nativity is also heralded by angels—in this case, an angelic choir that brings the news of Christ's birth to nearby shepherds. Most often the angels sing their praise of the event from the heavens, but sometimes they are shown as having descended to earth to worship the newborn Christ in his manger, as in the Nativities by Hugo van der Goes (page 44) and Philippe de Champaigne (page 80).

Detail of SANDRO BOTTICELLI (1445–1510), *The Annunciation*, c. 1489–90. See page 37.

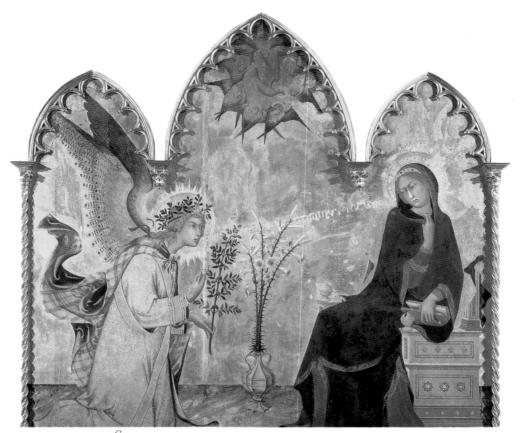

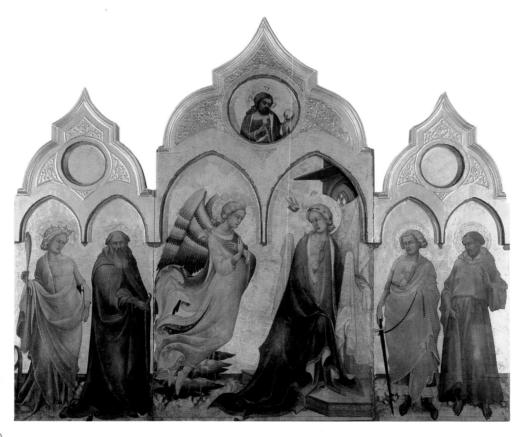

CORENZO MONACO (c. 1370–1422/25). The Annunciation with Saints Catherine, Anthony Abbot, Procolo, and Francis, c. 1410. Tempera on wood, 81¹/₂ x 90 in. (207.2 x 228.8 cm). Galleria dell'Accademia, Florence.

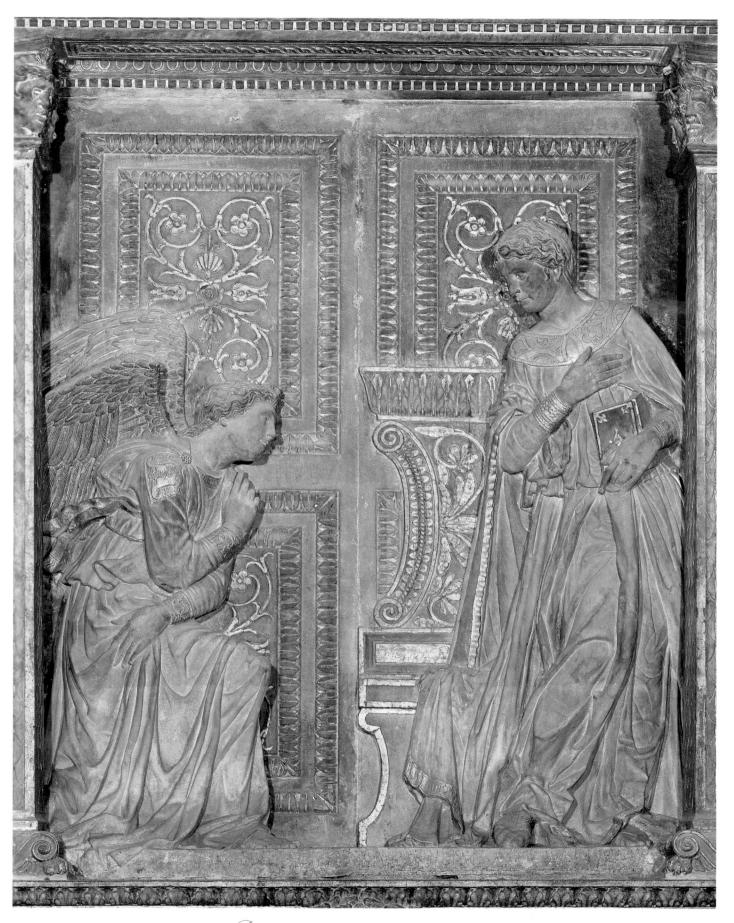

Gilded and polychromed *pietra di macigno*, 165 x 108 in. (419.1 x 274.3 cm). Santa Croce, Florence.

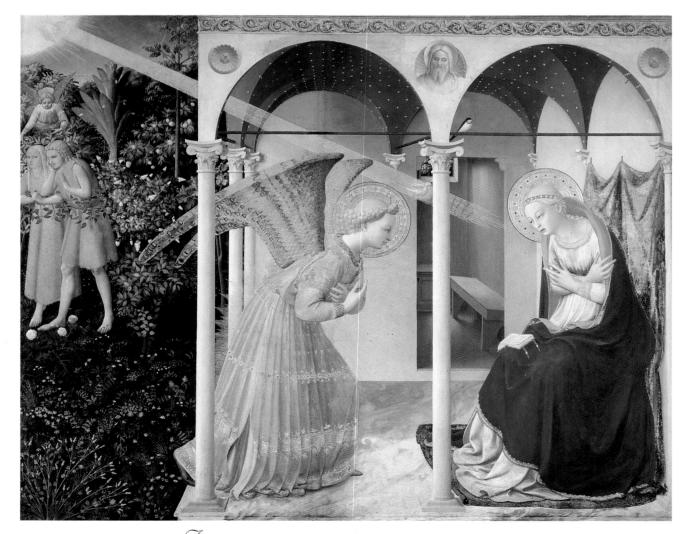

FRA ANGELICO (c. 1400–1455). Detail of *The Annunciation*, 1435–45. Tempera on wood, 76³/₈ x 76³/₈ in. (194 x 194 cm), overall. Museo del Prado, Madrid.

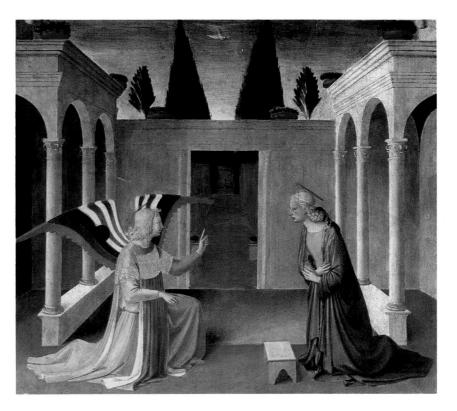

FRA ANGELICO (c. 1400–1455). The Annunciation, detail of Panel with Nine Scenes from the Silver Chest of Santissima Annunziata, c. 1450. Tempera on wood, each scene: 15% x 15% in. (39 x 39 cm). Museo di San Marco, Florence.

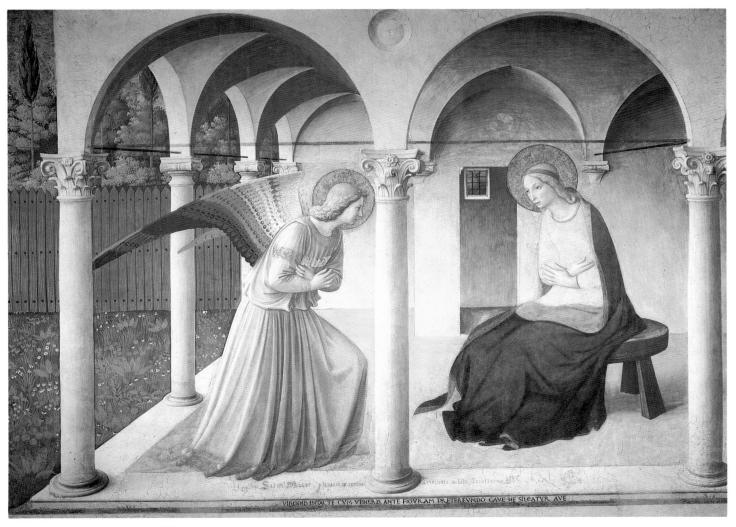

FRA ANGELICO (c. 1400–1455) and workshop. *The Annunciation*, late 1430s–early 1440s. Fresco, 73⁵/₈ x 61³/₄ in. (187 x 157 cm), overall. Monastery of San Marco, Florence.

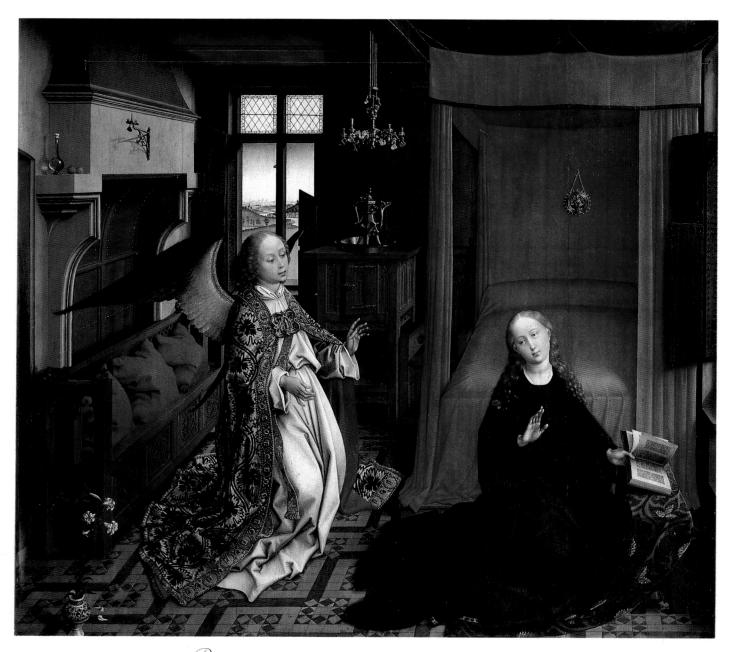

ROGIER VAN DER WEYDEN (1399/1400–1464). *The Annunciation*, c. 1435. Wood, 33⁷/₈ x 36³/₈ in. (86 x 93 cm). Musée du Louvre, Paris.

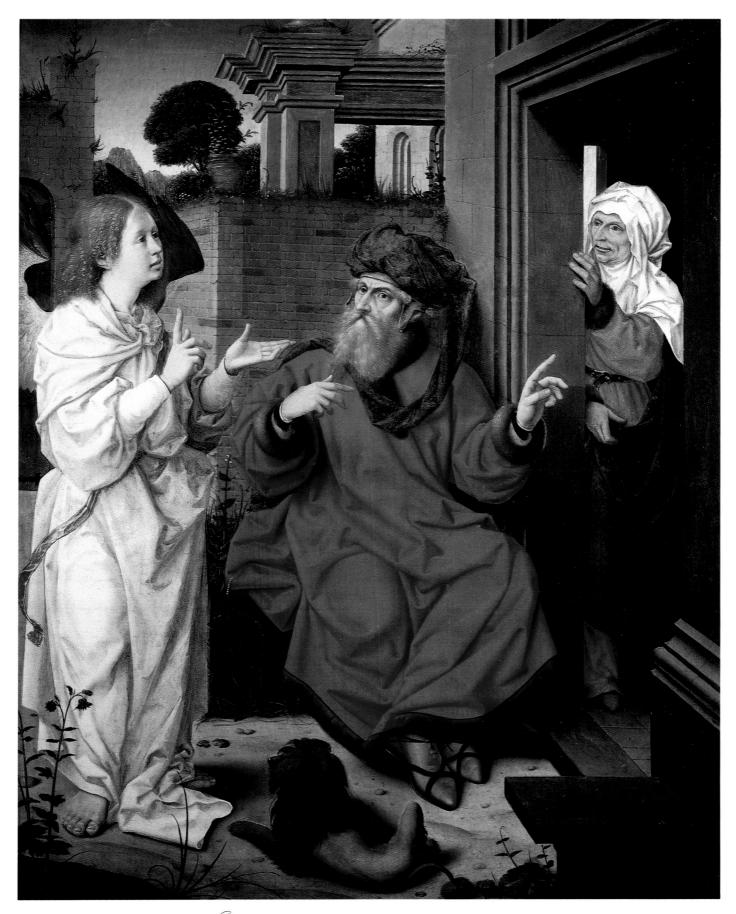

JAN PROVOST (1465–1520). Abraham, Sarah, and the Angel, n.d. Oil on wood, 29½ x 22 in. (75 x 56 cm). Musée du Louvre, Paris.

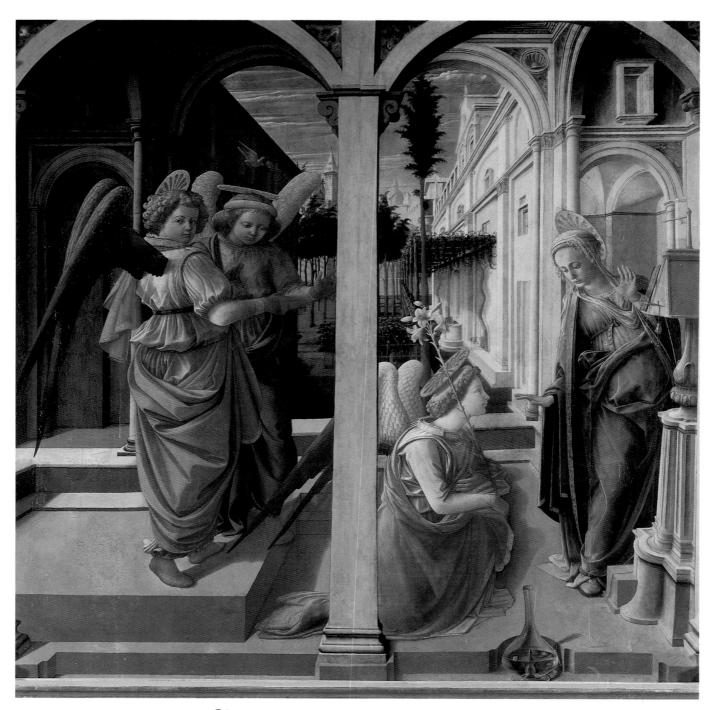

FRA FILIPPO LIPPI (c. 1406–1469). *The Annunciation*, c. 1440. Tempera on wood, 69 x 72 in. (175.3 x 183 cm). Martelli Chapel, San Lorenzo, Italy.

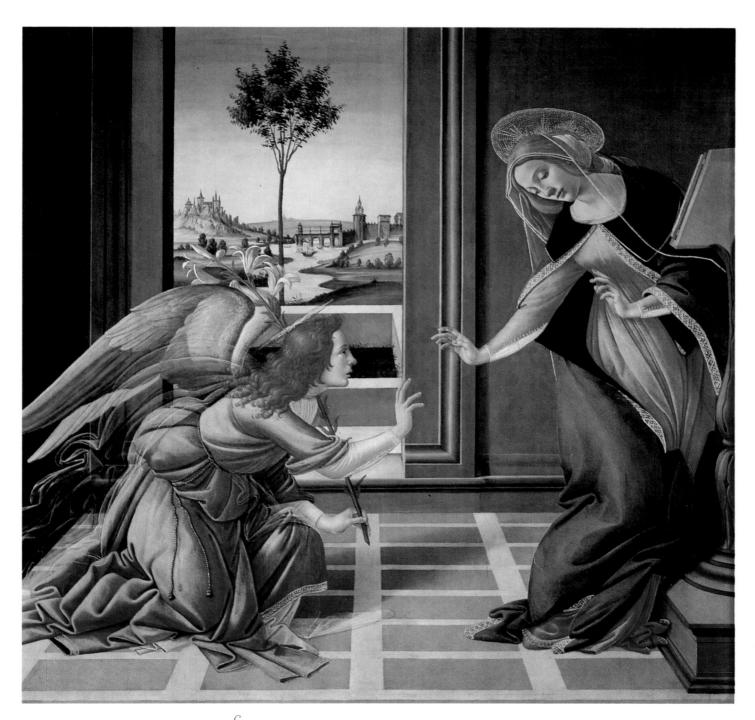

⊙∫ANDRO BOTTICELLI (1445–1510). *The Annunciation*, c. 1489–90. Tempera on wood, 59 x 61³/₈ in. (150 x 156 cm). Galleria degli Uffizi, Florence.

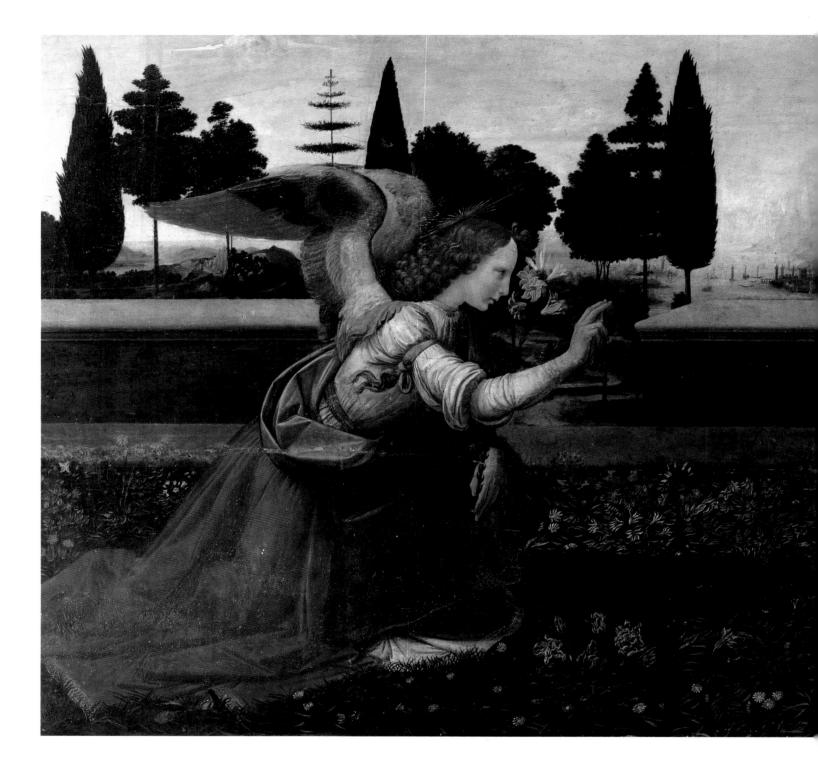

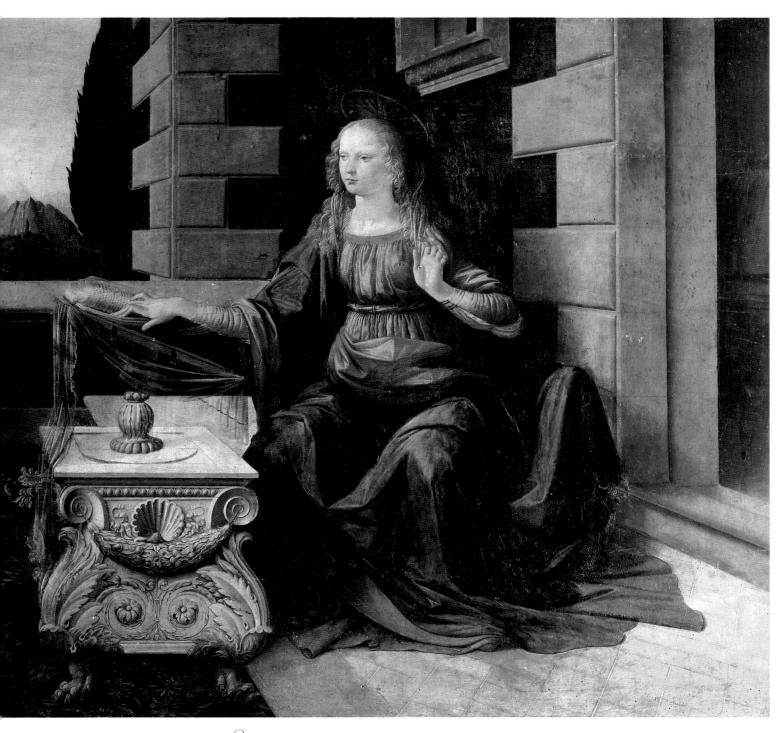

 \bigcirc EONARDO DA VINCI (1452–1519) and others. *The Annunciation*, c. 1472–75. Oil on wood, $38\frac{1}{2} \ge 85\frac{1}{2}$ in. (98 x 217 cm). Galleria degli Uffizi, Florence.

GAROFALO (1481–1559). The Annunciation, 1550. Tempera on wood, $98\frac{3}{8} \ge 65$ in. (250 ≥ 165 cm). Pinacoteca di Brera, Milan.

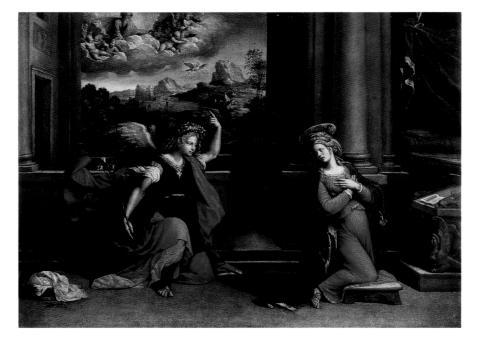

GAROFALO (1481-1559).The Annunciation, n.d. Oil on wood, $21\frac{5}{8} \ge 30$ in. (55.2 ≥ 76 cm). Galleria degli Uffizi, Florence.

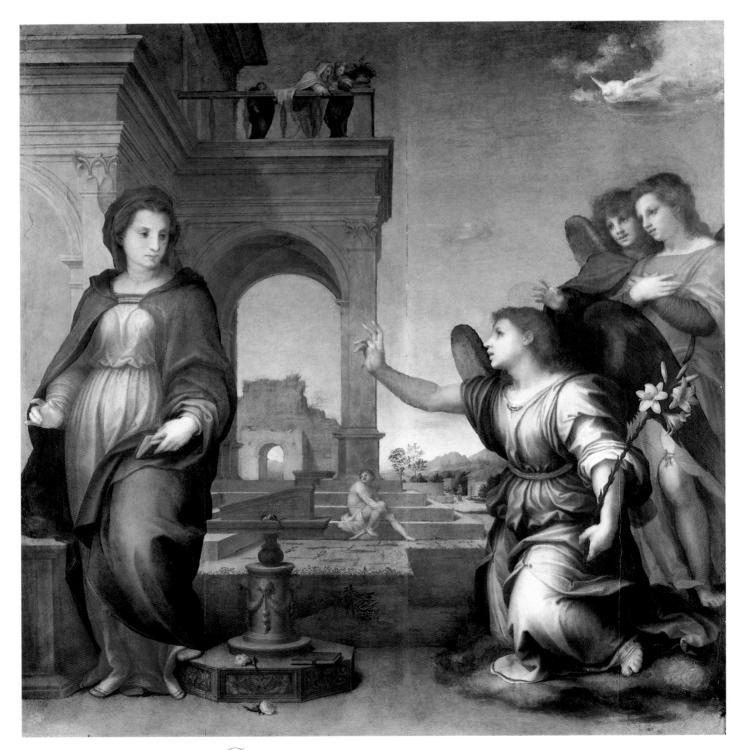

MDREA DEL SARTO (1486–1530). *The Annunciation*, 1512. Oil on wood, 71³/₄ x 69¹/₄ in. (182 x 176 cm). Galleria Palatina, Palazzo Pitti, Florence.

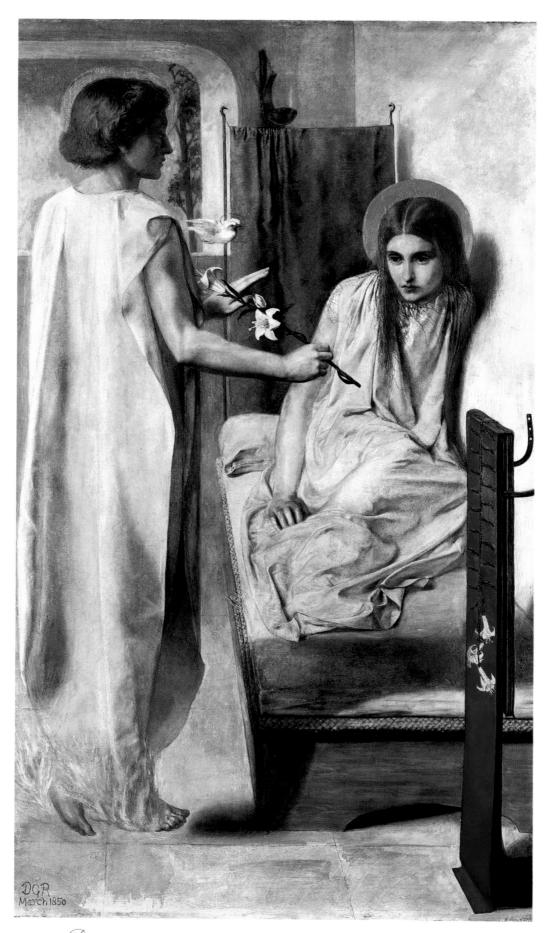

ØANTE GABRIEL ROSSETTI (1828–1882). "Ecce Ancilla Domini!" (The Annunciation), 1850.
 Oil on canvas, mounted on wood, 28⁵/₈ x 16¹/₄ in. (72.6 x 41.3 cm). Tate Gallery, London.

Comar (b. 1943) and MELAMID (b. 1945). *The Annunciation*, 1990. Steel, water, oil, and gold leaf, approximately 108 x 48 in. (274.3 x 121.9 cm). Courtesy of Ronald Feldman Fine Arts, New York.

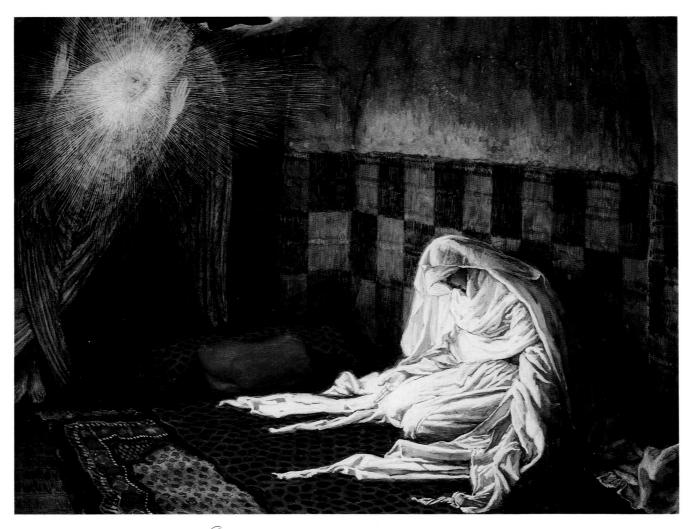

JAMES TISSOT (1836–1902). *The Annunciation*, c. 1886–96. Watercolor and gouache on paper. The Brooklyn Museum.

THE NATIVITY

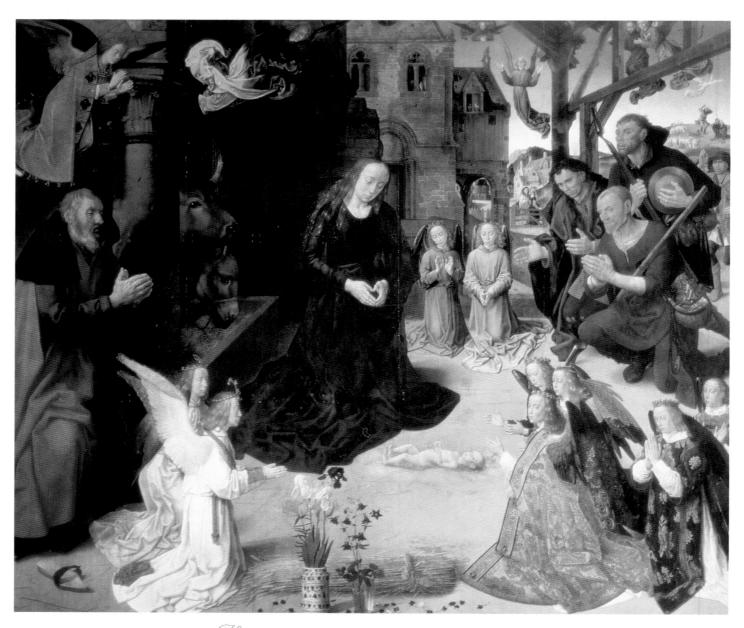

HUGO VAN DER GOES (c. 1440–1482). *Portinari Altarpiece*, 1475. Oil on wood, 99½ x 119% in. (253 x 304 cm). Galleria degli Uffizi, Florence.

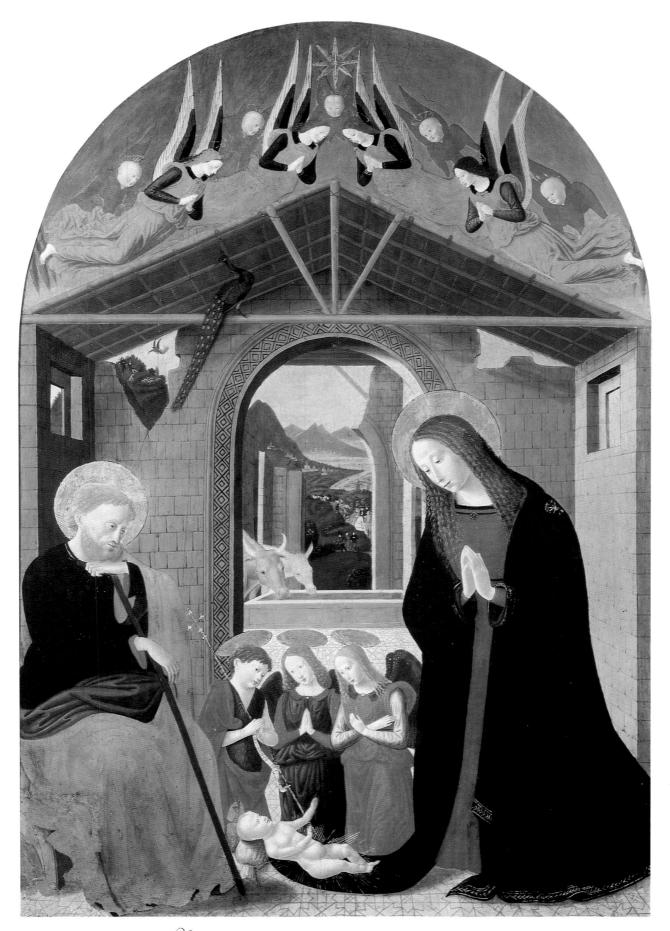

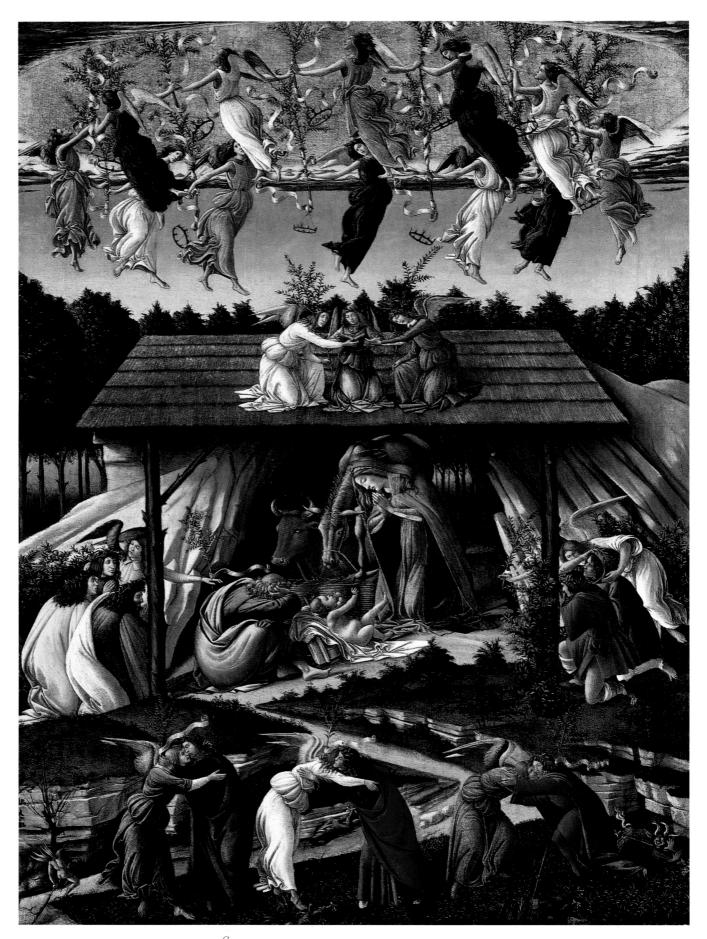

SANDRO BOTTICELLI (1445–1510). *Mystic Nativity*, c. 1500. Tempera on canvas, 49^{1/4} x 29^{1/2} in. (108.5 x 75 cm). The National Gallery, London.

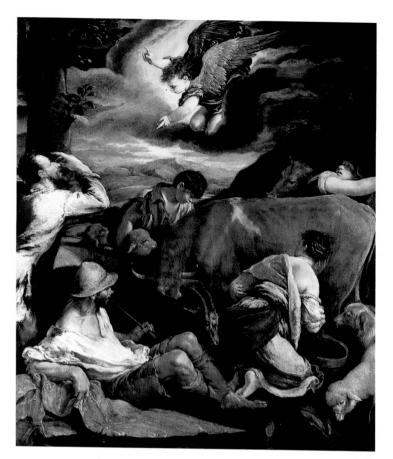

JACOPO BASSANO (c. 1510–1592). The Annunciation to the Shepherds, c. 1533. Oil on canvas, 45⁵/₈ x 37 in. (116 x 94 cm). Belvoir Castle, Leicestershire, England.

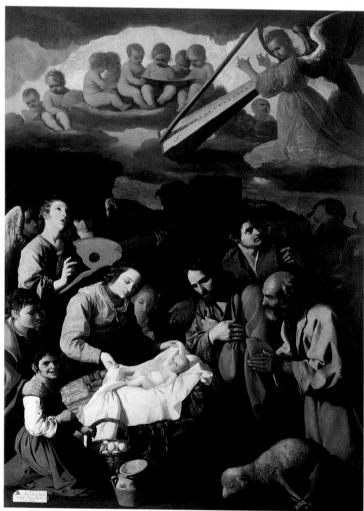

FRANCISCO ZURBARÁN (1598–1664). The Adoration of the Shepherds, 1638–39. Oil on canvas, 105 x 72³/4 in. (267 x 185 cm). Musée des Beaux-Arts, Grenoble, France.

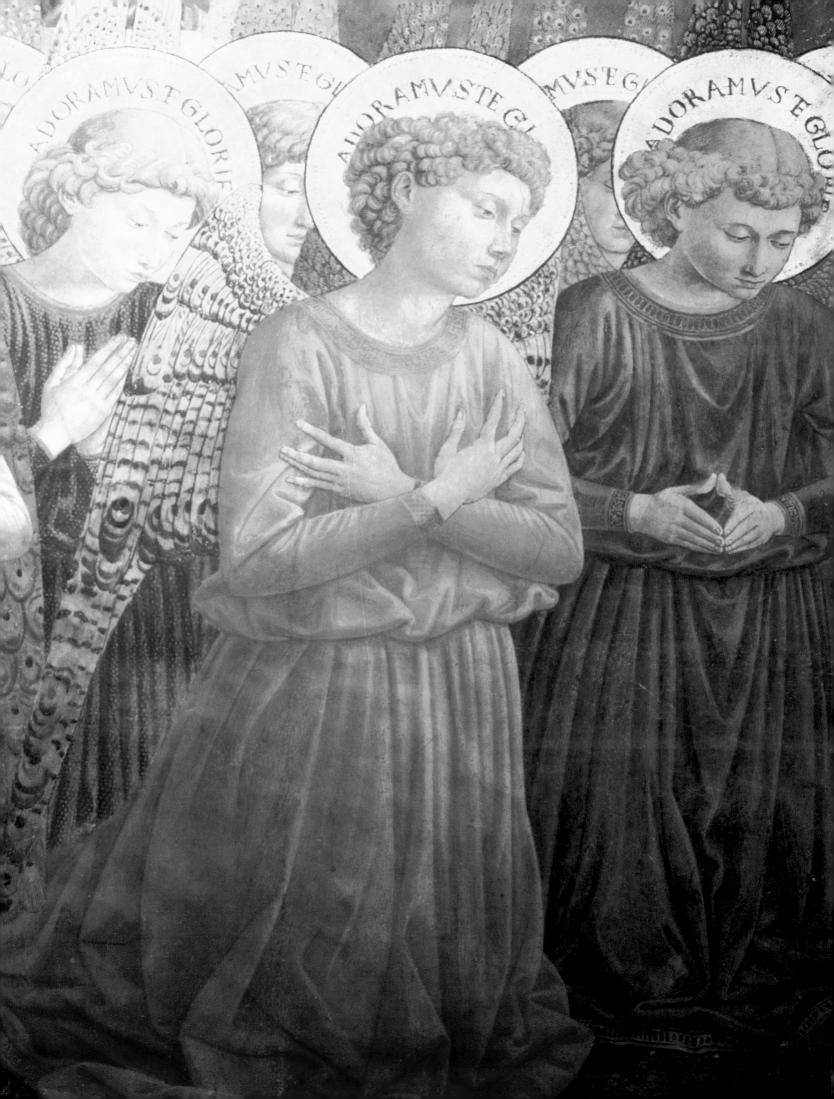

HOSTS OF ANGELS

And there are three hundred angels very bright, who keep the garden, and with incessant sweet singing and neversilent voices serve the Lord throughout all days and hours. Book of the Secrets of Enoch 9:1

rtists reveled in the opportunity to portray large groups of angels, finding an infinite number of ways to enliven and vary such scenes. Sometimes groups of angels are clustered around a heavenly throne, as in Cimabue's *Madonna and Child in Majesty Surrounded by Angels* (page 50) and Stefan Lochner's *Virgin in a Rose Arbor* (page 69). At other times they are witnessing the Ascension of the resurrected Christ into heaven, as in Giotto's gold-brightened fresco in the Arena Chapel (page 51).

And often these angelic bands are making music. The Book of the Secrets of Enoch (17:1) provides a supposedly eyewitness account of one session of celestial music-making:

In the midst of the heavens I saw armed soldiers, serving the Lord, with tympana and organs, with incessant voice, with sweet voice, with sweet and incessant voice and various singing, which it is impossible to describe, and which astonishes every mind, so wonderful and marvelous is the singing of those angels, and I was delighted listening to it.

Such musical angels are particularly associated with scenes of paradise, either in connection with the Assumption of the Virgin or with the Last Judgment, as shown in Ridolfo Ghirlandaio's trumpeting angels celebrating the Virgin's Coronation (page 67). The delineation of the horns, harps, and other instruments in these unearthly scenes is often painstakingly precise, and has provided invaluable information to researchers of early music.

Some accounts hold that angels, being made of light themselves, were brought into existence on the very first day of creation, when God separated light from darkness—an event recalled by Giusto de Menabuoi's *Creation of the World* (page 51). Early artists trying to represent angels as creatures of light often clad them in white or gold, as in the dazzling mosaics that decorate the interior dome of the Baptistery in Florence (page 54), where all nine categories of angels can be seen in marvelous detail.

BENOZZO GOZZOLI (1421–1497). Adoring Angels, detail of The Journey of the Magi, 1459–61. Fresco, length: approximately 24 ft. 7 in. (7.5 m), overall. Chapel of the Palazzo Medici-Riccardi, Florence.

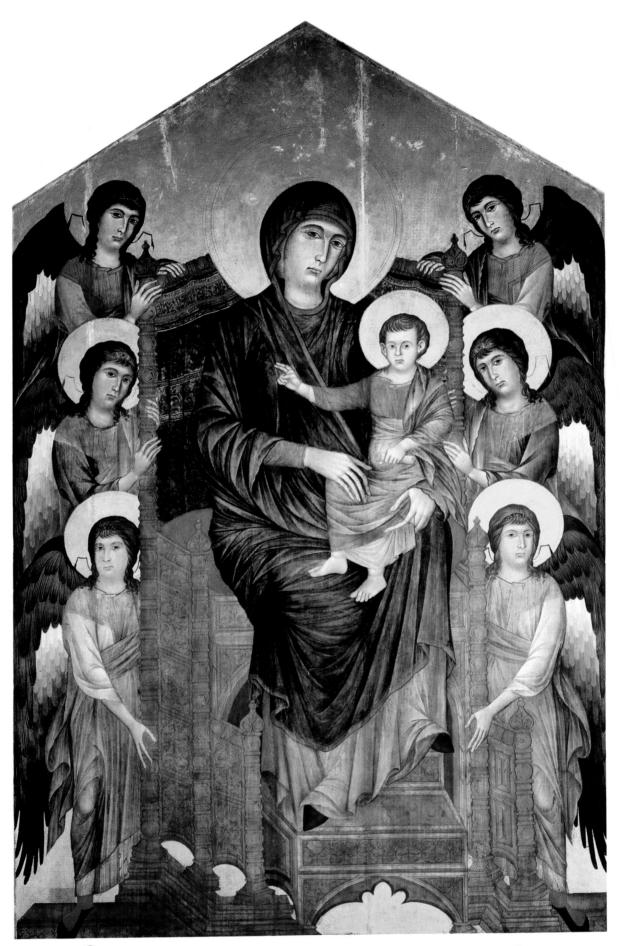

CIMABUE (c. 1240–after 1302). Madonna and Child in Majesty Surrounded by Angels, c. 1270(?). Wood, 14 ft. x 9 ft. 3 in. (4.27 x 2.8 m). Musée du Louvre, Paris.

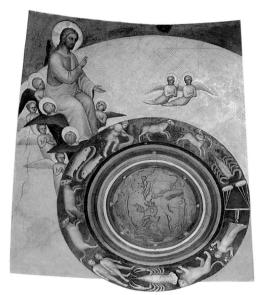

GIUSTO DE MENABUOI (14th century). The Creation of the World, c. 1376. Fresco. Baptistery of the Cathedral, Padua, Italy.

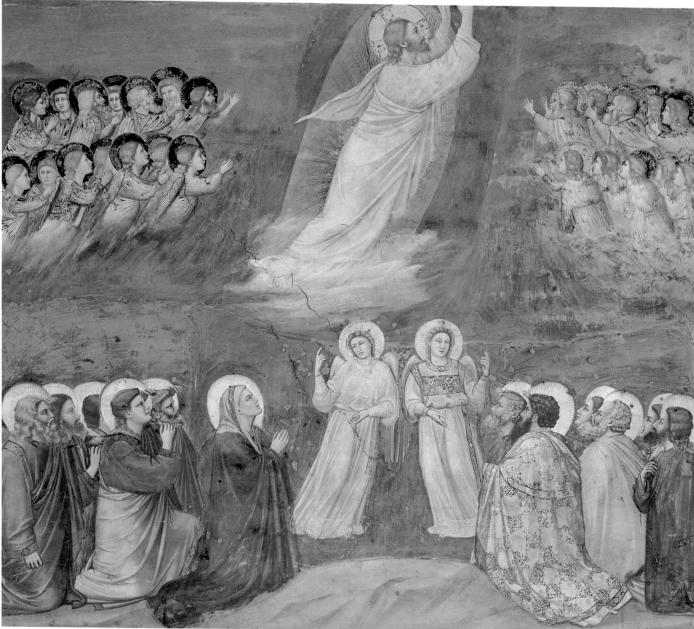

GIOTTO (1266/67–1337). The Ascension, c. 1305–13. Fresco. Arena Chapel, Padua, Italy.

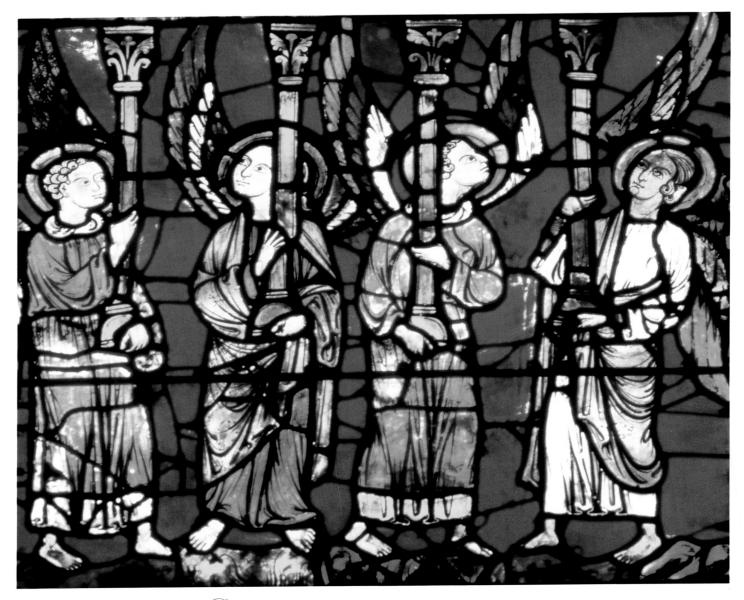

(Angels from "Notre Dame de la Belle Verrière," c. 1180. Stained glass, height: 94½ in. (240 cm). Chartres Cathedral, Chartres, France.

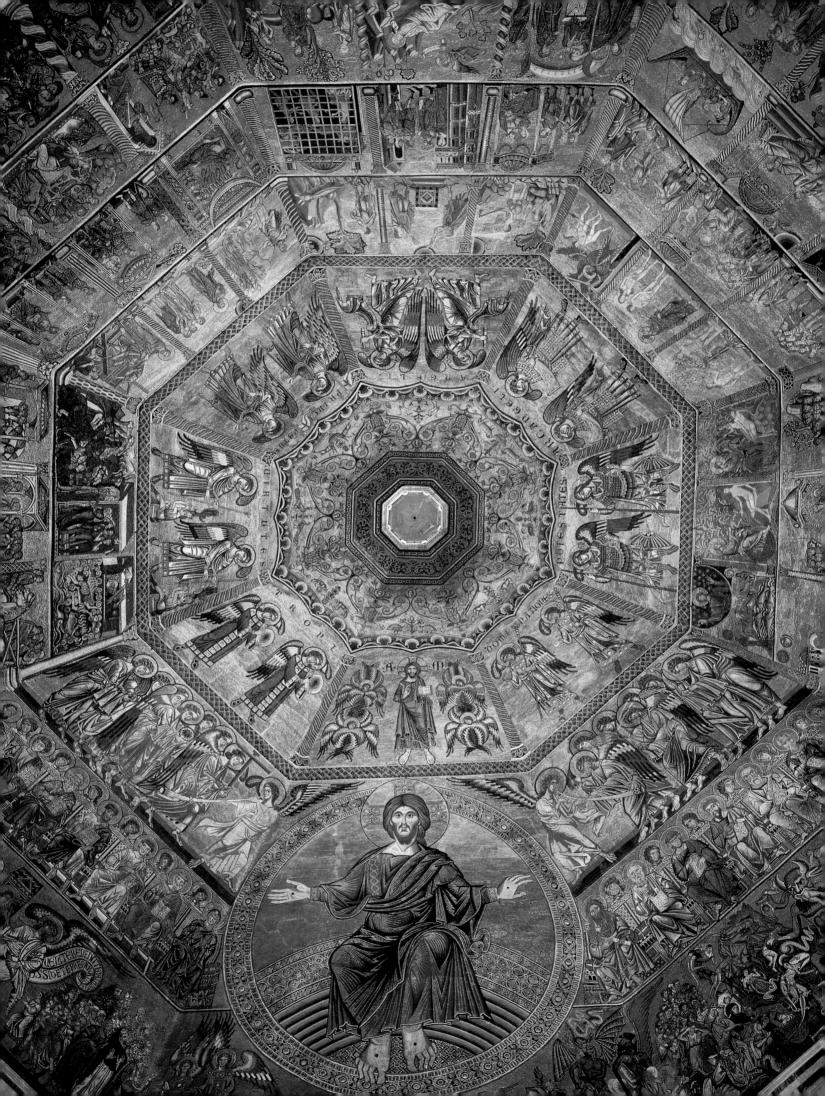

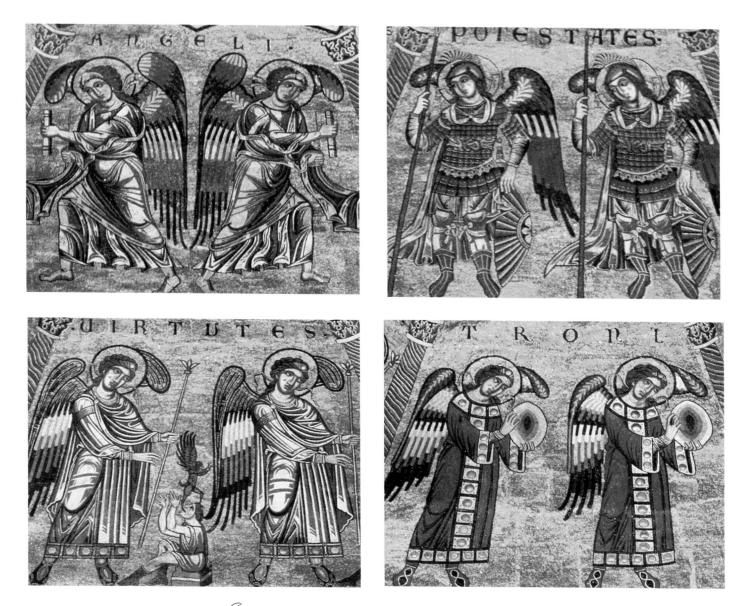

Interior of the dome of the Baptistery, mid-13th century. Mosaic. Florence.

O MENICO GHIRLANDAIO (1449–1494). Detail of*The Adoration of the Magi*, 1488.Tempera on wood, 112^{1/4} x 94^{1/2} in. (285 x 240 cm), overall. Ospedale degli Innocenti, Florence.

Unknown English or French artist. *The Wilton Diptych* (right panel), c. 1395. Egg tempera on oak, 18 x 11½ in. (45.7 x 29.2 cm). The National Gallery, London.

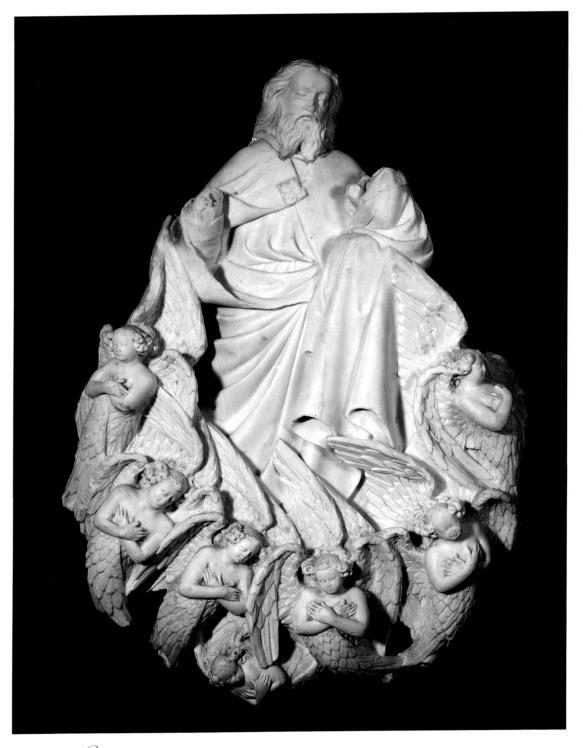

Christ Surrounded by Cherubim, Carrying His Mother's Soul. Berry, France, 15th century. Marble, height: 22³/₄ in. (57 cm). Musée du Louvre, Paris.

> The Annunciation: Archangel Gabriel, 1465. From The Hours of Charles of France. Colors and gold on vellum, 6¾ x 4⅛ in. (17 x 12.4 cm). The Metropolitan Museum of Art, New York; The Cloisters Collection, 1958.

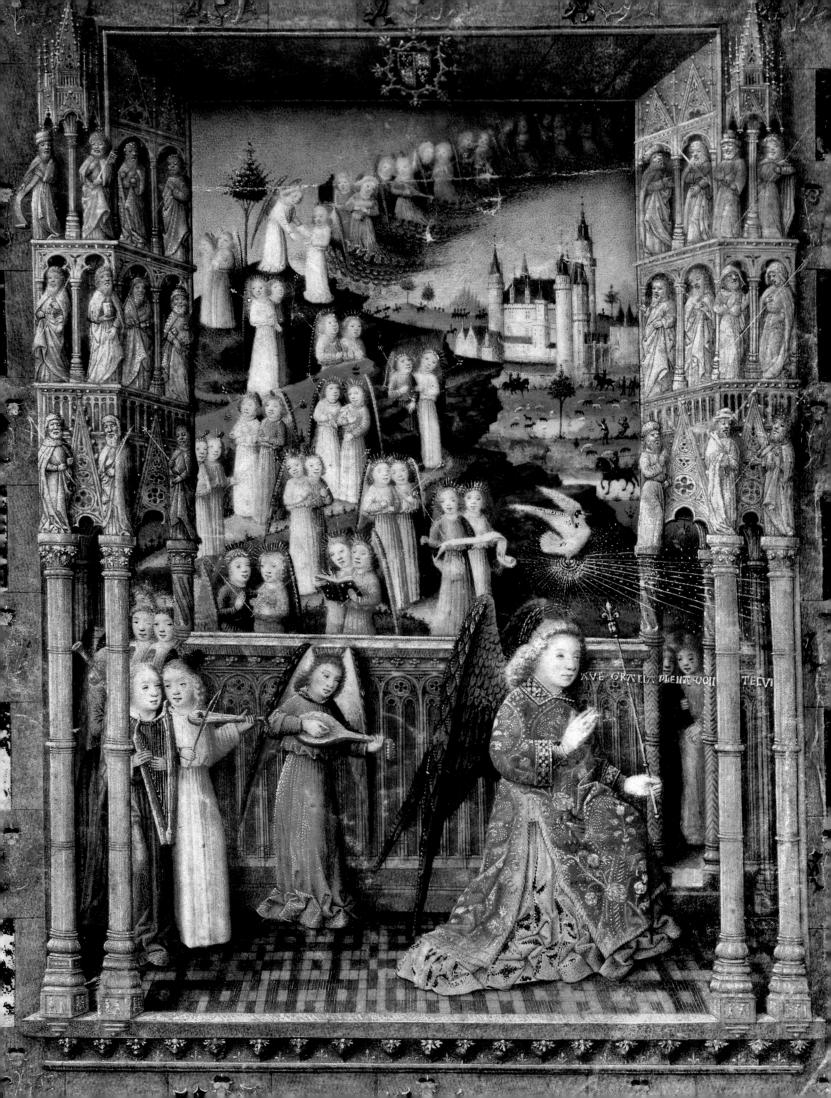

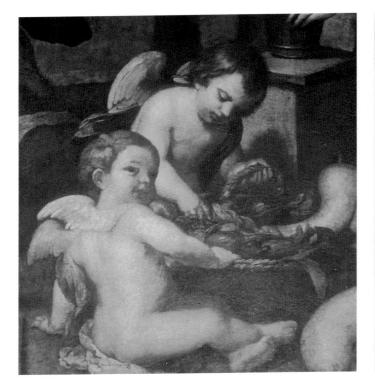

BARTOLOMÉ ESTEBÁN MURILLO (1617/18–1682). *The Angels' Kitchen*, 1646. Oil on canvas, 5 ft. 11 in. x 15 ft. 9 in. (1.8 x 4.8 m). Musée du Louvre, Paris.

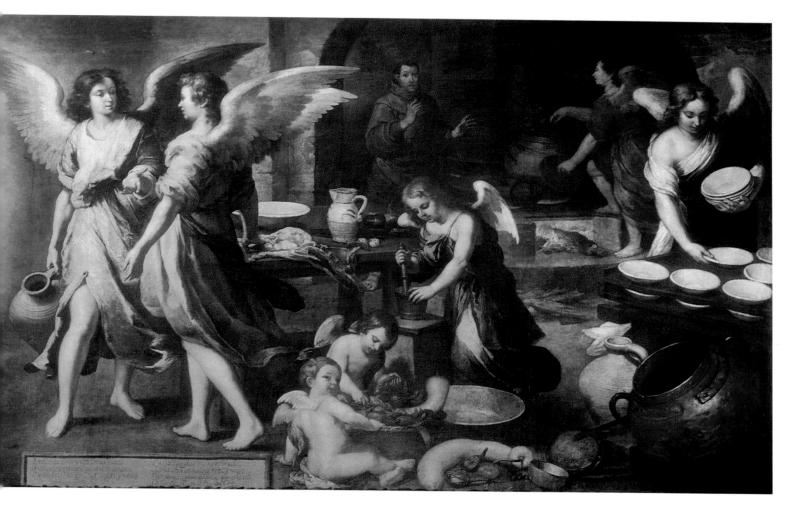

Evelyn De Morgan (1855–1919). Our Lady of Peace, n.d. Oil on canvas. De Morgan Foundation, London.

CELESTIAL CHOIRS

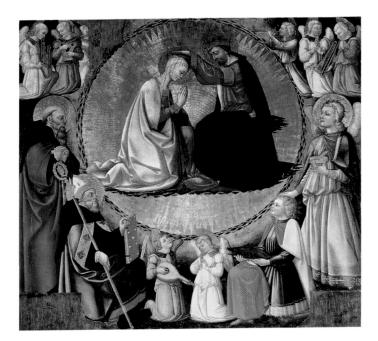

MERI DI BICCI. *The Coronation of the Virgin*, 14th century. Oil on wood, 63 x 69 in. (160 x 175 cm). Musée du Petit Palais, Avignon, France.

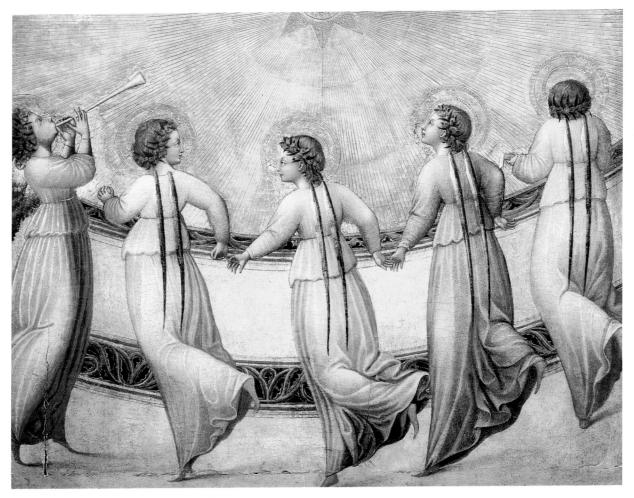

 $\int e^{3}ngels \ Dancing \ in \ Front \ of \ the \ Sun.$ Italian, 15th century. Oil on wood, 22³/₈ x 25⁵/₈ in. (57 x 65 cm). Musée Condé, Chantilly, France.

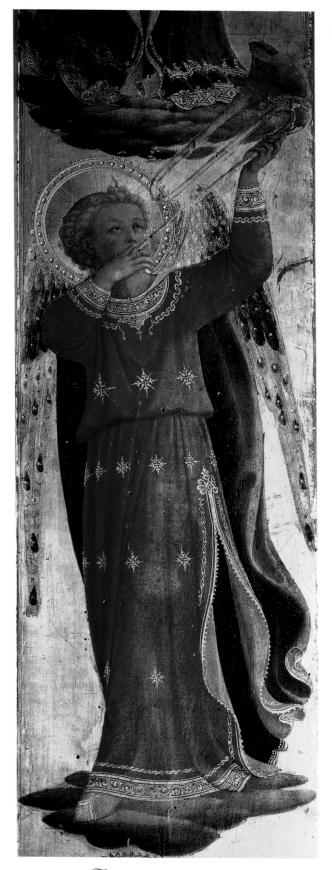

FRA ANGELICO (c. 1400–1455). Detail of *The Linaiuoli Triptych*, commissioned 1433. Tempera on wood, 102³/₈ x 129⁷/₈ in. (260 x 330 cm), overall. Museo di San Marco, Florence.

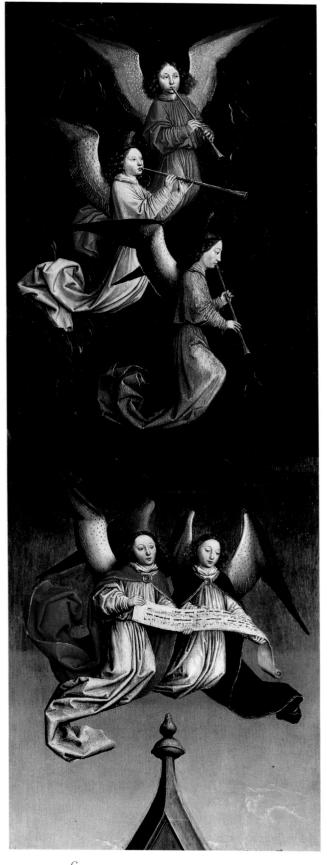

∫IMON MARMION (active 1449−d. 1489). *A Choir of Angels*, c. 1459. Oak, 22⁵⁄₈ x 8¹⁄₈ in. (57.8 x 20.5 cm). The National Gallery, London.

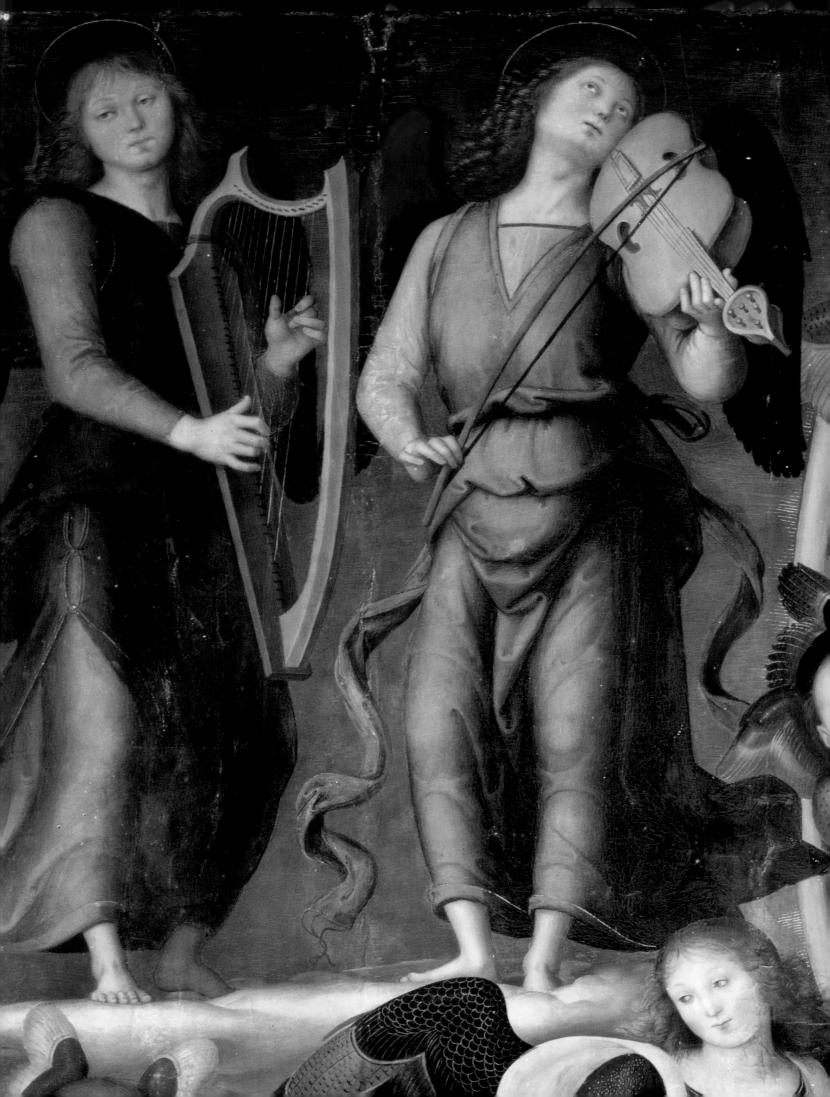

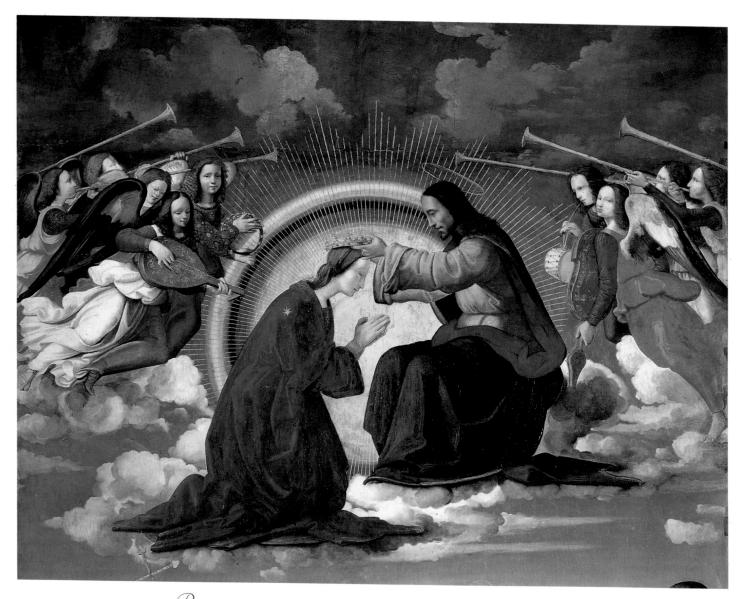

RIDOLFO GHIRLANDAIO (1483–1561). Detail of *The Coronation of the Virgin*, 1504. Oil on wood, 108[%] x 75[%] in. (276 x 192 cm), overall. Musée du Petit Palais, Avignon, France.

PERUGINO (c. 1450–1523). Angel Musicians, detail of The Vallombrosa Altar, 1500. Galleria dell'Accademia, Florence.

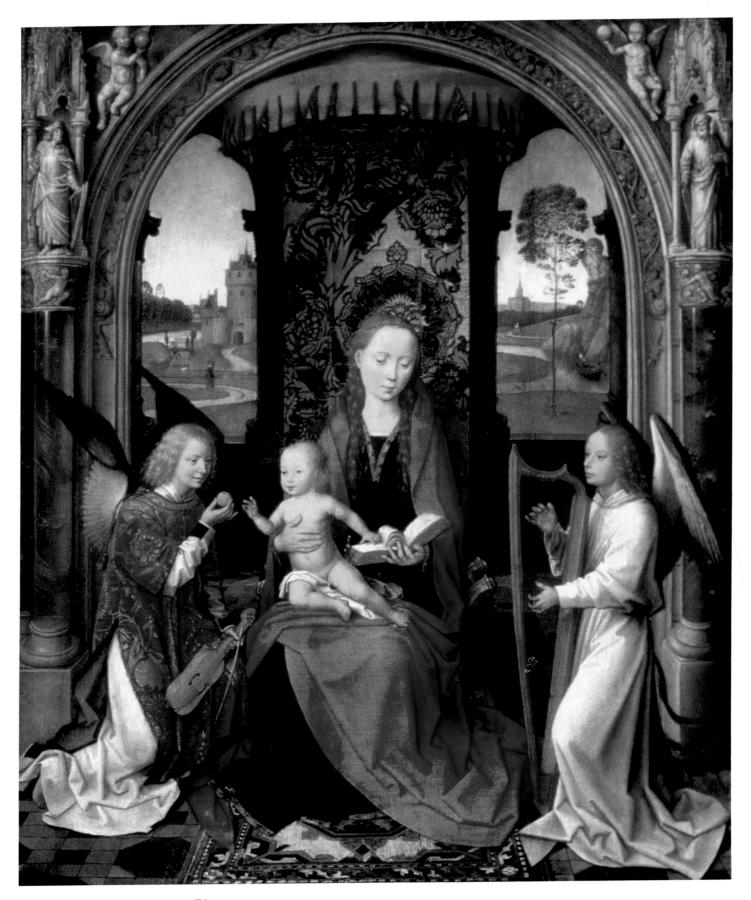

HANS MEMLING (c. 1430/40–1494). Madonna and Child with Angels, c. 1480. Wood, 23¹/₈ x 18³/₈ in. (59 x 48 cm). National Gallery of Art, Washington, D.C.; Andrew W. Mellon Collection.

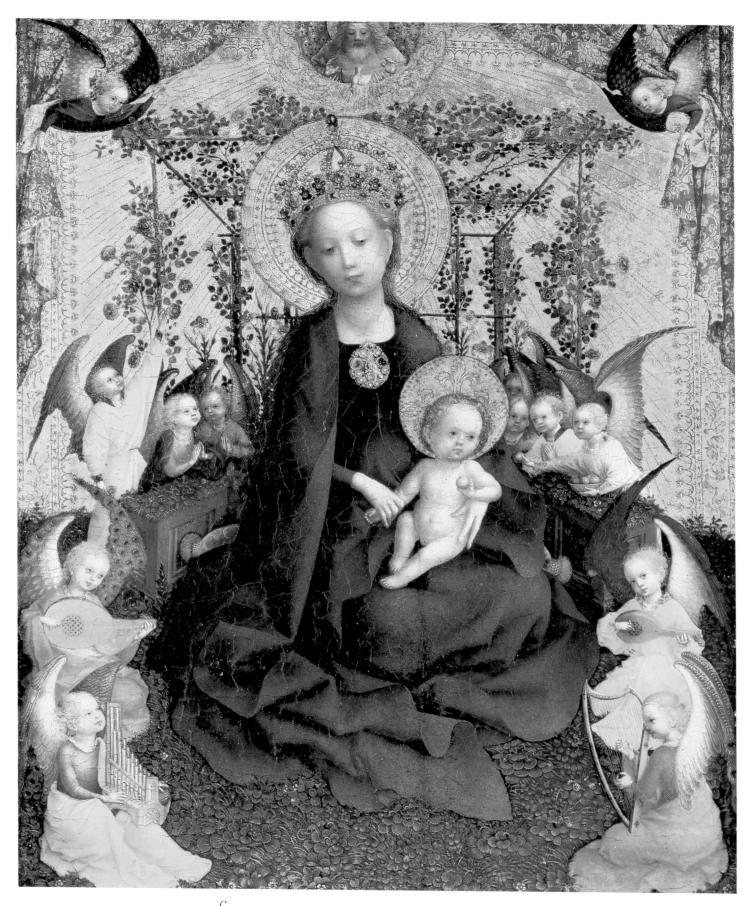

∫TEFAN LOCHNER (c. 1400−1451). *The Virgin in a Rose Arbor*, c. 1440. Wood, 67³/₈ x 48 in. (171 x 122 cm). Wallraf-Richartz Museum, Cologne, Germany.

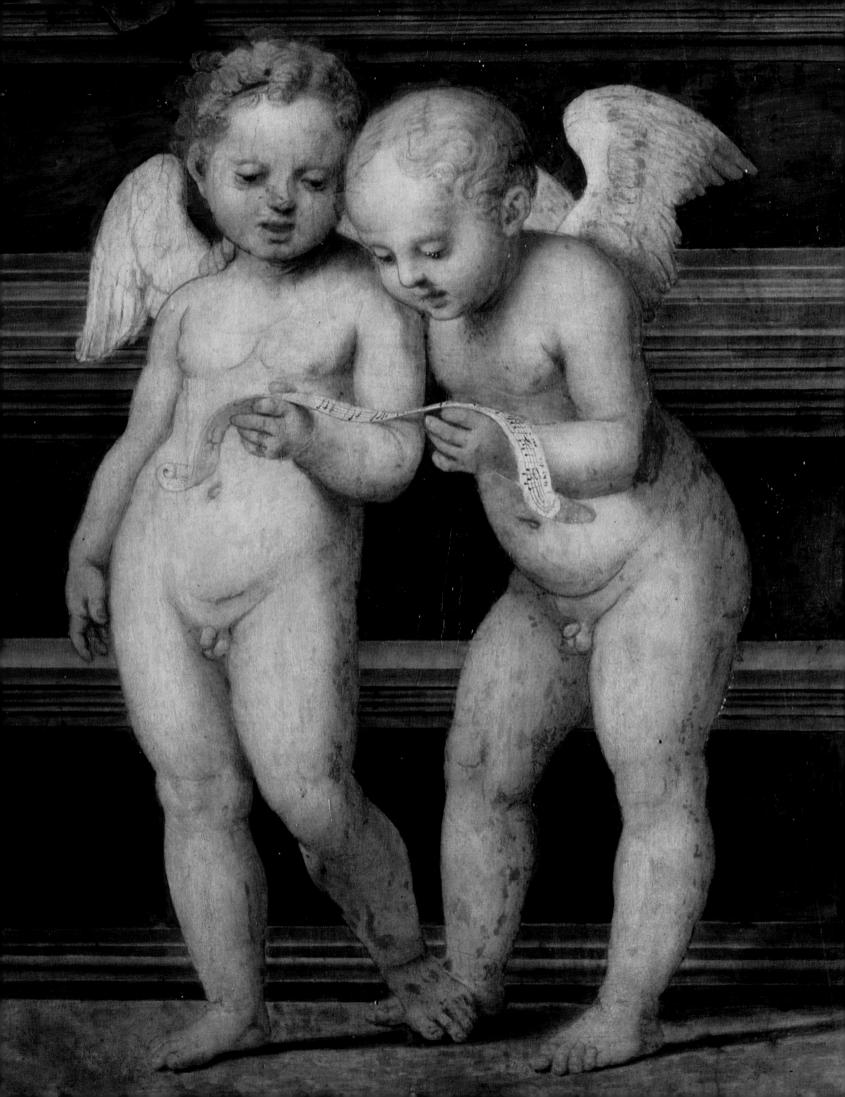

CHERUBS

Every morn from hence A brisk Cherub something sips Whose sacred influence Adds sweetness to his sweetest Lips. Then to his music. And his song Tastes of this Breakfast all day long.

Richard Crashaw (1613–1649), "The Weeper"

cherub is not a cupid, although they often look much the same; in fact, in purely visual terms, they are frequently indistinguishable. But their meanings are as different as spirituality and sexuality.

Cupid, the Roman god known as Eros to the Greeks, is a symbol of sensual love. Portrayed as a male child or adolescent, he often carries a bow and arrow, which are emblems of love's power; he is also frequently blindfolded, because love is blind. A cherub, however, has quite another meaning. Cherubim (the original plural form of *cherub*) rank as the second highest group in the celestial hierarchy and are the first angels mentioned in the Bible: in Genesis cherubim with a flaming sword guard the Tree of Life in the Garden of Eden.

In Byzantine and medieval European art cherubim often are shown as little more than stylized circle faces with four wings; even in Lucas Cranach I's sixteenth-century painting of the Trinity (page 78) the streams of cherub faces are more diagrammatic than illusionistic. With the move toward classicism and more overt eroticism in the Renaissance, and even more with the sensuality of the Baroque, they gradually evolved into the playful young cherubs seen in works by Peter Paul Rubens and Anthony Van Dyck (page 79). Cherubs rarely wear anything more than flowers, and the form they take is that of *putti* (Italian for "little boys")—the plump, rosy-bottomed male figures used as decorative elements in both religious and mythological art. Some particularly playful butterfly-winged *putti* can be seen in Andrea Mantegna's frescoes in the Camera degli Sposi (page 72).

Adoring cherubs often worship the young Christ, as in Raphael's famous *Sistine Madonna* (page 74). Paintings of the Virgin, either on earth or in heaven, frequently emphasize her role as heavenly mother by incorporating scores of cherubs, sometimes with bodies, sometimes merely winged heads. Occasionally, as in Andrea del Sarto's *Assumption of the Virgin* (page 76), they seem to be playing around her feet like restless children. By the nineteenth century, cherubs often appeared in the company of young women as symbols of their innocence (page 83). They were, at that point, very far removed from the armed cherubim of Genesis.

GRAPHAEL (1483–1520). Detail of *Madonna del Baldacchino*, c. 1507. Oil on wood, 109 x 88¼ in. (277 x 224 cm), overall. Galleria Palatina, Palazzo Pitti, Florence.

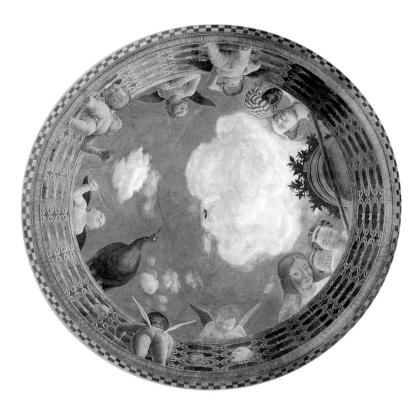

Andrea Mantegna (1431–1506). Detail of ceiling from the Camera degli Sposi, c. 1474. Fresco. Palazzo Ducale, Mantua, Italy.

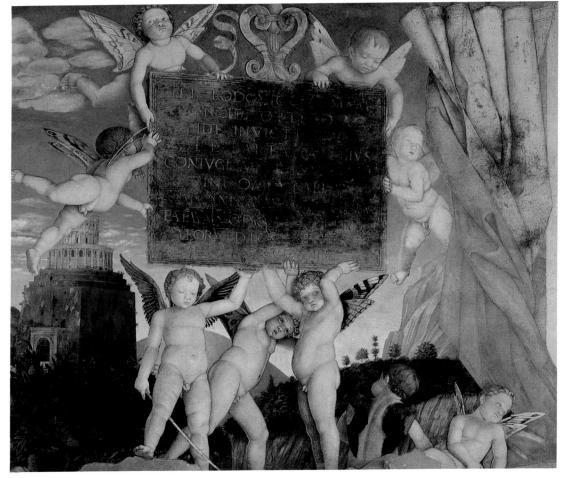

MNDREA MANTEGNA (1431–1506). Putti Holding Dedicatory Tablet, from the Camera degli Sposi, c. 1474. Fresco. Palazzo Ducale, Mantua, Italy.

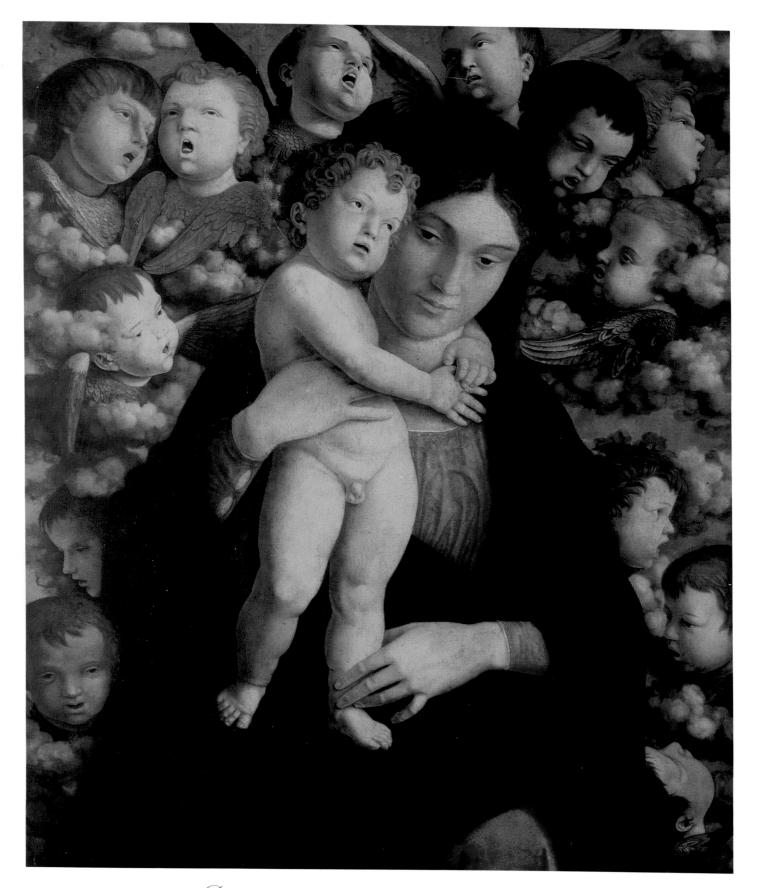

MDREA MANTEGNA (1431–1506). Madonna and Child with Cherubs, n.d. Tempera on wood, 34⁵/₈ x 27¹/₂ in. (88 x 70 cm). Pinacoteca di Brera, Milan.

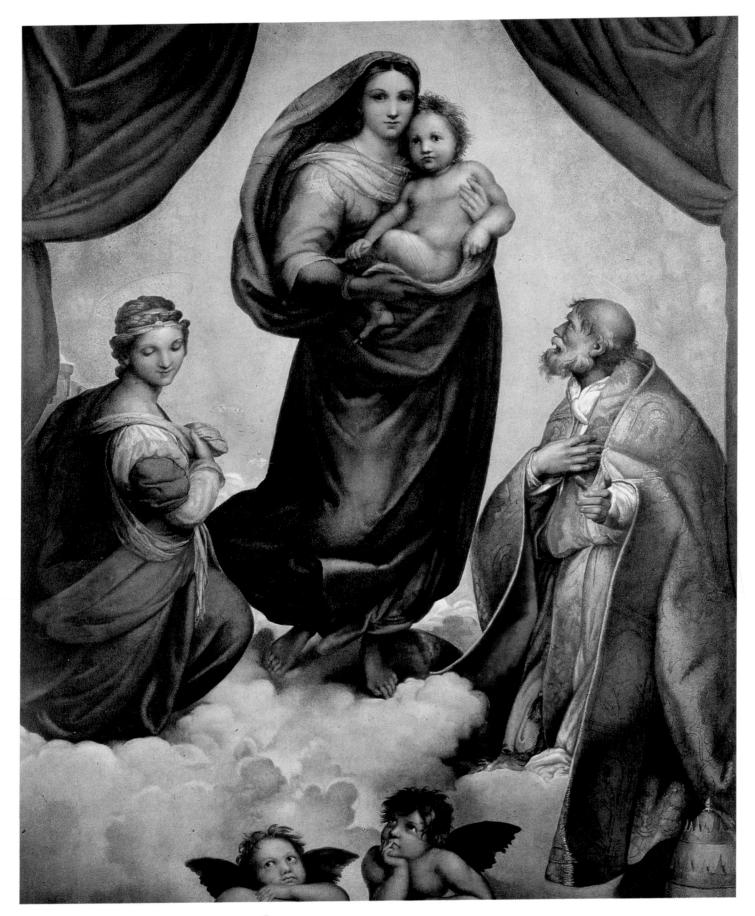

CAPHAEL (1483–1520). *The Sistine Madonna*, 1513. Oil on canvas, 102[%] x 78[%] in. (260 x 200 cm). Staatliche Kunstsammlungen, Dresden, Germany. See detail, opposite top.

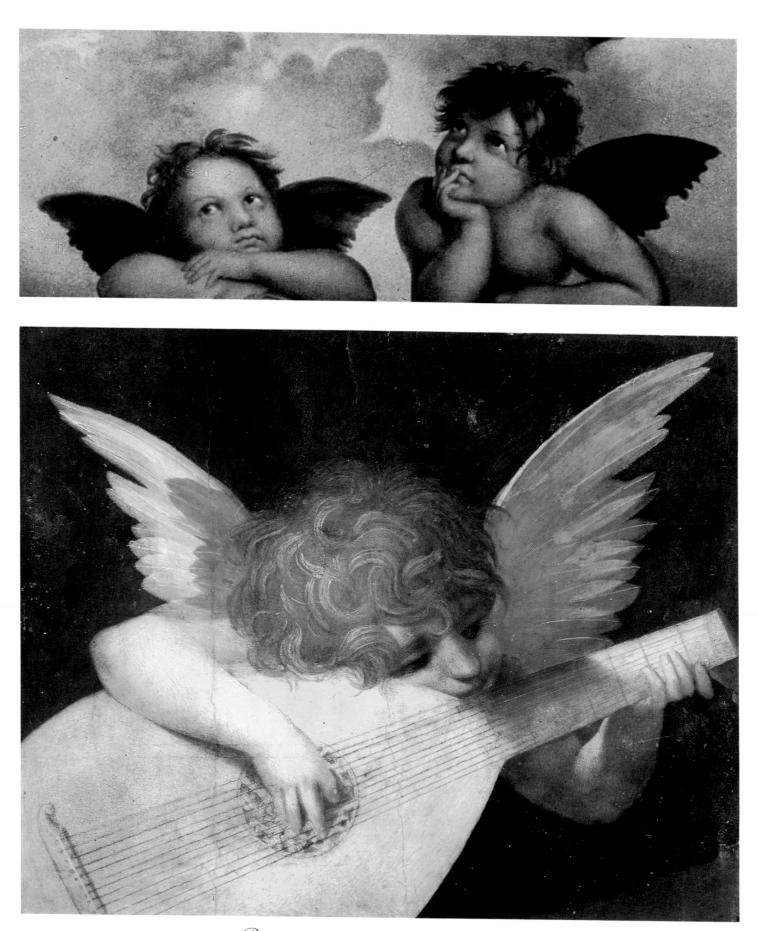

Rosso FIORENTINO (1495–1540). *Musical Angel,* c. 1522. Tempera on wood, 15^{1/4} x 18^{1/2} in. (39 x 47 cm). Galleria degli Uffizi, Florence.

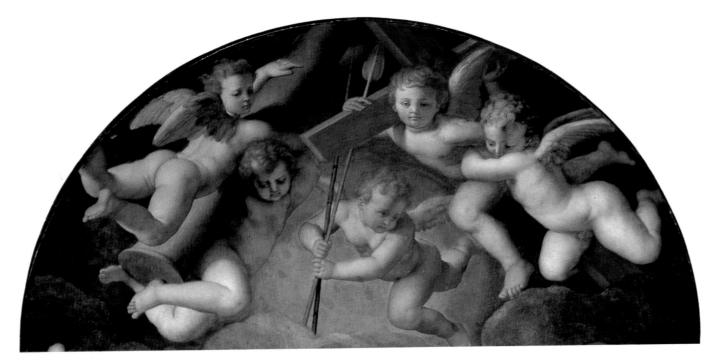

GNOLO BRONZINO (1503–1572). The Deposition of Christ (replica), c. 1560. Oil on wood and fresco. Chapel of Eleonora of Toledo, Palazzo Vecchio, Florence.

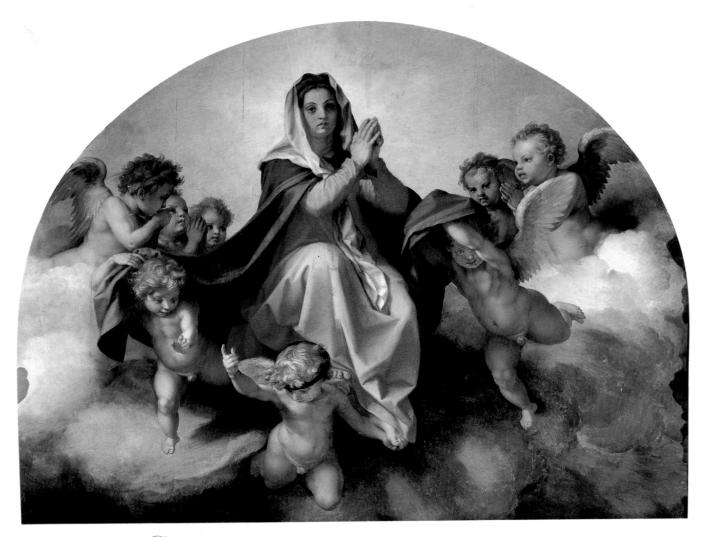

ANDREA DEL SARTO (1486–1530). Details of *The Assumption of the Virgin*, mid-1520s. Oil on wood, 149¼ x 87½ in. (379 x 222 cm), overall. Galleria Palatina, Palazzo Pitti, Florence.

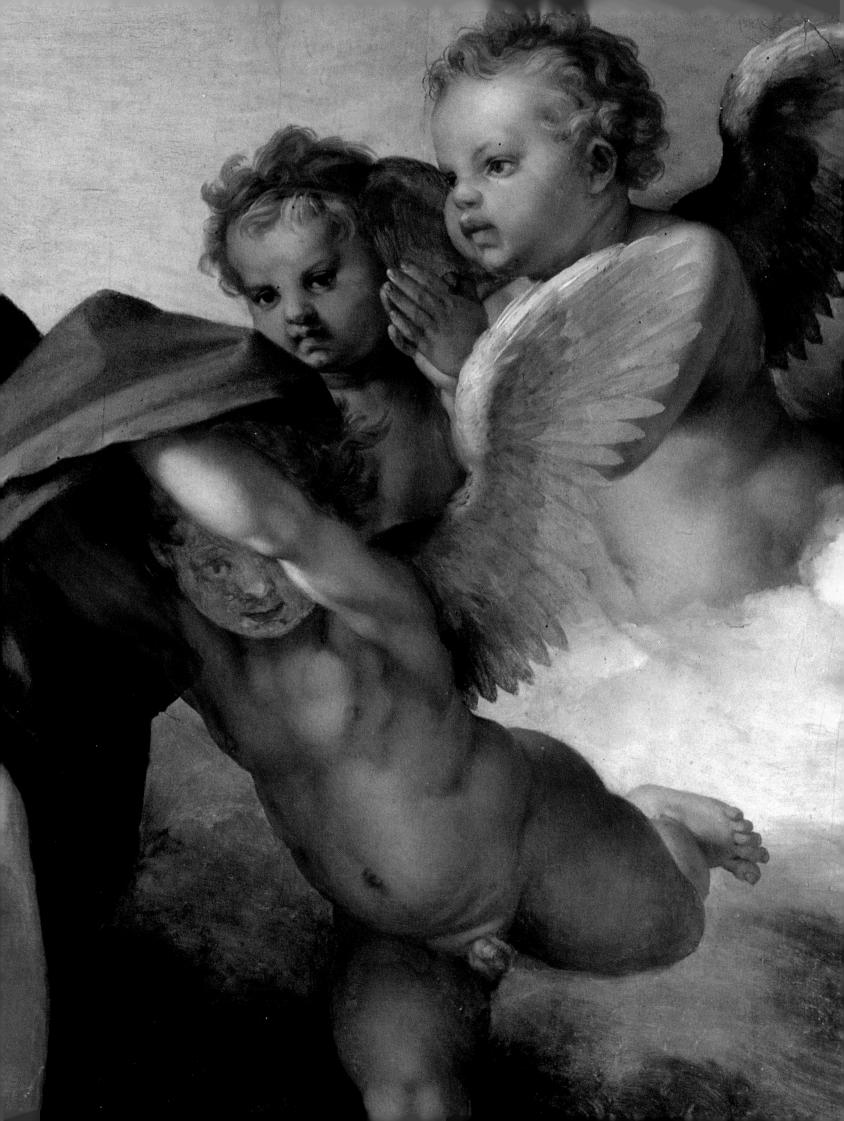

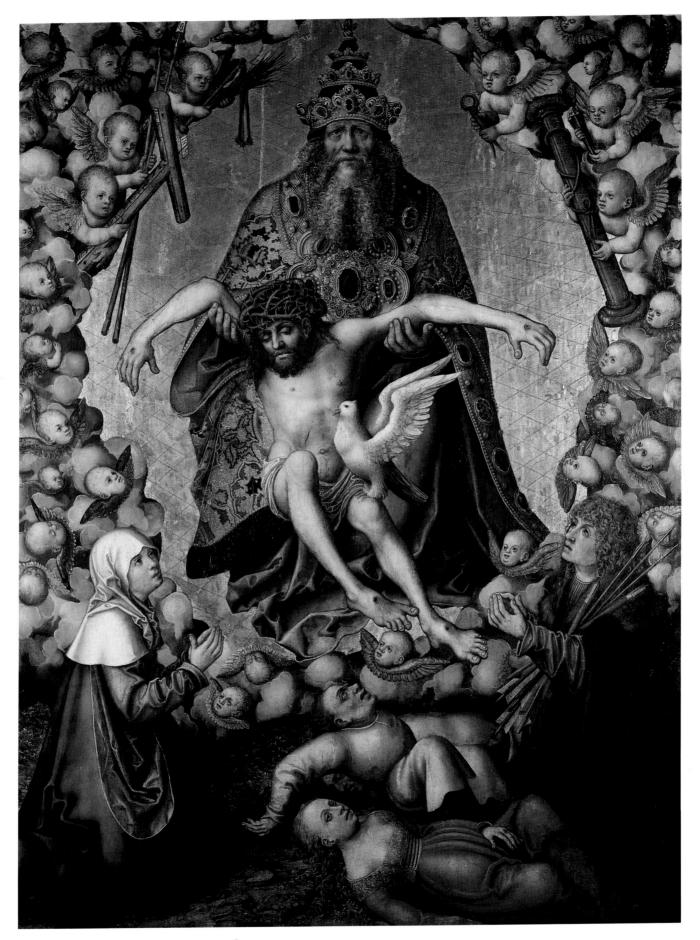

CUCAS CRANACH I (1472–1553). *The Trinity*, n.d. Oil on wood, 55 x 39 in. (140 x 99 cm). Museum der Bildenden Künste, Leipzig, Germany.

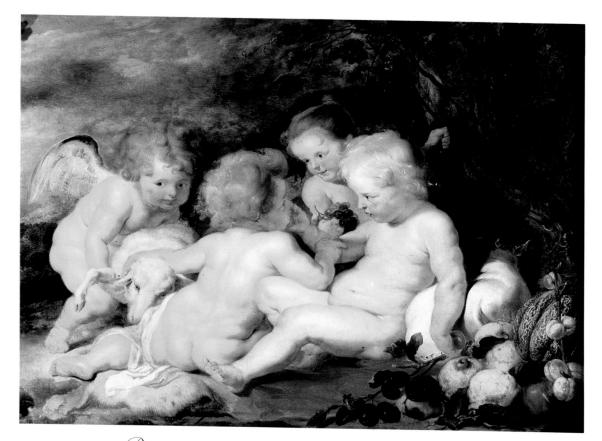

PETER PAUL RUBENS (1577–1640). Christ and Saint John with Angels, n.d. Oil on canvas, 37½ x 48 in. (95 x 122 cm). Wilton House, Wiltshire, England.

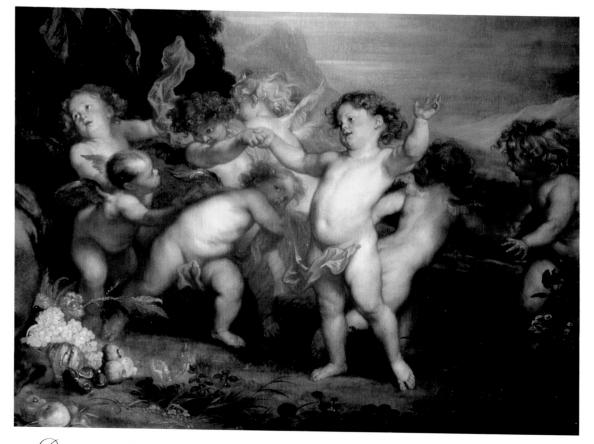

ANTHONY VAN DYCK (1599–1641). Detail of *The Rest on the Flight into Egypt (Virgin with Partridges)*, c. 1630. Oil on canvas, 84⁵/₈ x 112³/₈ in. (215 x 285.5 cm), overall. The Hermitage Museum, Saint Petersburg, Russia.

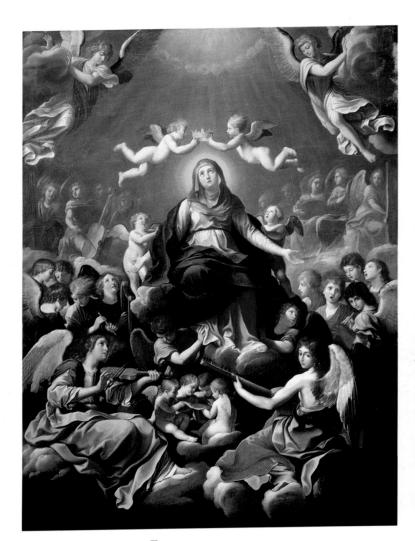

GUIDO RENI (1575–1642). The Coronation of the Virgin, 1626. Oil on brass, 28⁵/₈ x 20⁵/₈ in. (73 x 52.5 cm). Musée Bonnat, Bayonne, France.

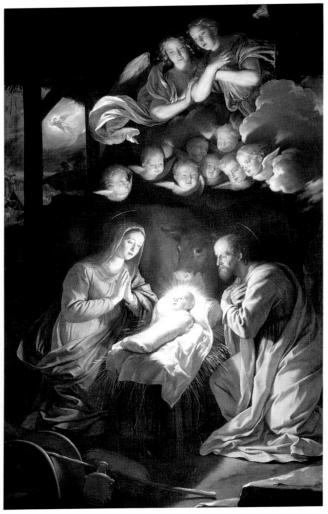

PHILIPPE DE CHAMPAIGNE (1602–1674). *The Nativity*, 1643. Oil on canvas, 81½ x 45⁵/₈ in. (207 x 116 cm). Musée des Beaux-Arts, Lille, France.

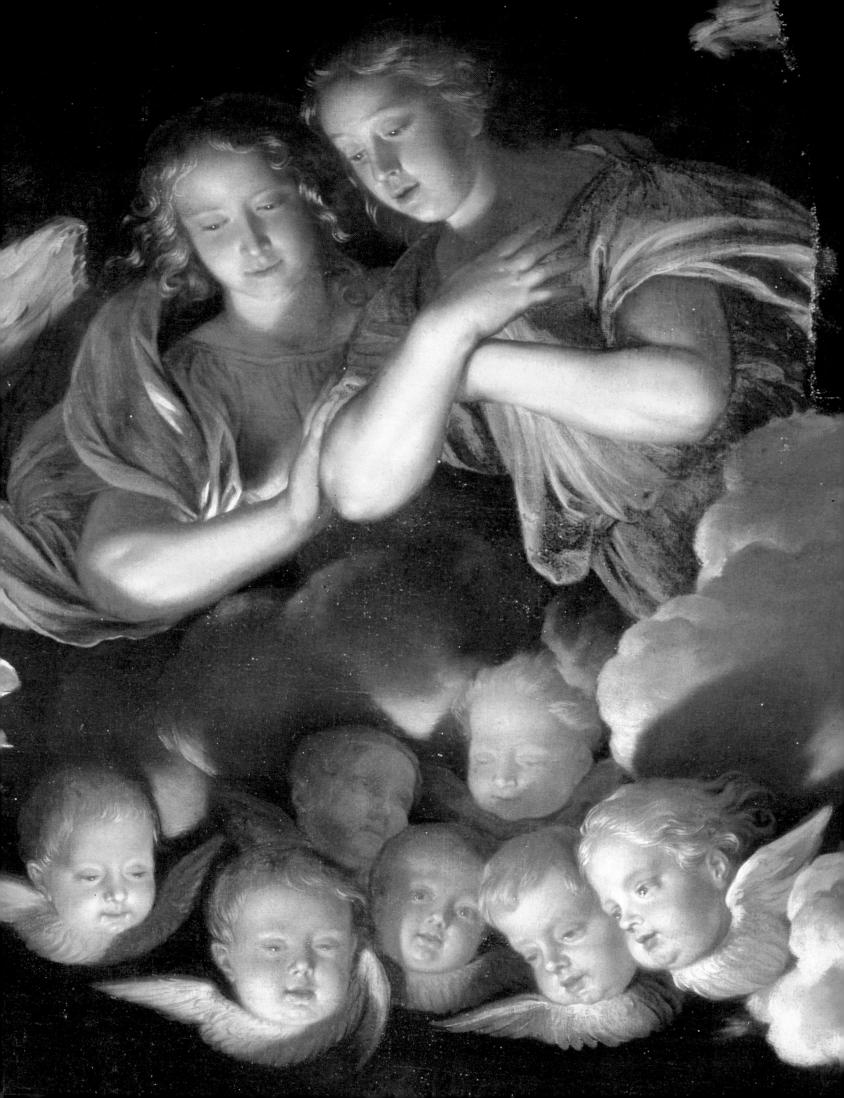

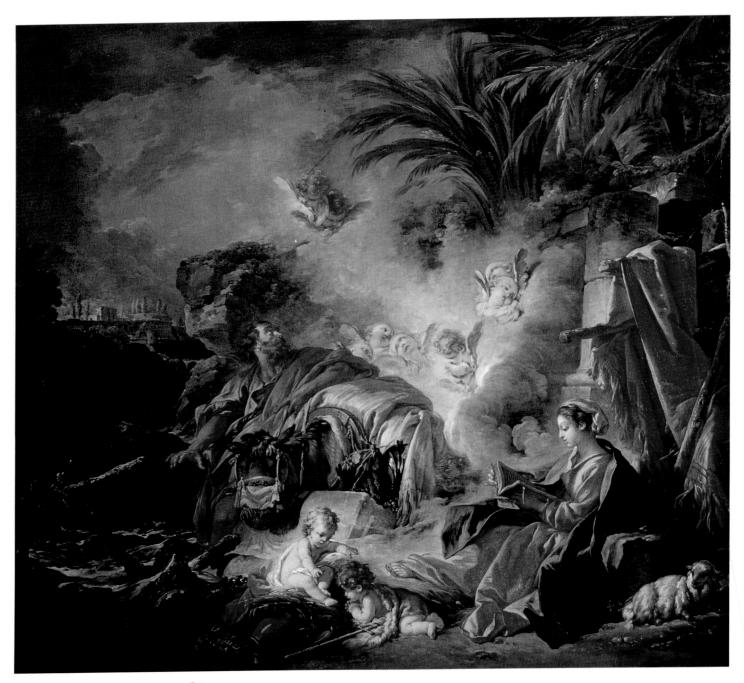

FRANÇOIS BOUCHER (1703–1770). The Rest on the Flight into Egypt, c. 1737. Oil on canvas, 55 x 58½ in. (140 x 148.6 cm). The Hermitage Museum, Saint Petersburg, Russia.

 WILLIAM BOUGUEREAU (1825–1905). Innocence, 1890.
 Oil on canvas, 47 x 28 in. (119.5 x 71 cm). Christie's, London.

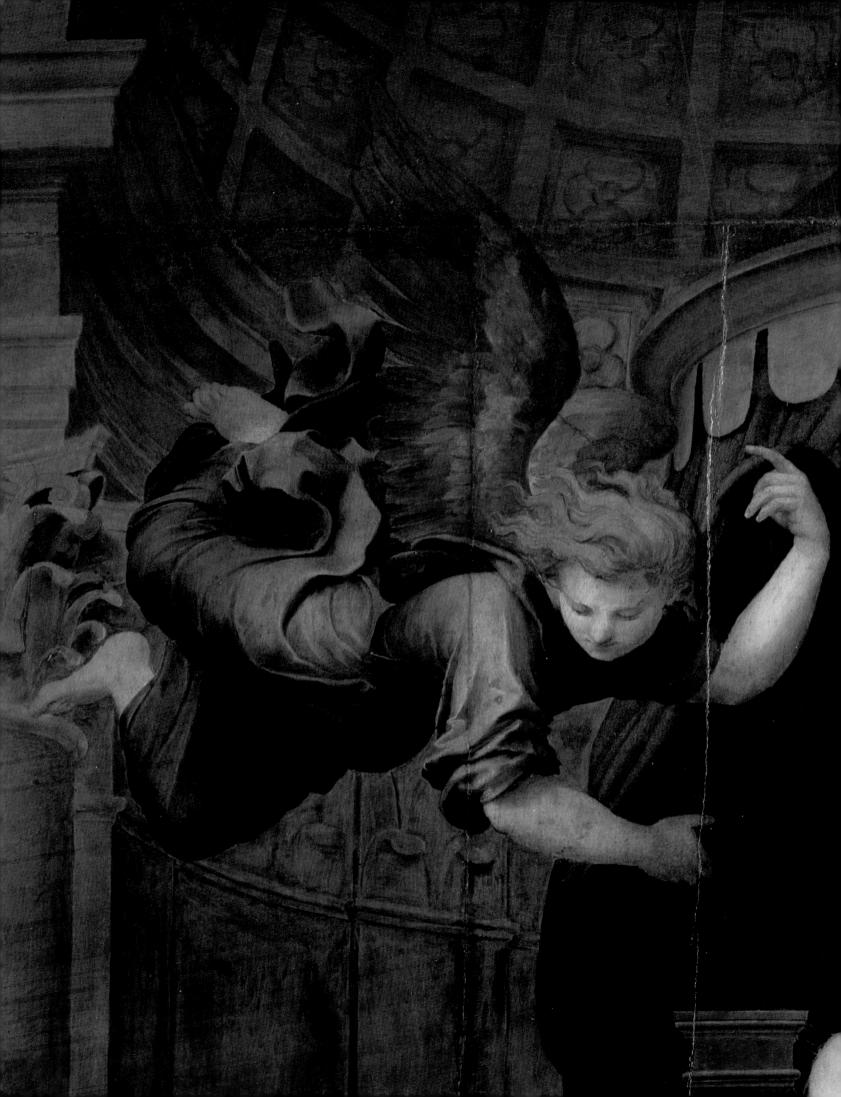

PATTERNS OF FLIGHT

And when they went, I heard the noise of their wings, like the noise of great waters, as the voice of the Almighty, the voice of speech, as the noise of an host: when they stood, they let down their wings.

Ezekiel 1:24

s intermediaries between heaven and earth, angels relied on their wings to carry them swiftly from one world to the other. Once faith in the mysterious workings of the cosmos (angels were once believed to be responsible for the rotation of all the celestial bodies) began to give way to reliance on the scientific investigation of natural laws, artists started to describe the flight of angels with increasing literalness.

Surprisingly, until the fourth century angels were shown wingless, but once wings started to appear, angels often were portrayed as mostly wings and very little body. In medieval paintings and manuscript illuminations, the number (and often the color) of wings for each type of angel was very explicitly indicated. Seraphim, for instance, were consistently identified by their six red wings, a configuration based on Isaiah's vision in the Old Testament:

> Above it stood the seraphims: each one had six wings; with twain he covered his face, and with twain he covered his feet, and with twain he did fly.

(Isaiah 6:2)

Giotto's myriad angels in the Arena Chapel (pages 86–87) are irrepressibly acrobatic, swooping in from all directions, either solo or in battalions. As the Renaissance progressed and artists mastered the skills needed to convey convincing illusions, angels became more heavily lifelike and hence needed commensurately more substantial wings to loft them. Looking for believable models, artists studied the movement of birds, particularly those with muscular wings, such as swans and geese. At the same time, artists became ever more inventive and even whimsical in depicting the mechanics of flight, as in Braccesco's fifteenth-century *Annunciation* (page 92), where the angel appears to be surfboarding on its own halo. Views from behind or beneath airborne angels became favorite pictorial devices (see pages 93–96), and flight no longer seemed an act innate to an incorporeal spirit but rather the sometimes strained effort of a weighty body.

CAPHAEL (1483–1520). Detail of *Madonna del Baldacchino*, c. 1507. Oil on wood, 109 x 88¼ in. (277 x 224 cm), overall. Galleria Palatina, Palazzo Pitti, Florence.

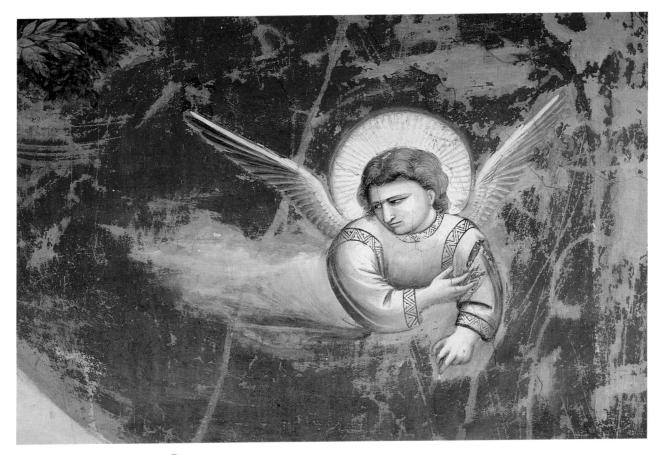

GIOTTO (1266/67–1337). Detail of *The Flight into Egypt*, c. 1305–13. Fresco. Arena Chapel, Padua, Italy.

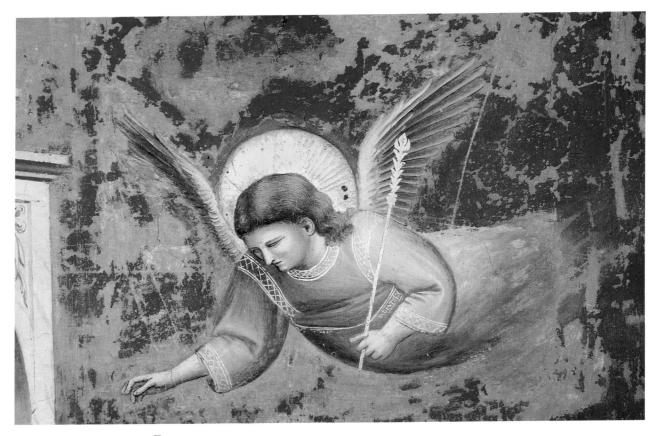

GIOTTO (1266/67–1337). Detail of *The Presentation at the Temple*, c. 1305–13. Fresco. Arena Chapel, Padua, Italy.

PATTERNS OF FLIGHT

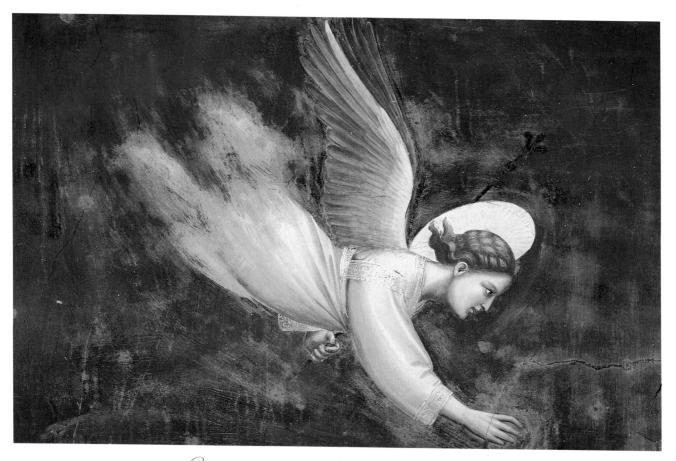

GIOTTO (1266/67–1337). Detail of *Joachim's Dream*, c. 1305–13. Fresco. Arena Chapel, Padua, Italy.

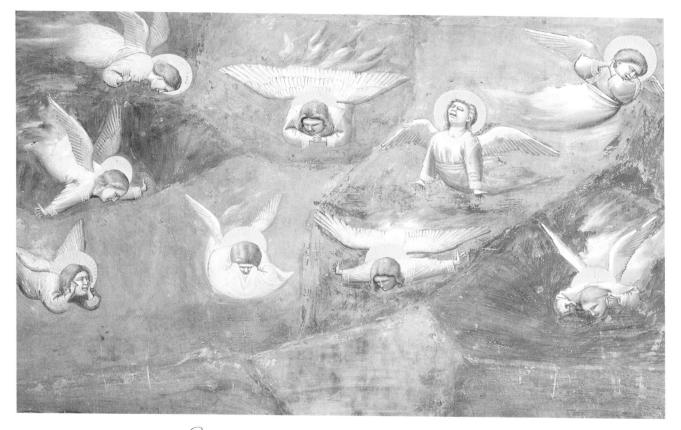

GIOTTO (1266/67–1337). Detail of *The Lamentation*, c. 1305–13. Fresco. Arena Chapel, Padua, Italy.

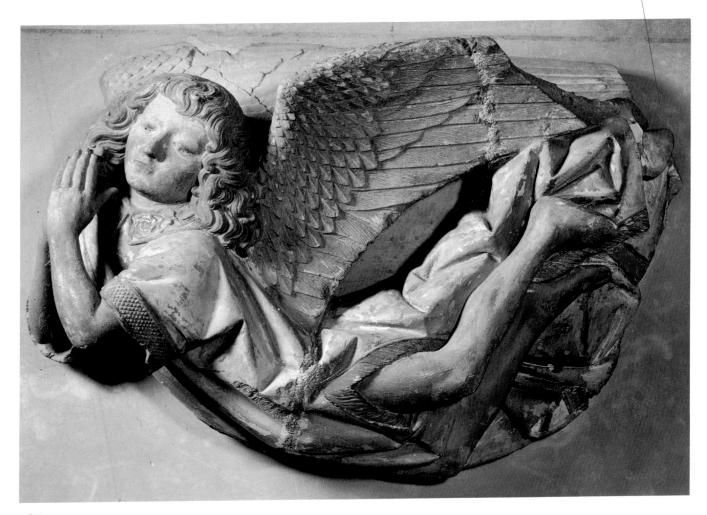

Hying Angel, 15th century. Polychromed wood, length: 21¼ in. (54 cm). Musée du Louvre, Paris.

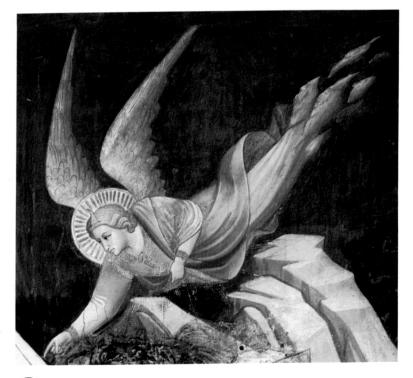

Anolo GADDI (active c. 1370–d. 1396). Detail of *The Dream of Heraclius*, 1380. Fresco. Santa Croce, Florence.

ANTONIO DEL POLLAIOLO (C. 1432–1498). Angel, 1467. Fresco and oil. Chapel of the Cardinal of Portugal, San Miniato al Monte, Florence.

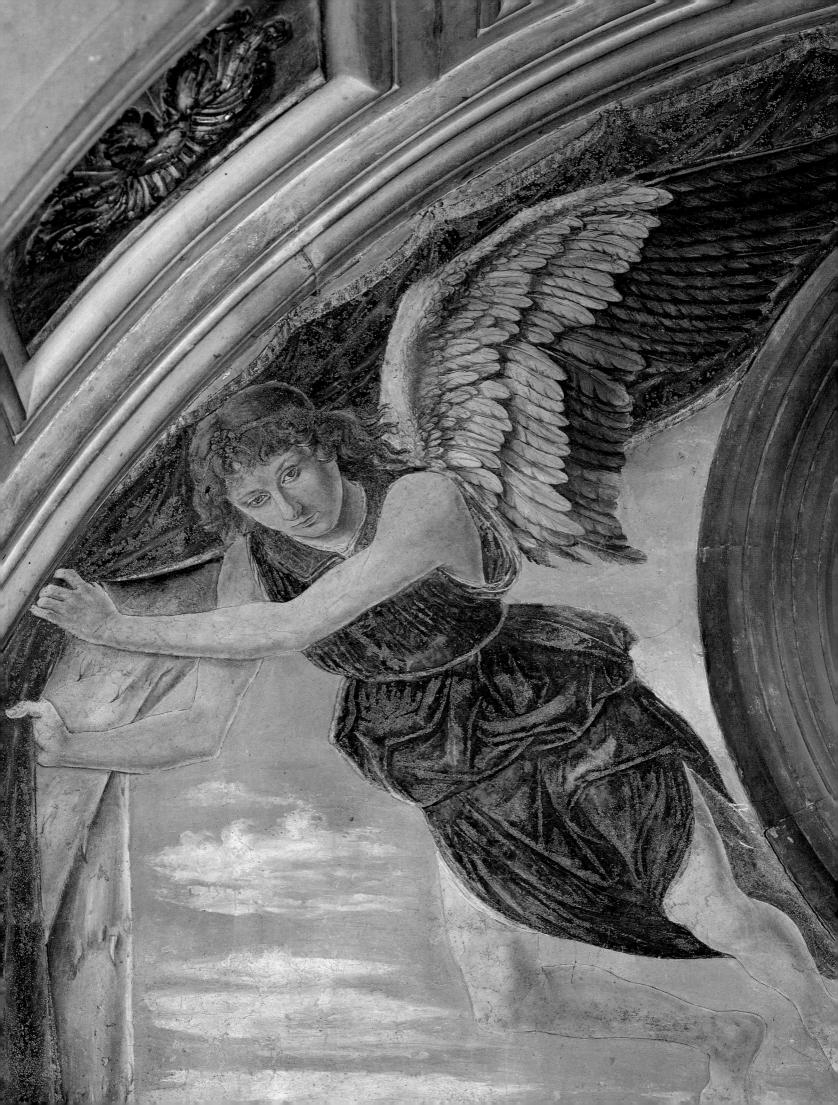

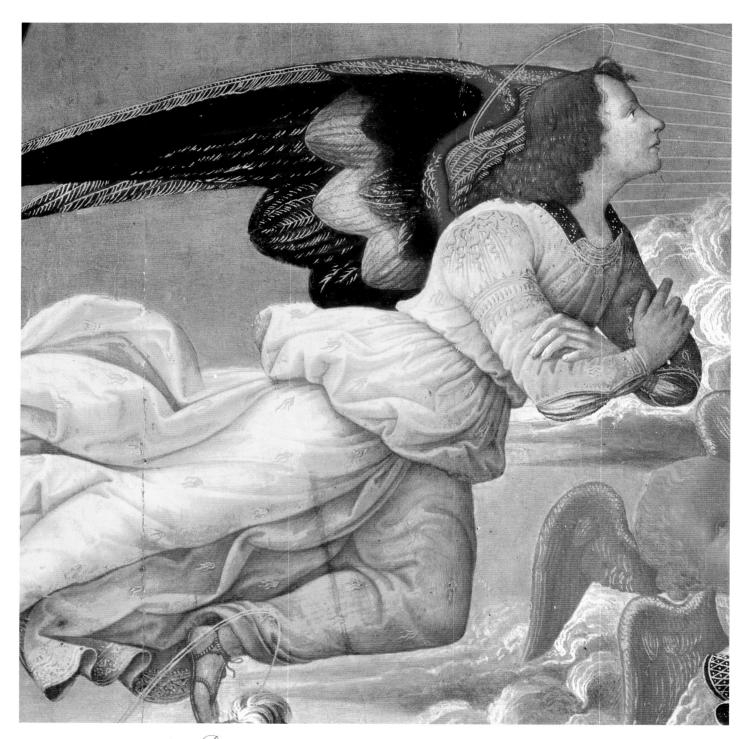

DOMENICO GHIRLANDAIO (1449–1494). Detail of *Christ in Glory*, 1492. Tempera on wood, 114^{1/4} x 74^{3/4} in. (294 x 190 cm), overall. Pinacoteca Comunale, Volterra, Italy.

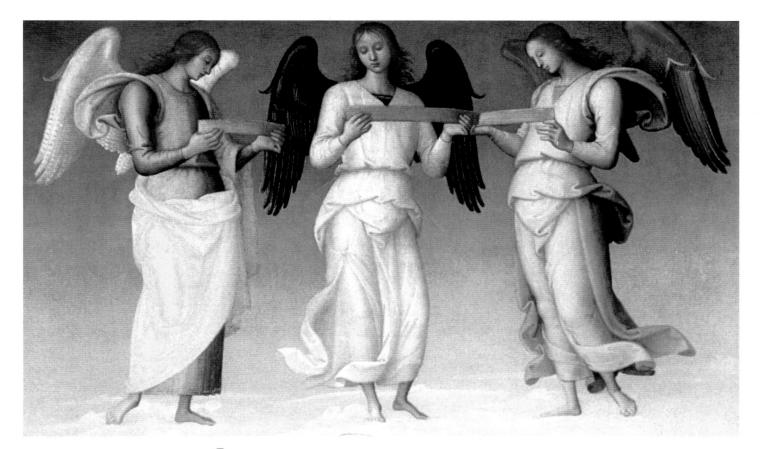

 $\begin{array}{l} \red{eq: line for the lin$

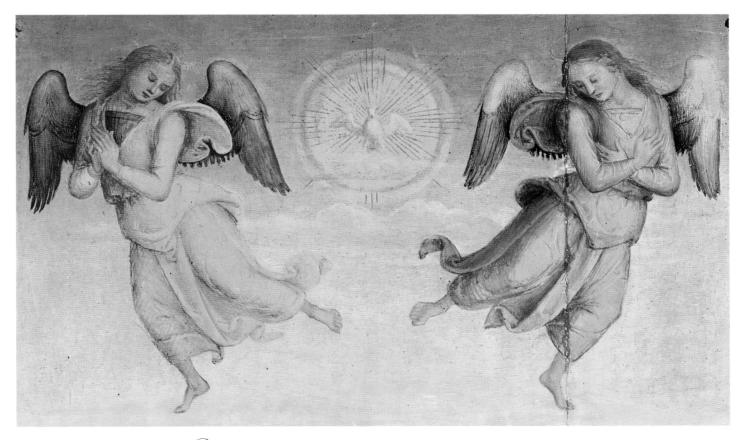

PERUGINO (c. 1450–1523). Detail of *The Saint Augustine Polyptych*, c. 1470. Fresco. Galleria Nazionale dell'Umbria, Perugia, Italy.

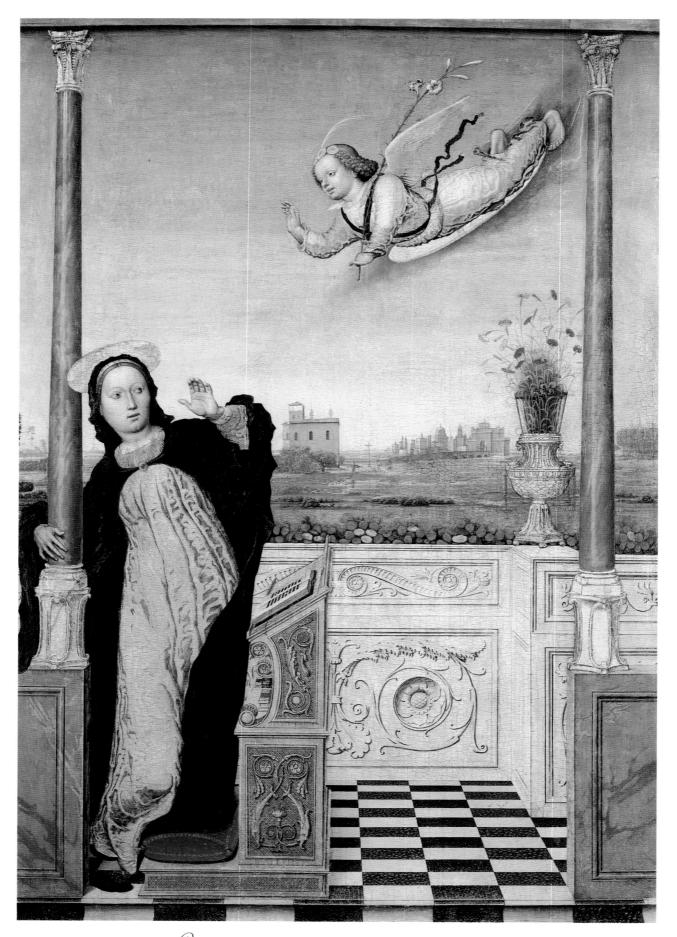

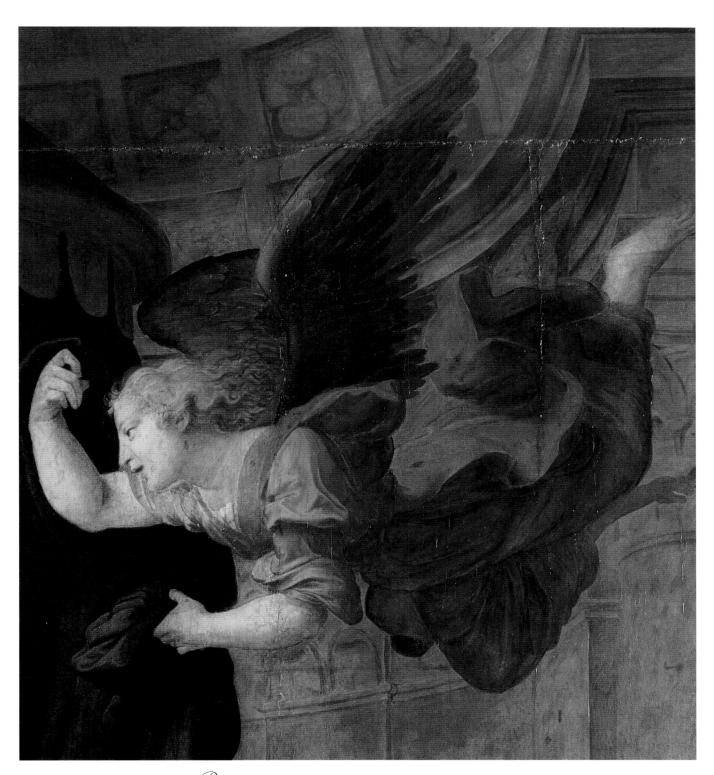

RAPHAEL (1483–1520). Detail of *Madonna del Baldacchino*, c. 1507. Oil on wood, 109 x 88¼ in. (277 x 224 cm), overall. Galleria Palatina, Palazzo Pitti, Florence.

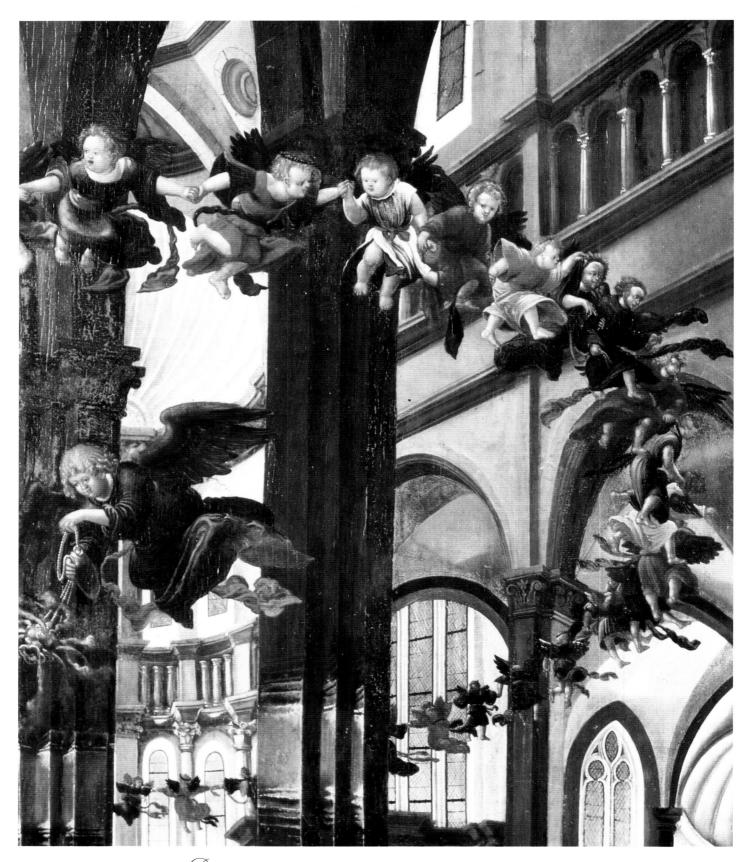

FEDERICO BAROCCI (c. 1535–1612). Detail of *The Circumcision*, 1590. Oil on canvas, 130¹⁄₄ x 98³⁄₄ in. (356 x 251 cm), overall. Musée du Louvre, Paris.

PAOLO VERONESE (1528–1588). Detail of *The Wife of Zebedee Interceding with Christ over Her Sons*, n.d. Oil on canvas, 141^{3/4} x 71 in. (360 x 180 cm), overall. Burghley House, Stamford, England.

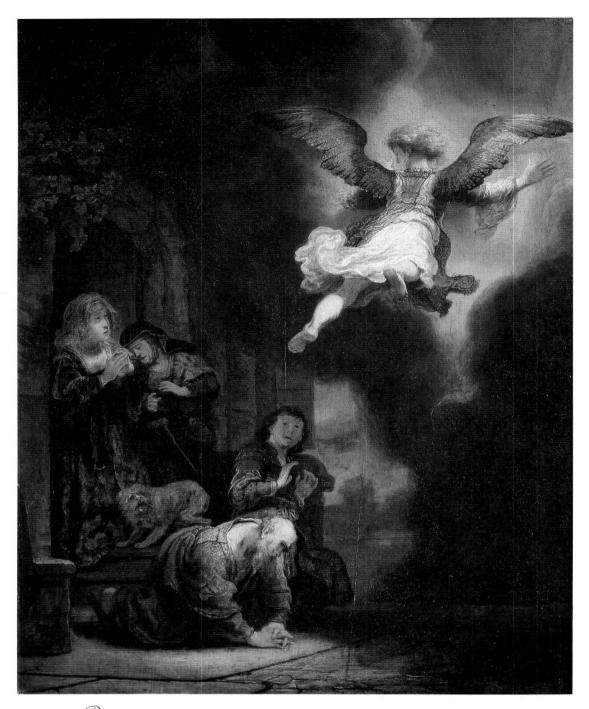

REMBRANDT VAN RIJN (1606–1669). *The Archangel Raphael Leaving Tobias's Family*, 1637. Oil on wood, 26 x 20½ in. (66 x 52 cm). Musée du Louvre, Paris.

EL GRECO (1541–1614). Detail of *The Assumption of the Virgin,* 1577. Oil on canvas, 158 x 90 in. (401 x 229 cm), overall. Museo de Santa Cruz, Toledo, Spain.

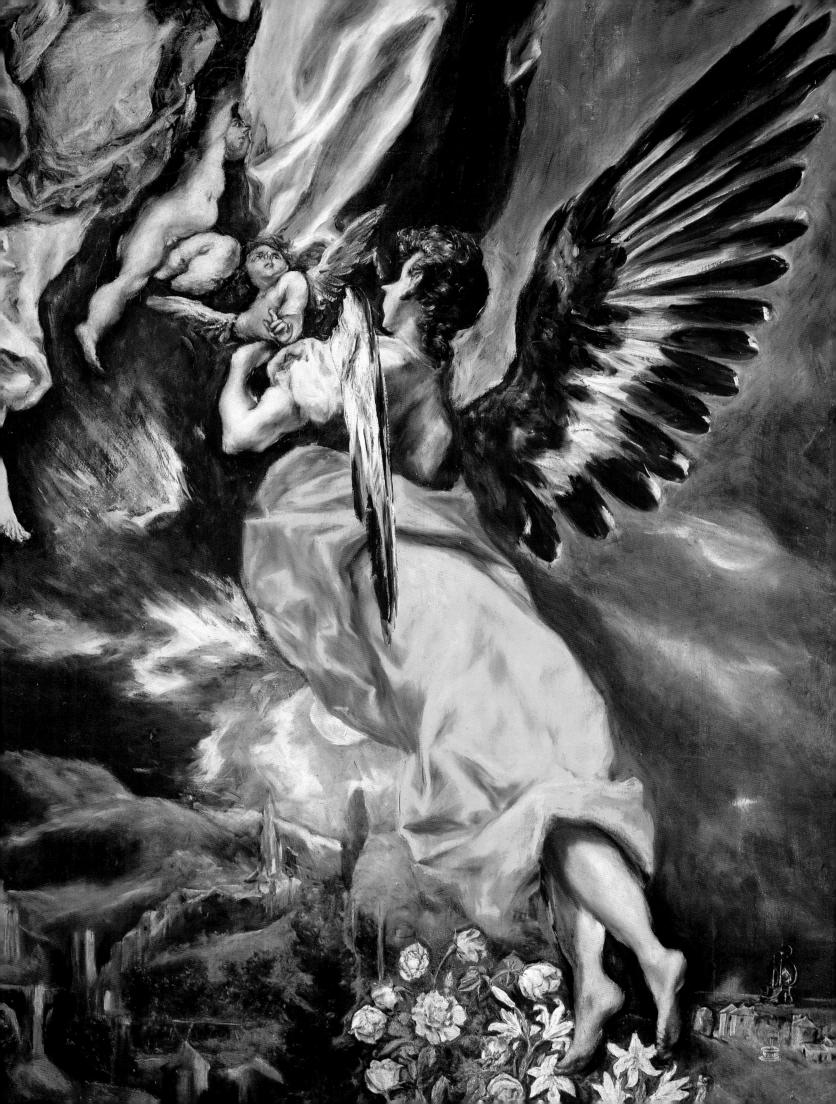

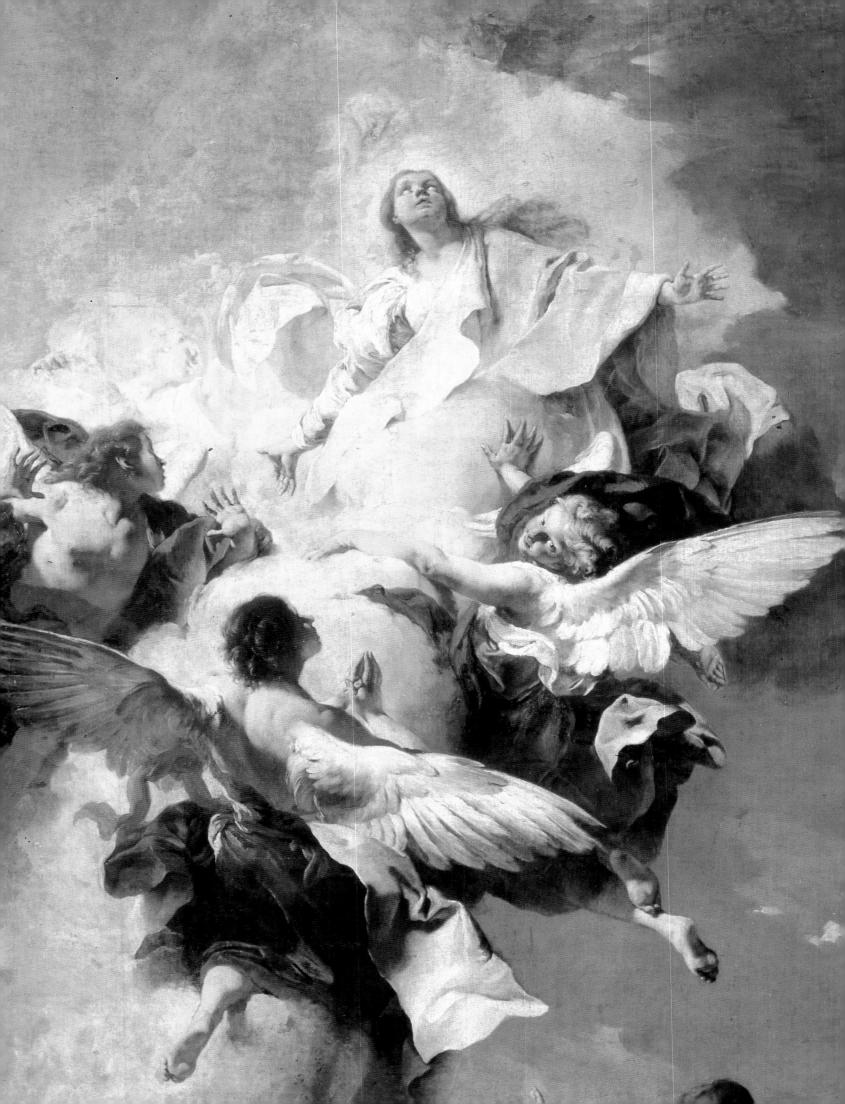

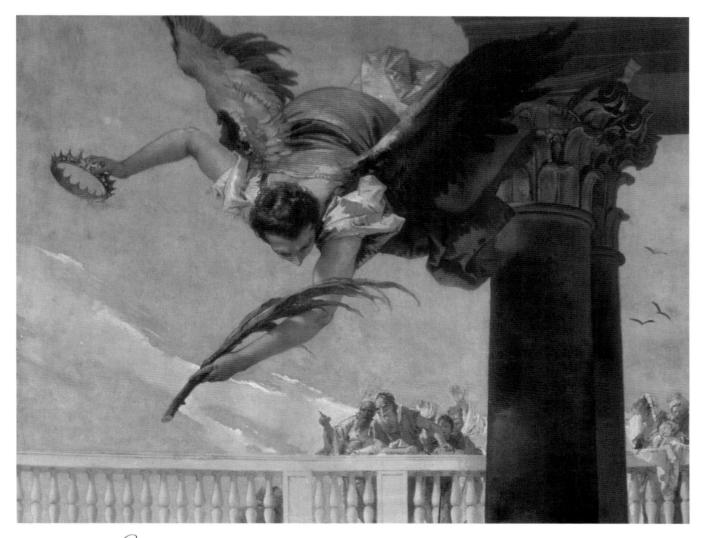

GIAMBATTISTA TIEPOLO (1696–1770). Detail of *The Martyrdom of Saint John of Bergamo*, n.d. Oil on canvas. Duomo, Bergamo, Italy.

GIAMBATTISTA PIAZZETTA (1683–1754). Detail of *The Assumption of the Virgin*, 1735. Oil on canvas, 16 ft. 11 in. x $96\frac{1}{2}$ in. (5.15 x 2.45 m), overall. Musée du Louvre, Paris.

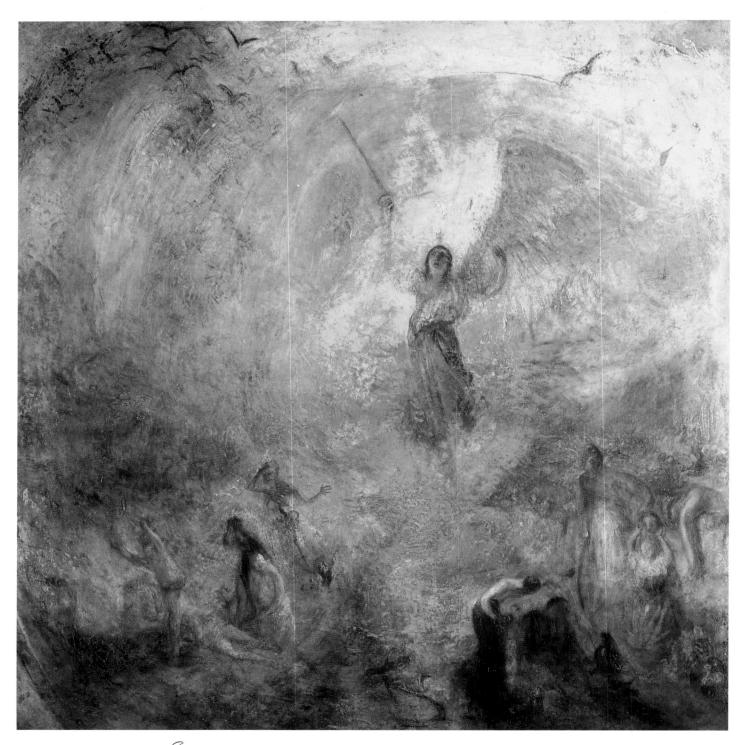

JOSEPH MALLORD WILLIAM TURNER (1775–1851). Angel Standing in Storm, c. 1840. Oil on canvas, 31 x 31 in. (78.7 x 78.7 cm). Tate Gallery, London.

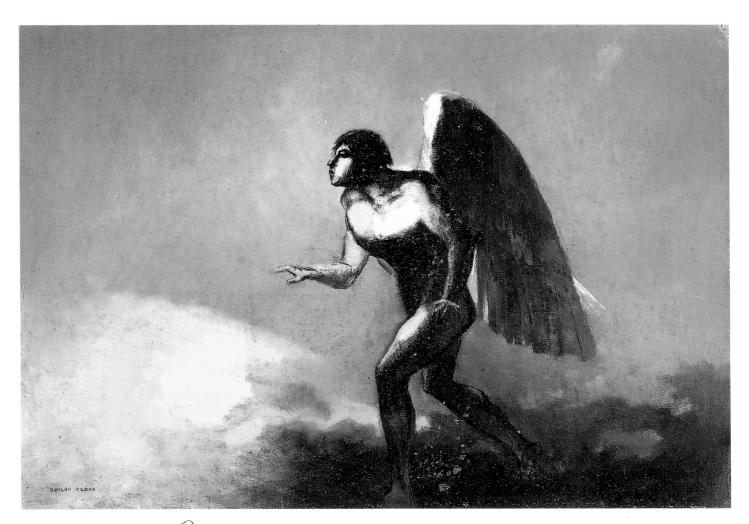

ODILON REDON (1840–1916). *The Winged Man or the Fallen Angel*, before 1880. Oil on cardboard, 9³/₈ x 14 in. (24 x 35.5 cm). Musée des Beaux-Arts, Bordeaux, France.

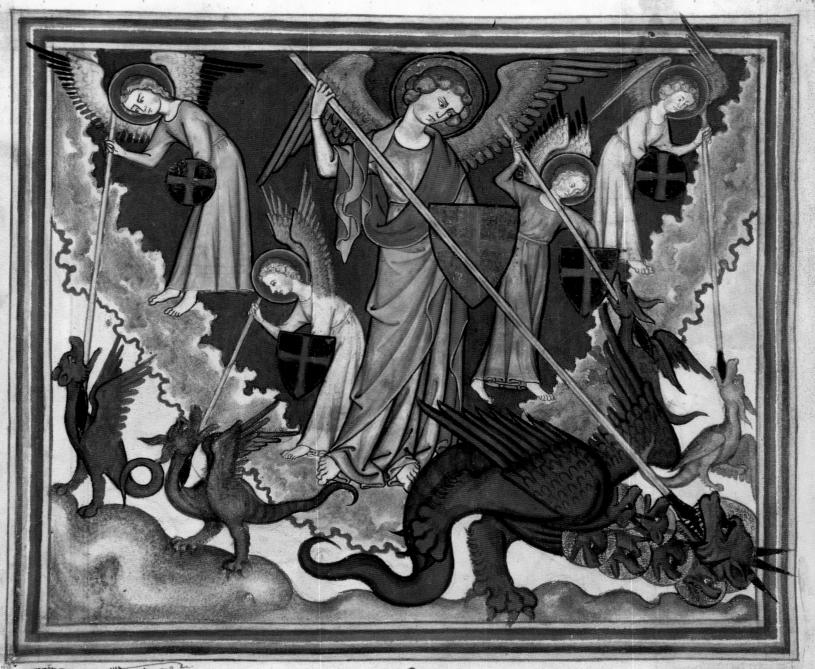

Findum ephum magnitado. midia el er angeli emo prehabato otdone. er diacho pugnabao rangli ei r n ualmeruno: negi locus umentus e cor apli mielo. Er protectus e dincho ille magnus. Espris anaquus qui nocutar dialolus ria thamas-gledicar unicefium orkem piert" è in cinui: er angeli emo cii illo nuthanit. er anduu nocutaria cii illo nuthanit.

×

Raucha é la lus + uns. er regrum da nolta. er pæltas rpilt ens: qua protetus é acarlator fin níor à acutabar cos ana coulratum dy nir die ac note. Et ipl unærumt enm propter langumen agu. er fr nerbum æltmonn fuer non dilerennir annas has ulip að moæ. fra leannin æli er ábitans in ets De terre + man-quelændir diablus að nos hús utin uaguan . la ens gruodianu ænipusbaber.

BATTLES OF GOOD AND EVIL

And there was war in heaven: Michael and his angels fought against the dragon. Revelation 12:7

Vil seems to be more inspiring than goodness to artists and writers, and both have long given the devil his due. Dante's *Inferno* and John Milton's *Paradise Lost* provided much of the imagery adopted by visual artists in portraying scenes of the war in heaven between the rebel angels, led by Satan, and the good angels, led by the archangel (and later saint) Michael. This metaphoric battle between good and evil was often depicted quite literally, with Satan and an armor-clad, sword-wielding Michael in armed combat. According to Milton, Satan had rebelled at being instructed to bow down to Christ, and in resistance he gathered round him a third of all the angels in heaven. As Milton wrote in book 6 of *Paradise Lost:*

Wide was spread

That war, and various: sometimes on firm ground

A standing fight; then, soaring on main wing,

Tormented all the air; all air seemed then

Conflicting fire.

After losing the battle, the rebel angels plummeted into the depths of hell, a scene spectacularly portrayed by Pieter Bruegel I (page 109) and others.

Having originated as chief of the seraphim (the highest angelic order), Satan retained certain characteristics of angel anatomy that were perverted into devilish attributes. According to canto 34 of Dante's *Inferno*:

A wondrous thing it was to see his head, Wearing three faces, scarlet to the fore; . . . Beneath each head two mighty wings emerged . . . No feathers did they bear but like a bat's Their covering was.

> (J)etail of *War in Heaven*. Norman, c. 1320. From *The Apocalypse*. Color, gold, silver, and brown ink on vellum, 12¹/₈ x 9 in. (30.7 x 23 cm), overall. The Metropolitan Museum of Art, New York; The Cloisters Collection, 1968.

Sometimes Satan takes the guise of a dragon rather than a man (see pages 110, 111), but leathery wings are almost always an identifying feature, as is a serpentine tail.

The New Testament Book of Revelation, which provides the basic text for the story of the end of the world, is filled with complex and visually specific imagery. Artists were particularly inspired by the Four Horsemen and the Seven Angels of the Apocalypse (pages 118–19). The Last Judgment—which is predicted to take place after the final battle with Satan has been won and Christ has returned to earth in triumph to judge "the quick and the dead" was also a favored scene. Christ often is shown encircled by numerous angels, while down below devils are carrying away sinners to their eternal torment. Michael is usually there to aid in the judgment process by weighing souls (page 123), and a devil often lurks nearby—and occasionally tries to tip the scale in damnation's favor.

A few episodes in the Old and New Testaments describe conflicts between angels and humans, with angels acting in a punitive or combative rather than protective role. Particularly popular with artists were the Expulsion from Paradise, when an angel with a flaming sword drove Adam and Eve out of the Garden of Eden (below and opposite), and Jacob's night-long fight with an unnamed angel, from whom he was determined to wrest a blessing (pages 106–7).

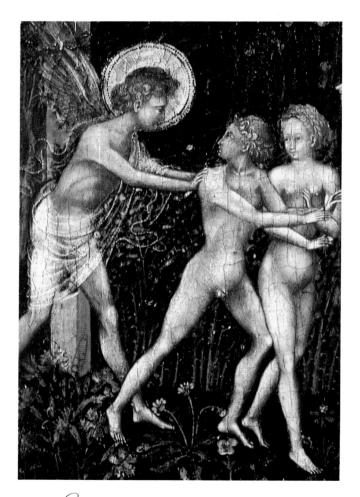

GIOVANNI DI PAOLO DI GRAZIA (C. 1400–1482). Detail of *The Annunciation*, c. 1445. Wood, 15^{3/4} x 18^{1/4} in. (40 x 46 cm), overall. National Gallery of Art, Washington, D.C.; Samuel H. Kress Collection.

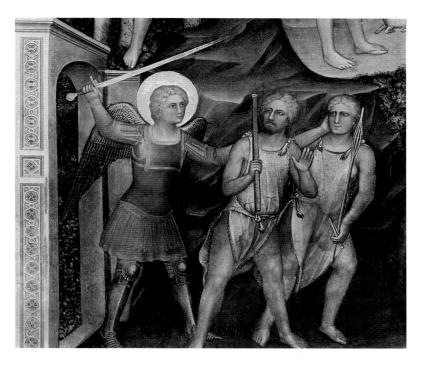

GIUSTO DE MENABUOI (14th century). Adam and Eve, 1376–78. Fresco. Baptistery of the Cathedral, Pisa, Italy.

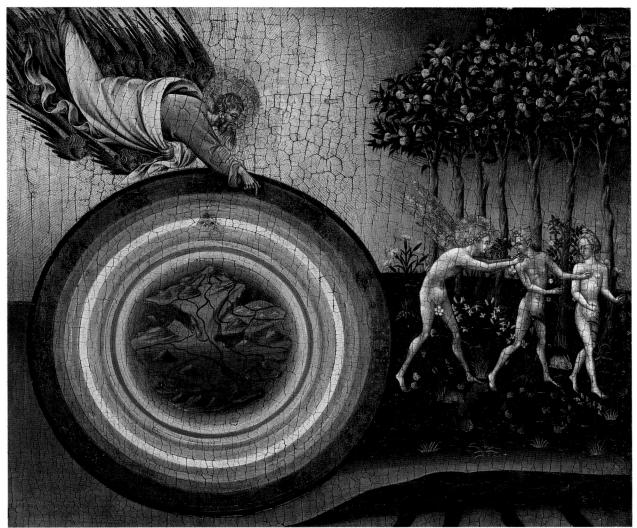

GIOVANNI DI PAOLO DI GRAZIA (c. 1400–1482). The Creation of the World and the Expulsion from Paradise, c. 1445. Tempera and gold on wood, 19 x 20½ in. (46.5 x 52 cm). The Metropolitan Museum of Art, New York; Robert Lehman Collection, 1975.

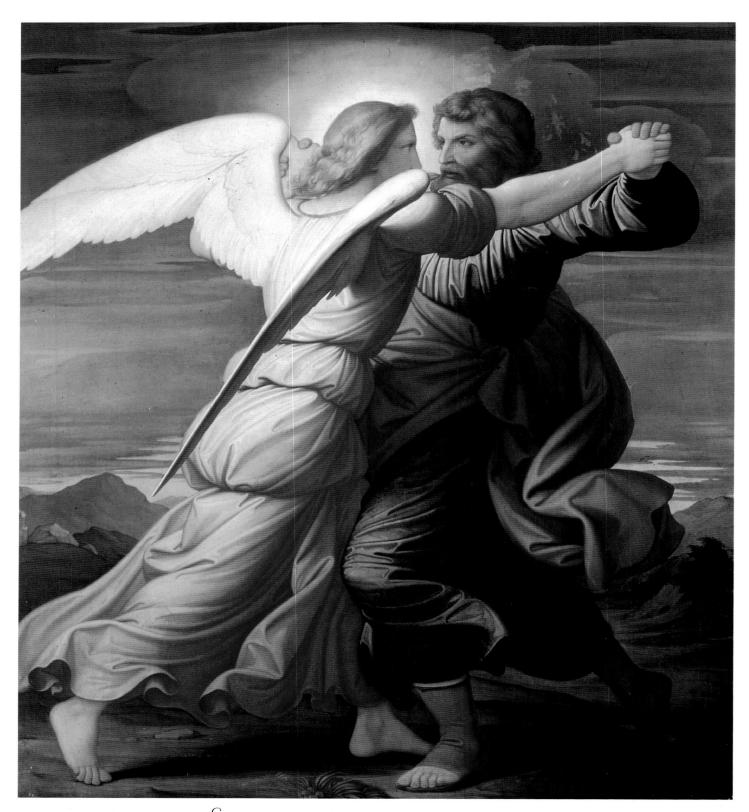

EDWARD STEINLE (1810–1886). Jacob Wrestling with the Angel, 1837. Oil on canvas. Private collection.

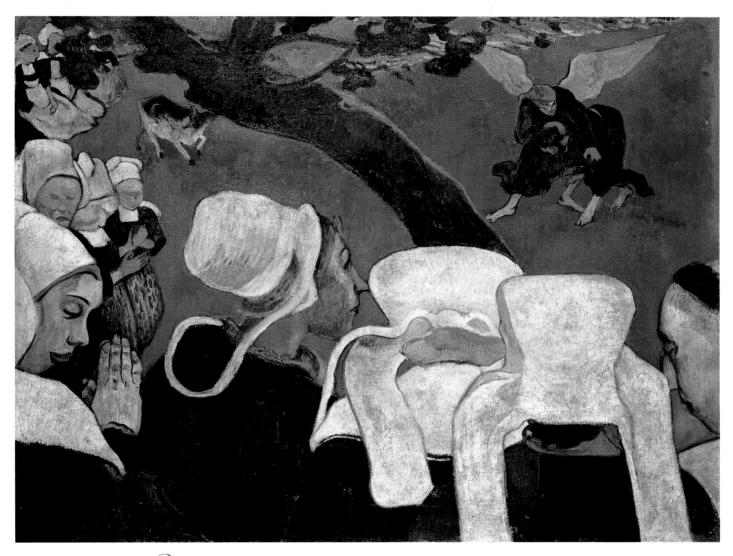

PAUL GAUGUIN (1848–1903). Vision after the Sermon: Jacob Wrestling with the Angel, 1888.Oil on canvas, $28\frac{3}{4} \ge 35\frac{3}{4}$ in. (72.2 ≥ 91 cm). The National Gallery of Scotland, Edinburgh.

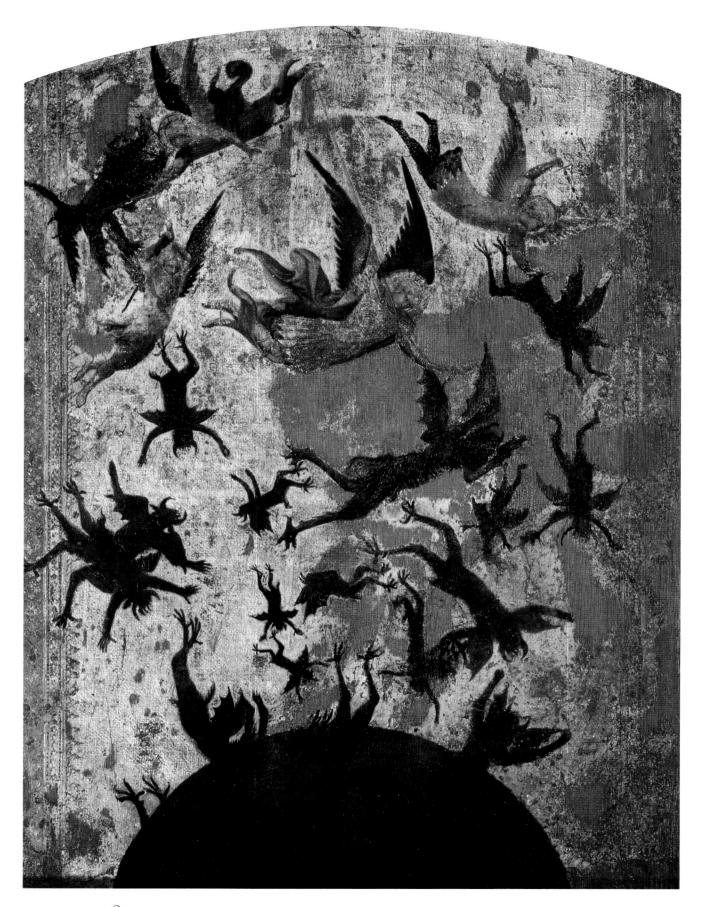

MASTER OF THE REBEL ANGELS (1st part of 14th century). Detail of *The Fall of the Rebel Angels*, n.d. Wood. Musée du Louvre, Paris.

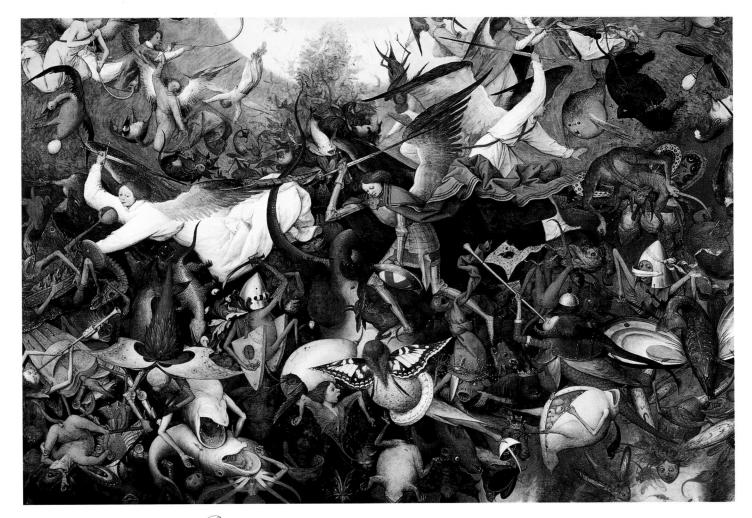

PIETER BRUEGEL I (c. 1525/30–1569). The Fall of the Rebel Angels, 1562. Oak, 46 x 63³/4 in. (117 x 162 cm). Musée des Beaux-Arts, Brussels.

Jattoo by Bill Baker after Martin Schoengauer's woodcut of Saint Michael.

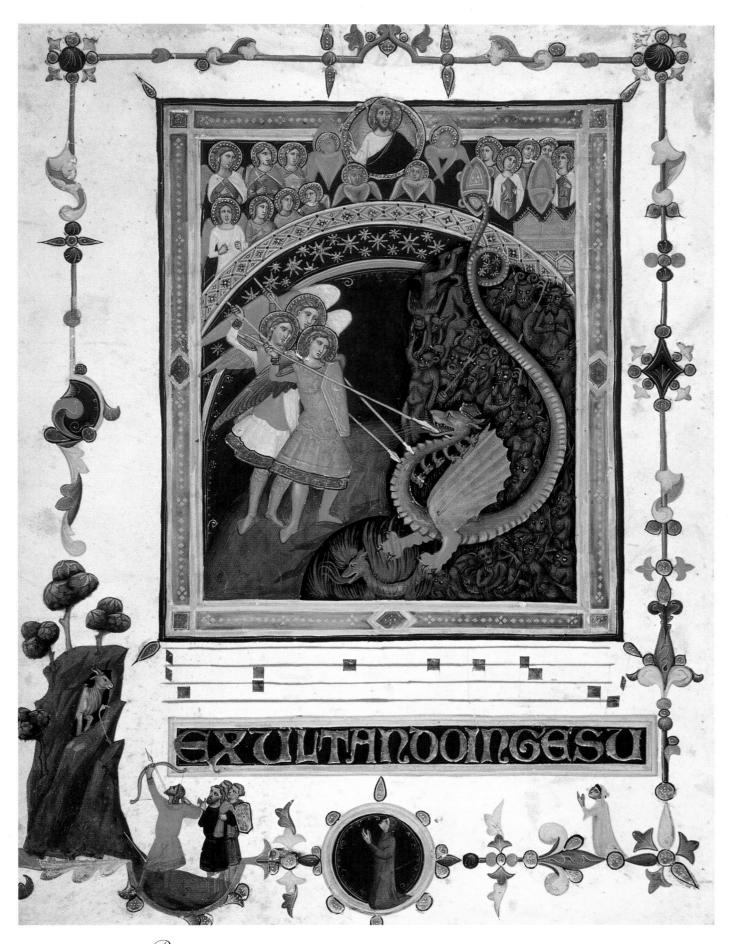

 \bigcirc ACINO DI BONAGUIDA (14th century). Detail of *The Apparition of Saint Michael*, c. 1340. Tempera and gold leaf on parchment, $17\frac{1}{4} \times 12\frac{5}{8}$ in. (43.8 x 32.2 cm). The British Library, London.

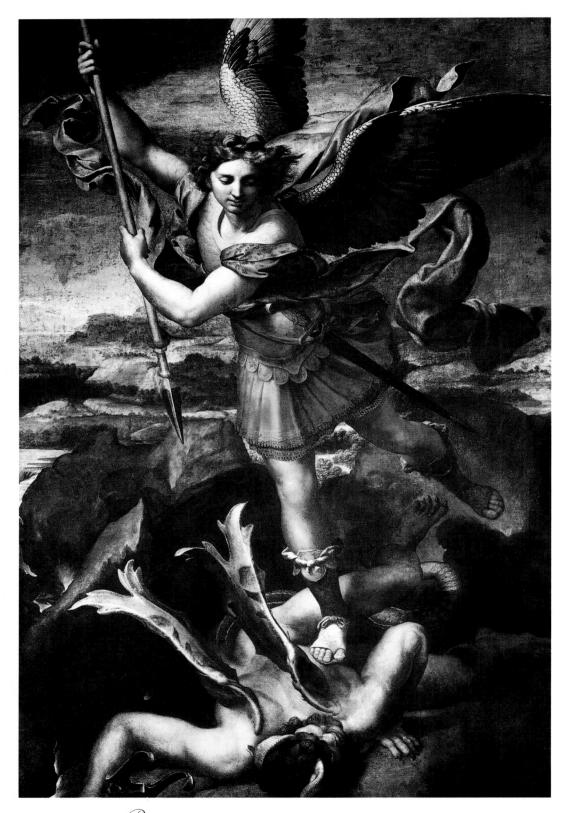

RAPHAEL (1483–1520). Saint Michael Trampling the Dragon, 1518. Oil on canvas, 106¾ x 63 in. (270 x 160 cm). Musée du Louvre, Paris.

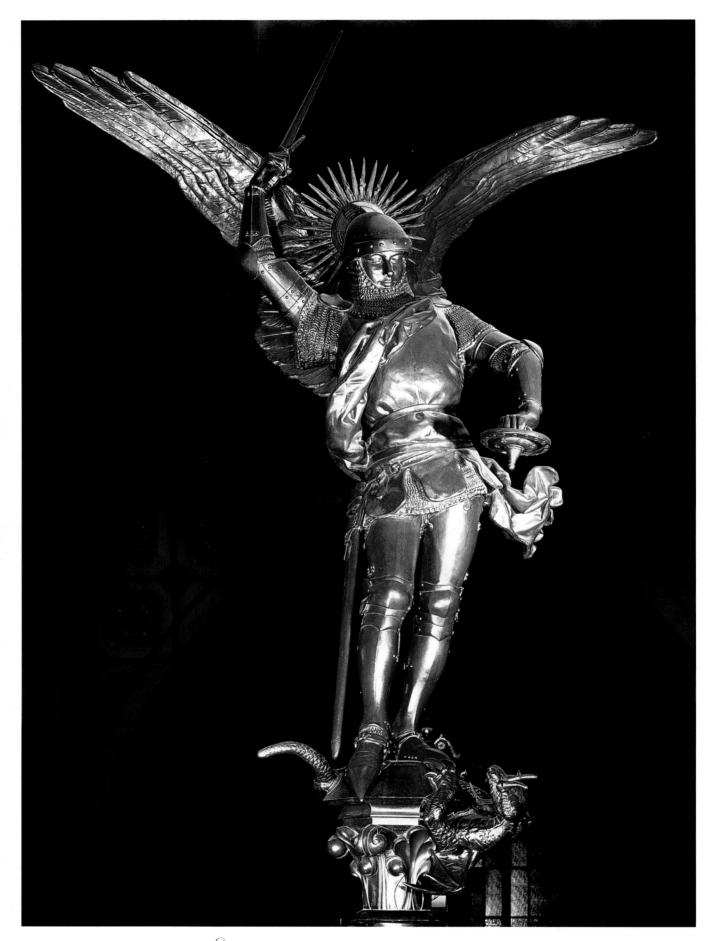

CMMANUEL FREMIET (1824–1910). Saint Michael, 1879–97. Hammered copper, 20 ft. 3 in. x 8 ft. 6 in. x 4 ft. (6.17 x 2.6 x 1.2 m). Musée d'Orsay, Paris; Gift of Mme. G. Pasquier.

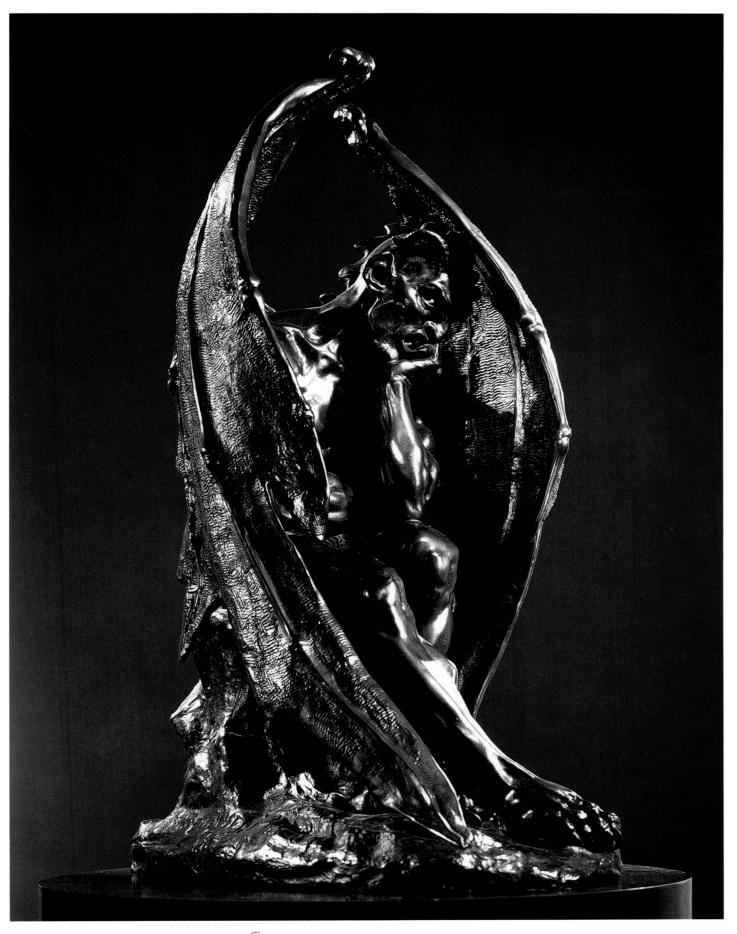

JEAN-JACQUES FEUCHÈRE (1807–1852). Satan, 1834. Bronze, 31 x 21 x 12½ in. (79 x 53 x 32 cm). Los Angeles County Museum of Art; Times Mirror Foundation.

THE APOCALYPSE

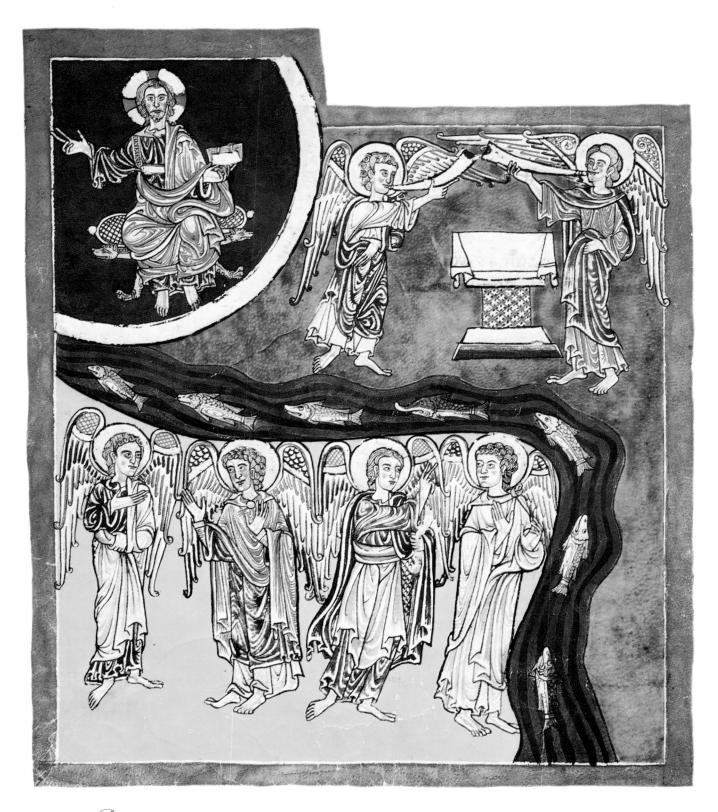

Detail of The Sixth Angel Delivers the Four Angels That Had Been Enchained in the Euphrates. Spanish, c. 1180.
 From Beatus de Liébana (d. 798), Commentary on the Apocalypse.
 Tempera and gold leaf on parchment, 17½ x 11¾ in. (44.5 x 30 cm).
 The Metropolitan Museum of Art, New York; Purchase, The Cloisters Collection,
 Rogers and Harris Brisbane Dick Funds, and Joseph Pulitzer Bequest, 1991.

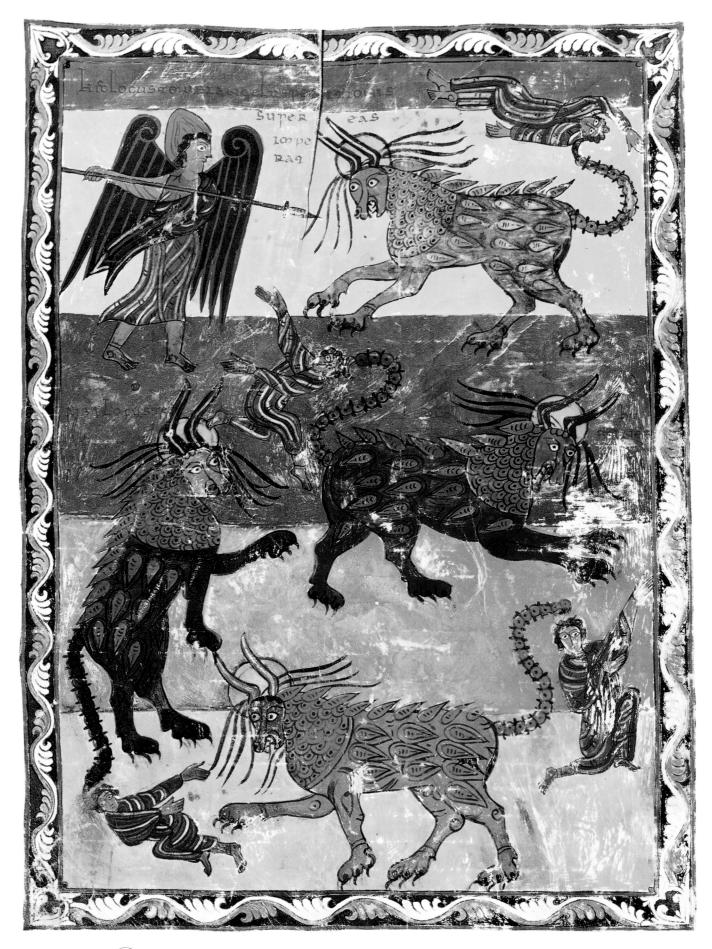

Detail of *Fifth Trumpet: The Plague of Locusts.* Spanish, mid-10th century. From Beatus de Liébana (d. 798), *Commentary on the Apocalypse*, and Jerome, *Commentary on Daniel*. Illuminated manuscript. The Pierpont Morgan Library, New York.

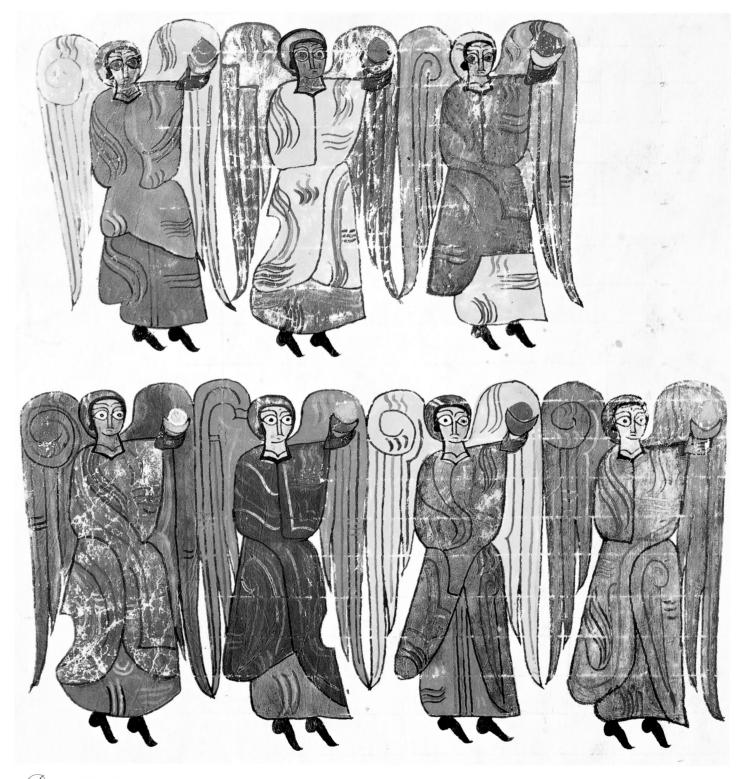

Detail of *The Mission of the Seven Angels with the Seven Cups.* Spanish, 1091–1109. From Beatus de Liébana (d. 798), *Commentary on the Apocalypse.* Miniature on parchment, 9¹/₄ x 13 in. (23.5 x 33 cm), overall. Biblioteca Nacional, Madrid.

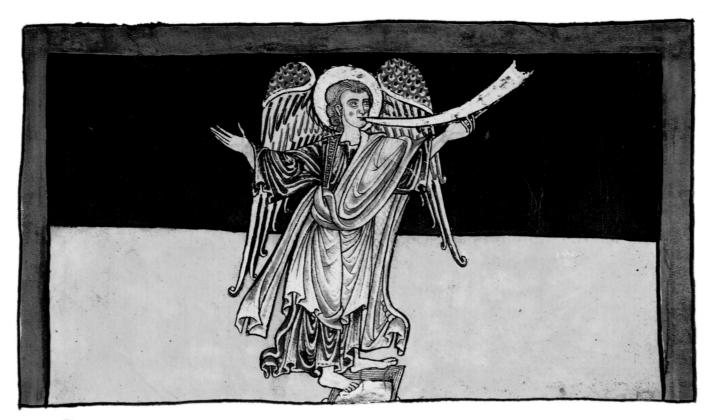

Detail of The Seventh Angel of the Apocalypse Proclaiming the Reign of the Lord. Spanish, c. 1180. From Beatus de Liébana (d. 798),
 Commentary on the Apocalypse. Tempera, gold, and ink on parchment, 17^{1/2} x 11^{3/4} in. (44.5 x 30 cm), overall.
 The Metropolitan Museum of Art, New York; Purchase, The Cloisters Collection,
 Rogers and Harris Brisbane Dick Funds, and Joseph Pulitzer Bequest, 1991.

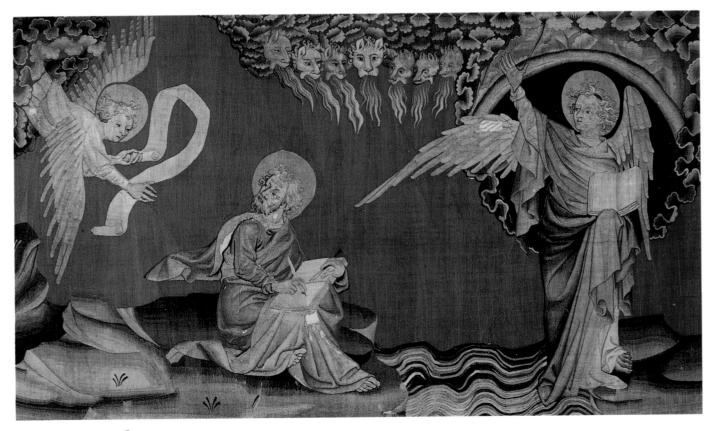

Orient John Takes the Book from the Seventh Angel, detail of The Apocalypse of Angers, c. 1360–80. Tapestry. Musée des Tapisseries, Angers, France.

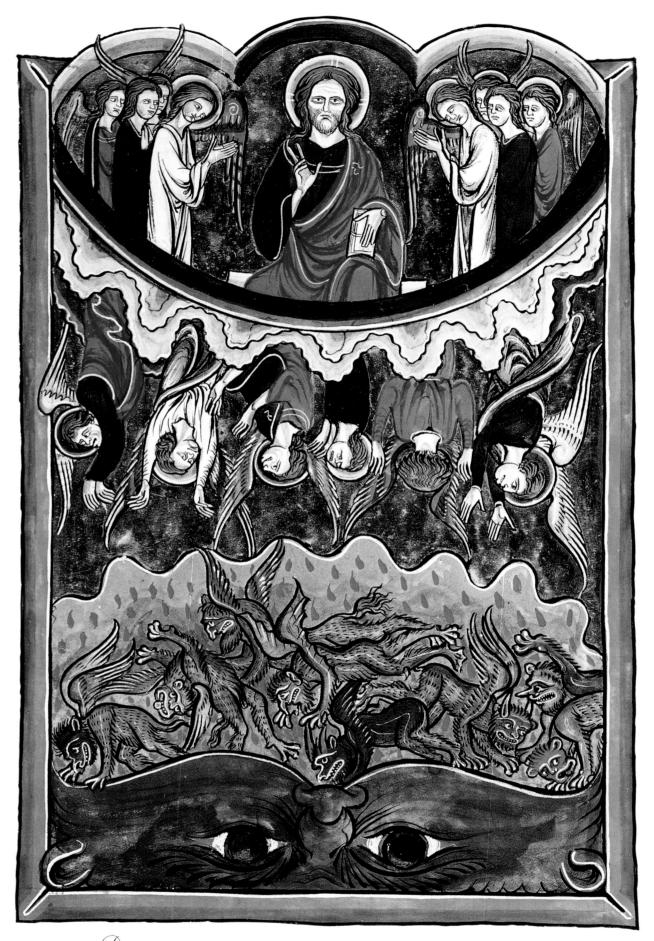

Detail of The Fall of the Rebel Angels, Psalter of Blanche de Castille. From Les Superstitions, 1186. Illuminated manuscript. Bibliothèque de l'Arsenal, Paris.

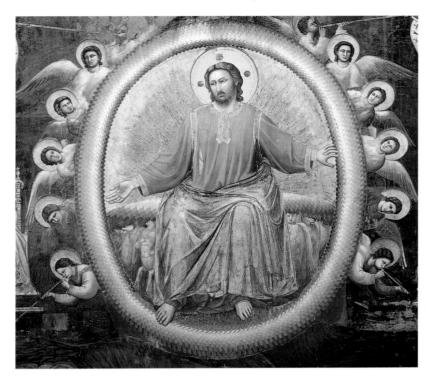

G10TTO (1266/67–1337). Detail of *The Last Judgment*, c. 1305–13. Fresco. Arena Chapel, Padua, Italy.

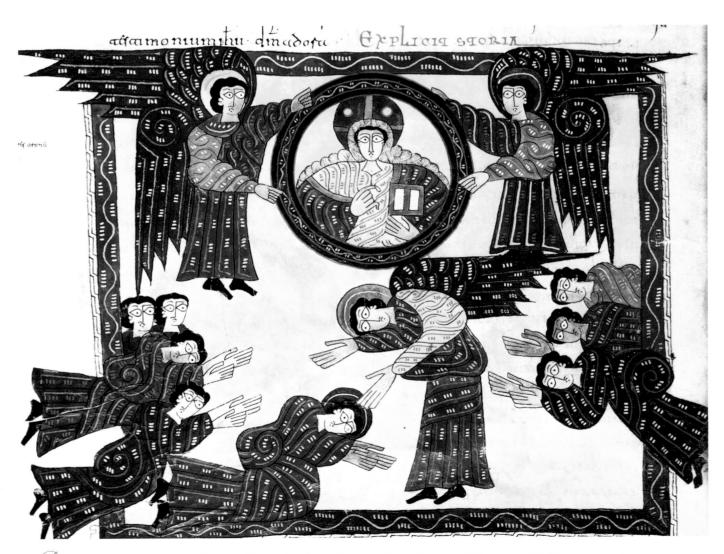

Detail of *Theophany: Adoration of God in Heaven.* Spanish, 10th century. From Beatus de Liébana (d. 798), *Commentary on the Apocalypse.* Illuminated manuscript. El Escorial, Real Biblioteca de San Lorenzo, San Lorenzo de El Escorial, Spain.

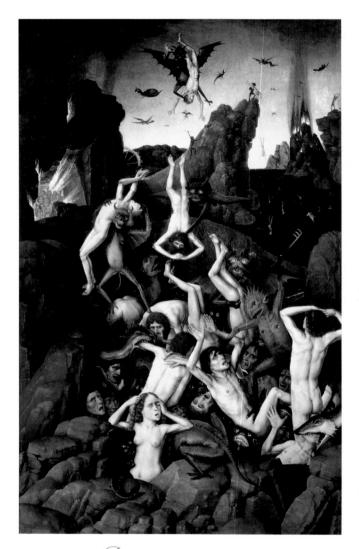

 $\underbrace{\bigcirc}_{\text{IERIC BOUTS (c. 1415-1475).} } \\ The Fall of the Danned, c. 1450. \\ \text{Oil on wood, } 45\frac{1}{4} \ge 27\frac{1}{8} \text{ in. (115 x 69.5 cm).} \\ \text{Musée des Beaux-Arts, Lille, France.}$

DIERIC BOUTS (c. 1415–1475).
The Way to Paradise, c. 1450.
Oil on wood, 45^{1/4} x 27^{1/8} in. (115 x 69.5 cm).
Musée des Beaux-Arts, Lille, France.

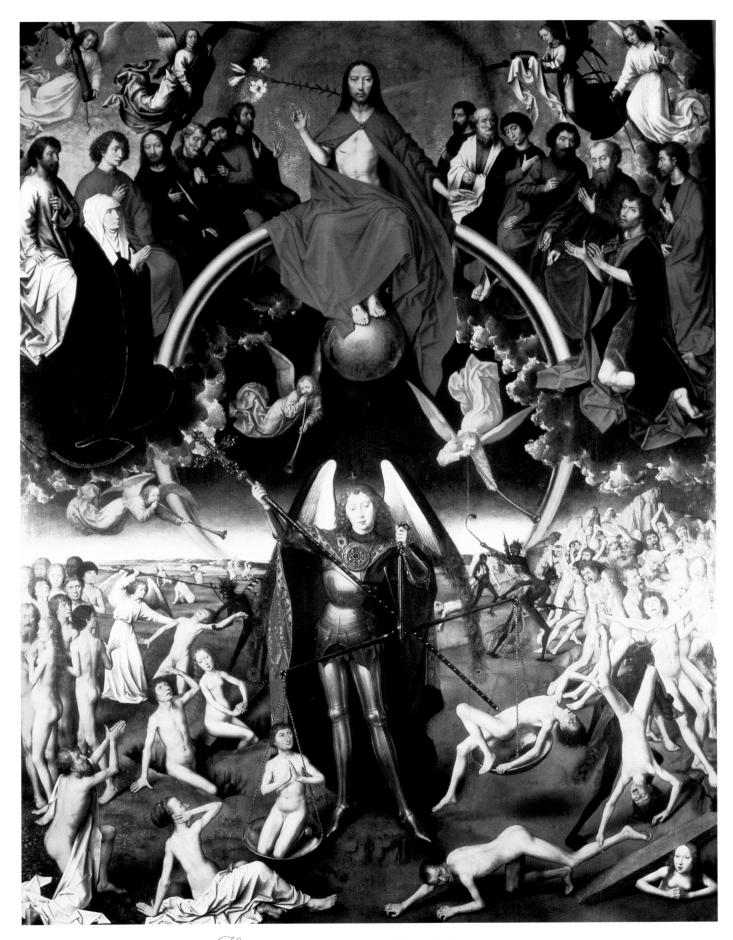

HANS MEMLING (1430/40–1494). The Last Judgment, c. 1480. Wood. Memling Museum, Bruges, Belgium.

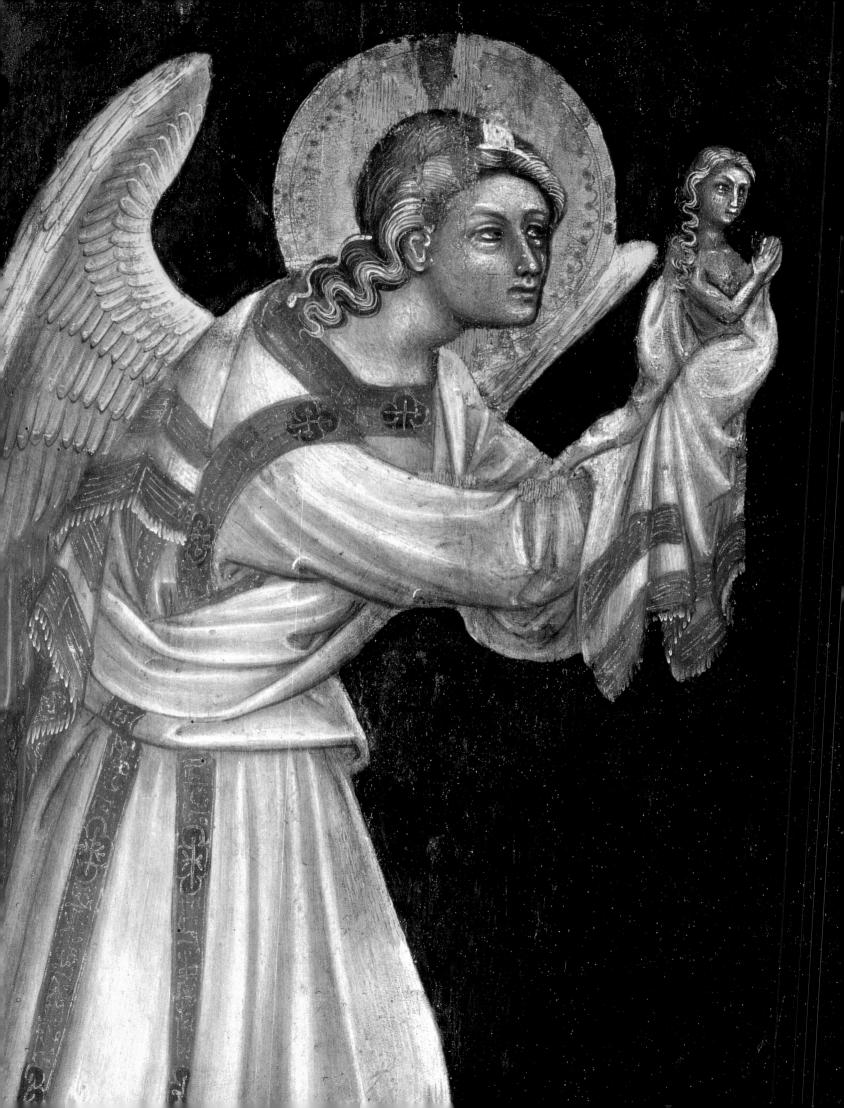

GUARDIAN ANGELS AND COMPANIONS

Every visible thing in this world is put under the charge of an angel. Saint Augustine (354–430), Eight Questions

D ithin the nine orders of angels, only archangels and angels (the two lowest categories in the hierarchy) are traditionally said to interact with man and woman in the course of daily life. In some cases, the angel serves only as a messenger, but in others, the angel lingers in visible form, taking responsibility for the well-being of individuals in trouble, guarding them from harm, offering them sustenance, or leading them out of danger.

The most elaborate tale is that of the blind Tobit and his son Tobias, from the apocryphal Book of Tobit. The archangel Raphael arrived, unannounced and unidentified, at Tobit's door, offering to guide Tobias on a business trip to a nearby town. Along the way, Raphael instructed Tobias to catch a large fish and preserve its gall, heart, and liver. When they arrived at their destination, Tobias learned about the travails of his cousin Sarah, who was possessed by a demon who had devoured each of her seven husbands on their wedding night. Tobias bravely married Sarah nonetheless, and at Raphael's instruction he cooked the heart and liver of the fish, whose fumes drove the demon to "the remotest parts of Egypt."

After Tobias and Sarah celebrated their good fortune, they returned to Tobit, whose blind eyes were opened—again at Raphael's instruction—once they were rubbed with the gall of the fish. This adventure-filled tale with its picturesque cast of characters, including Tobias's little dog, proved irresistible to artists ranging from Francesco Botticini (page 139) and a follower of Andrea delVerocchio (page 138) to Rembrandt (page 96).

Some Old Testament scenes of human-angel interaction particularly favored by artists include Daniel in the Lions' Den (page 127) and several events from the life of Abraham notably, the Sacrifice of Isaac, when, at the last minute, an angel stayed Abraham's hand from cutting his son's throat as an offering to God (pages 128–29). The prophet Elijah is often shown being fed by an angel in the wilderness (page 131) or being lifted to heaven in a fiery chariot led by an angel (page 130).

> GUARIENTO DI ARPO (c. 1338–1377). Detail of *Angel*, 1354. Wood, 32¹⁄₄ x 19³⁄₄ in. (82 x 50 cm), overall. Musei Civici, Padua, Italy.

In scenes inspired by the New Testament, angels are shown offering sustenance to the Holy Family on their flight into Egypt, which Anthony Van Dyck transformed into an image of cherubs frolicking with the young Christ (page 79). Later, an angel greeted the three Marys at the empty tomb, announcing to them that Christ had risen from the dead (page 133).

Certain characters are identifiable by their ever-present angels. Saint Matthew, one of the four Evangelists, is accompanied by an angel who dictates the Gospel to him (pages 134–35), and Saint Bernard is often portrayed with his vision of the Virgin Mary surrounded by a host of angels (page 137). In Victorian times, the idea of a guardian angel became particularly associated with children and young lovers, who often are shown under the sheltering wing of increasingly feminine angels.

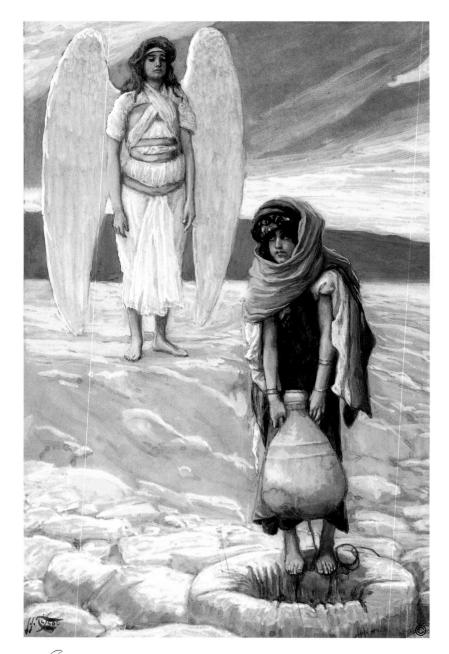

AMES TISSOT (1836–1902). *Hagar and the Angel in the Desert*, c. 1896–1900. Watercolor on paper, 9³/₈ x 6 in. (23.8 x 15.3 cm). The Jewish Museum, New York.

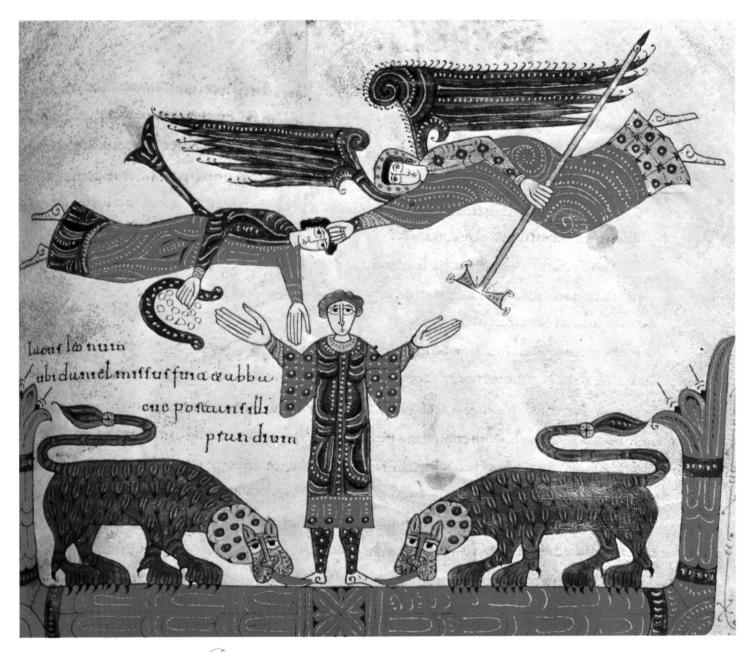

Detail of *Daniel in the Lion's Den*, n.d. From Beatus de Liébana (d. 798), *Commentary on the Apocalypse*. Illuminated manuscript. The British Library, London.

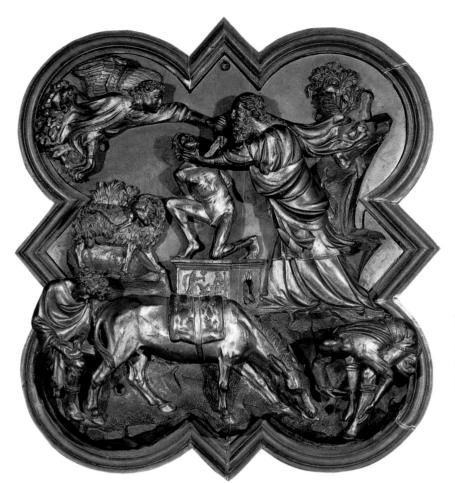

FILIPPO BRUNELLESCHI (1377–1446). The Sacrifice of Isaac, 1401–2. Competition panel for the Baptistery doors. Gilded bronze, 21 x $17\frac{1}{2}$ in. (53.3 x 44.5 cm). Museo Nazionale del Bargello, Florence.

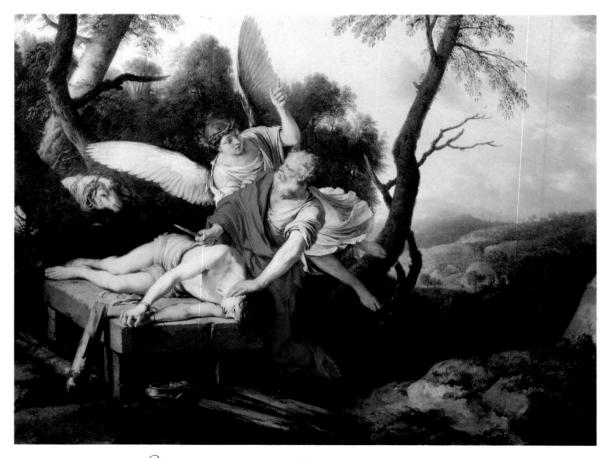

CAURENT DE LA HYRE (1606–1656). Abraham Sacrificing Isaac, 1650. Oil on canvas, 38 x 47[%] in. (96.4 x 121 cm). Musée Saint-Denis, Reims, France.

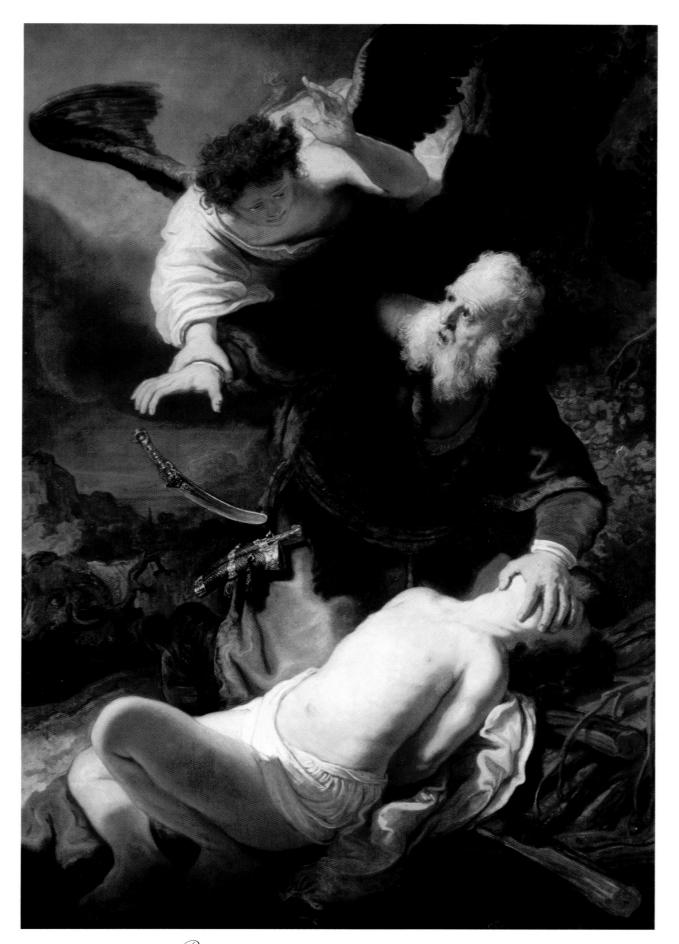

REMBRANDT VAN RIJN (1606–1669). *The Sacrifice of Isaac*, 1634. Oil on canvas, 62 ¼ x 46 in. (158 x 117 cm). The Hermitage Museum, Saint Petersburg, Russia.

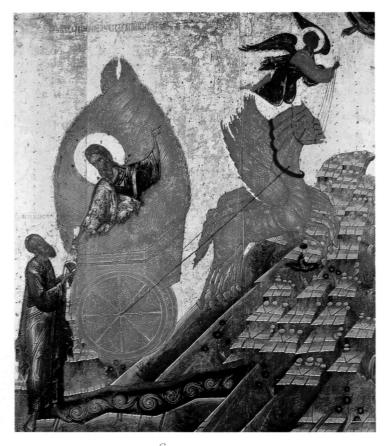

School of Psкov. *The Ascension of Elijah*, 15th century. Wood. Museum of the History of Religion, Saint Petersburg, Russia.

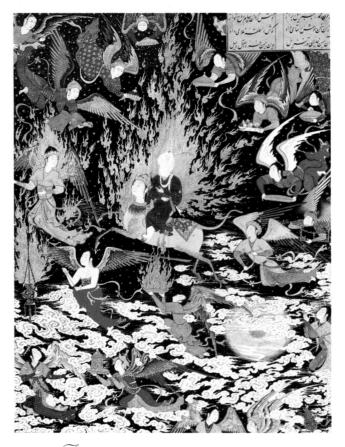

The Ascension of Mohammed on Buraq, His Mule, Guided by the Angel Gabriel. Persian, 1539–43. Illuminated manuscript. The British Library, London.

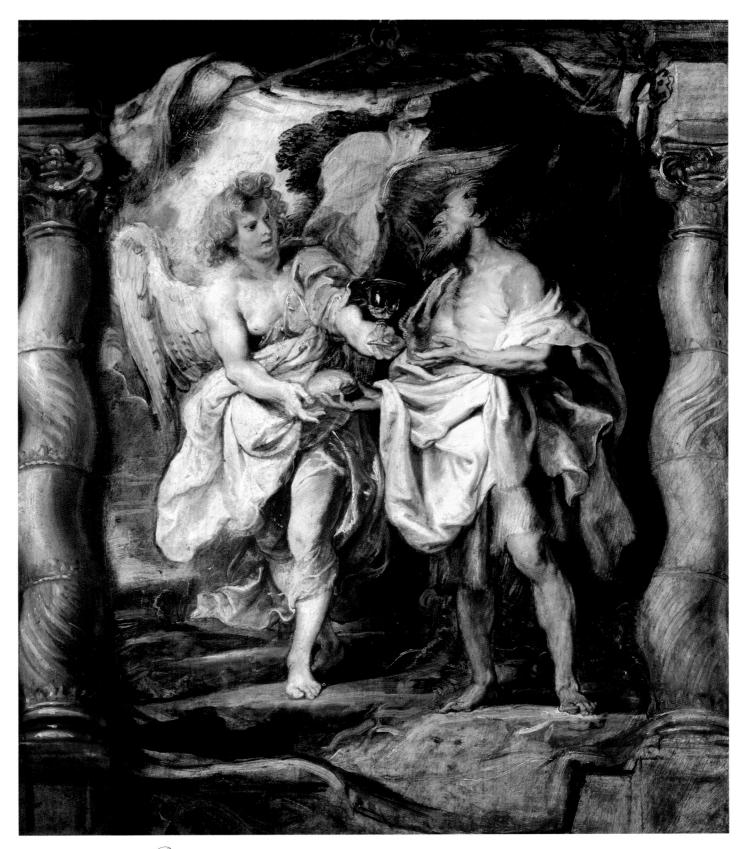

PETER PAUL RUBENS (1577–1640). The Prophet Elijah Receiving Bread and Water from an Angel, c. 1625–28. Oil on wood, 25% x 215% in. (65 x 55 cm). Musée Bonnat, Bayonne, France.

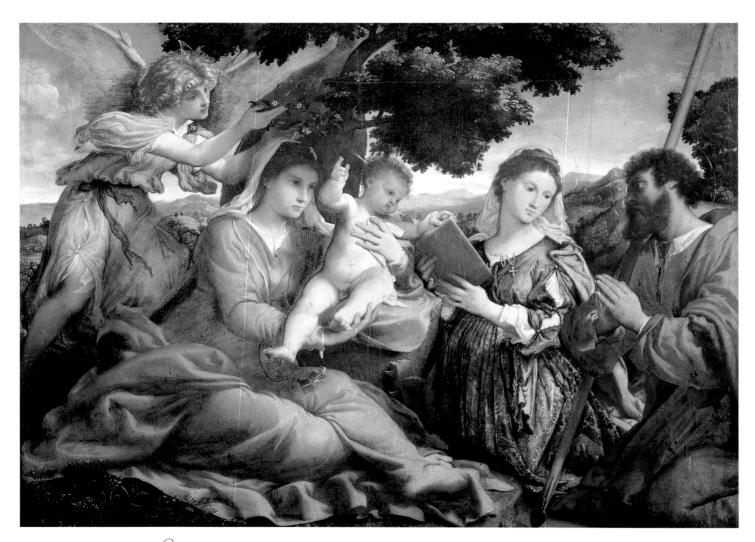

CORENZO LOTTO (c. 1480–1556). Madonna and Child with Saints Catherine and James, 1527–33. Oil on canvas, 43³/₄ x 59³/₄ in. (113.5 x 152 cm). Kunsthistorisches Museum, Vienna.

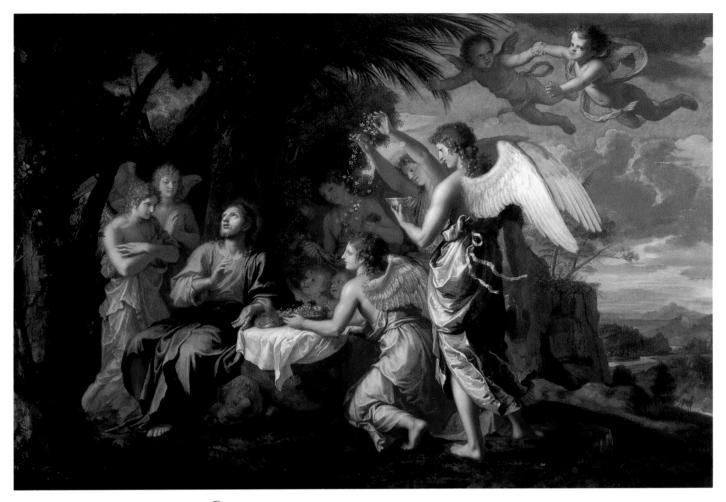

 $\int ACQUES DE STELLA (1596-1657). Christ Served by the Angels, n.d. Oil on canvas, <math>23\frac{5}{2} \times 31\frac{1}{2}$ in. (60 x 80 cm). Galleria degli Uffizi, Florence.

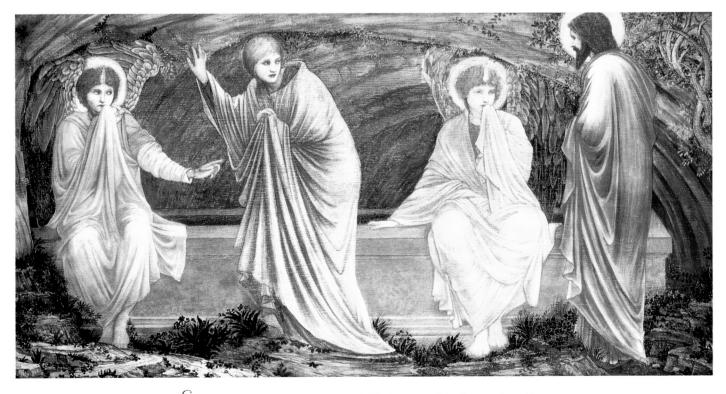

Edward Burne-Jones (1833–1898). The Morning of the Resurrection, 1882. Oil on canvas, 32^{1/2} x 60 in. (82.5 x 152.5 cm). Christie's, London.

Angel Dictating to Saint Matthew the Evangelist (from Chartres Cathedral), 2d quarter of 13th century. Stone, 26 x 19⁵% in. (66 x 50 cm). Musée du Louvre, Paris.

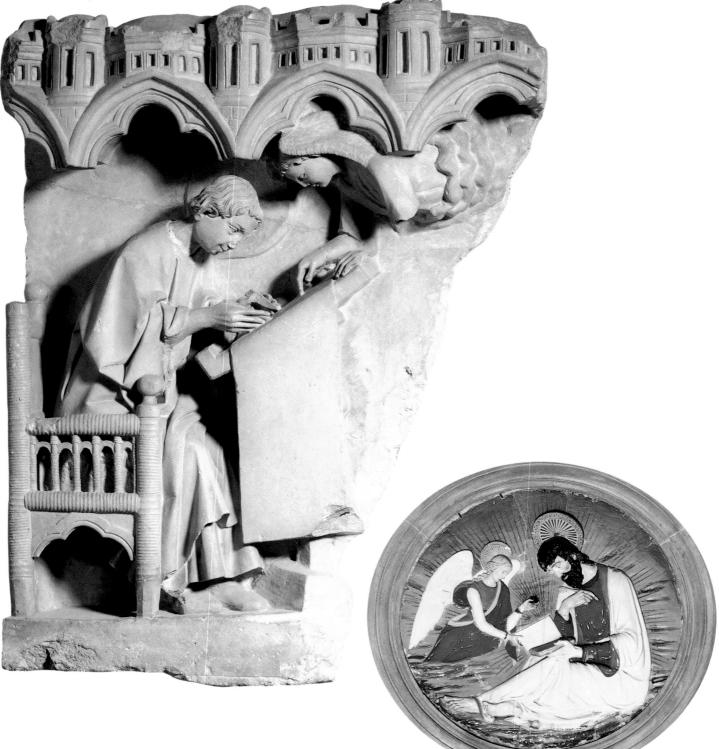

FILIPPO BRUNELLESCHI (1377–1446). Saint Matthew, 1442–46. Glazed terra-cotta, diameter: 67 in. (170 cm). Pazzi Chapel, Santa Croce, Florence.

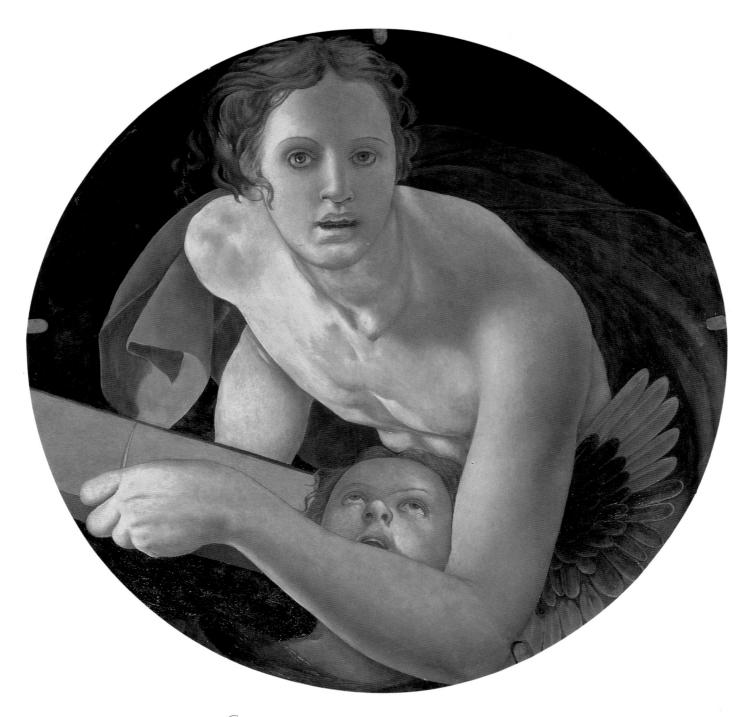

JACOPO DA PONTORMO (1494–1556). Saint Matthew, c. 1527–28. Oil on wood, diameter: 27½ in. (70 cm). Capponi Chapel, Santa Felicita, Florence.

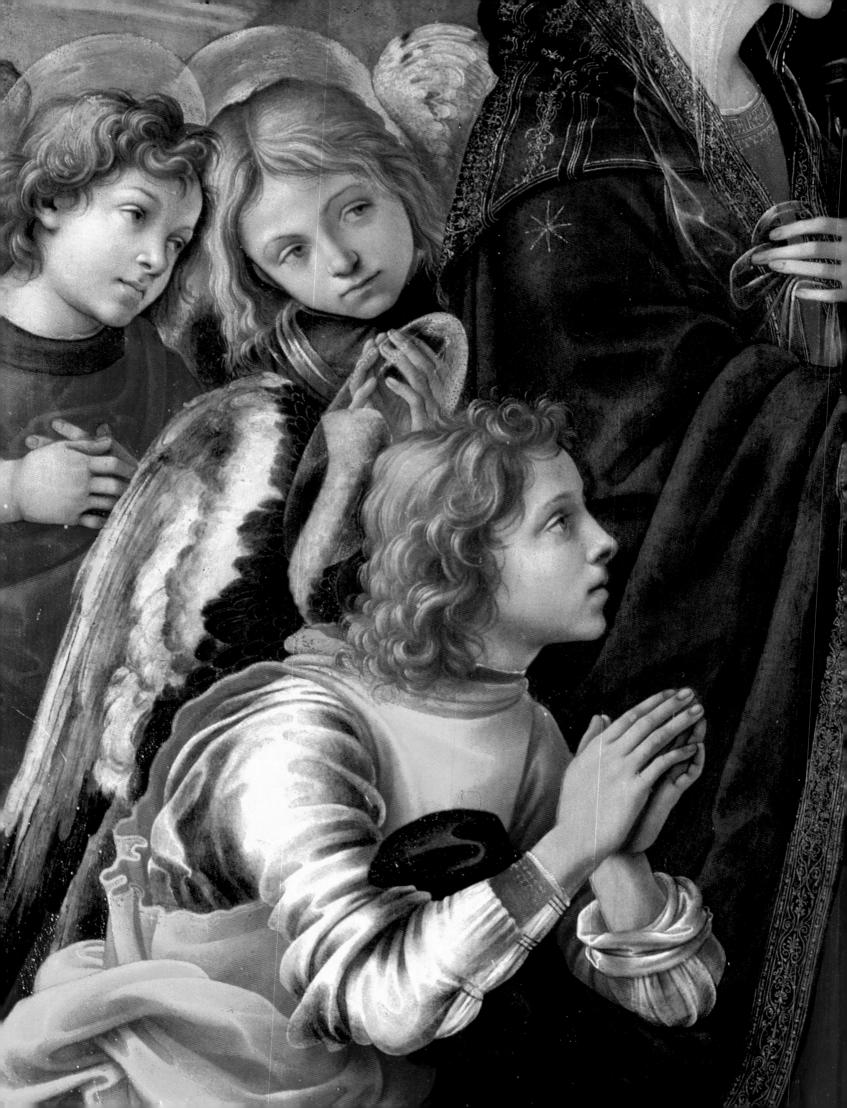

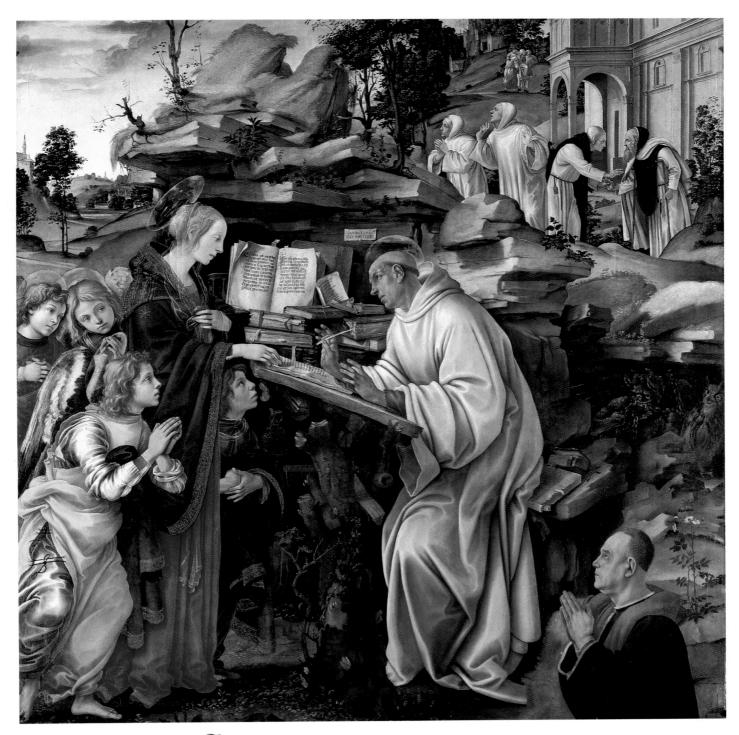

FILIPPINO LIPPI (1457/58–1504). *The Vision of Saint Bernard*, mid-1480s. Tempera on wood, 82³/₄ x 76³/₄ in. (210 x 195 cm). Badia, Fiesole, Italy.

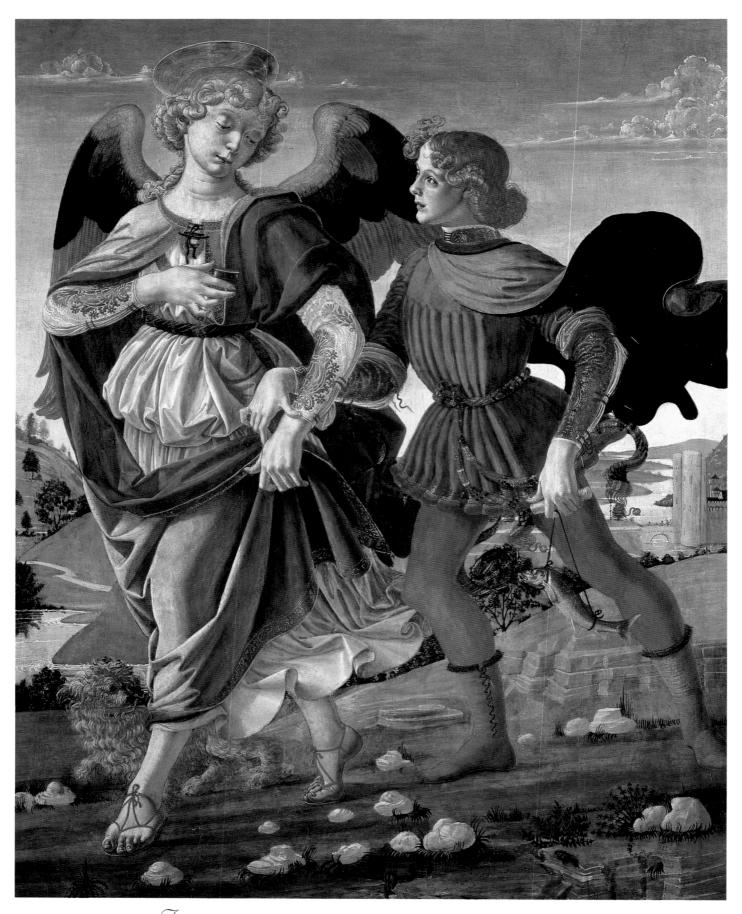

Follower of ANDREA DELVEROCCHIO (c. 1435–1488). *Tobias and the Angel*, c. 1470–80. Egg tempera on poplar, 33 x 26 in. (83.6 x 66 cm). The National Gallery, London.

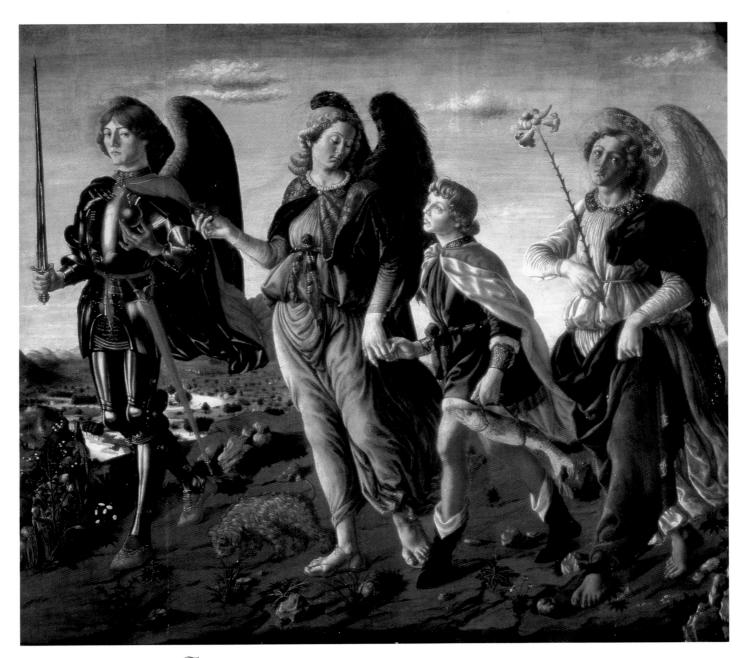

FRANCESCO BOTTICINI (c. 1446–1497). The Three Archangels and Tobias, c. 1470. Tempera on wood, 60¼ x 60¼ in. (153 x 154 cm). Galleria degli Uffizi, Florence.

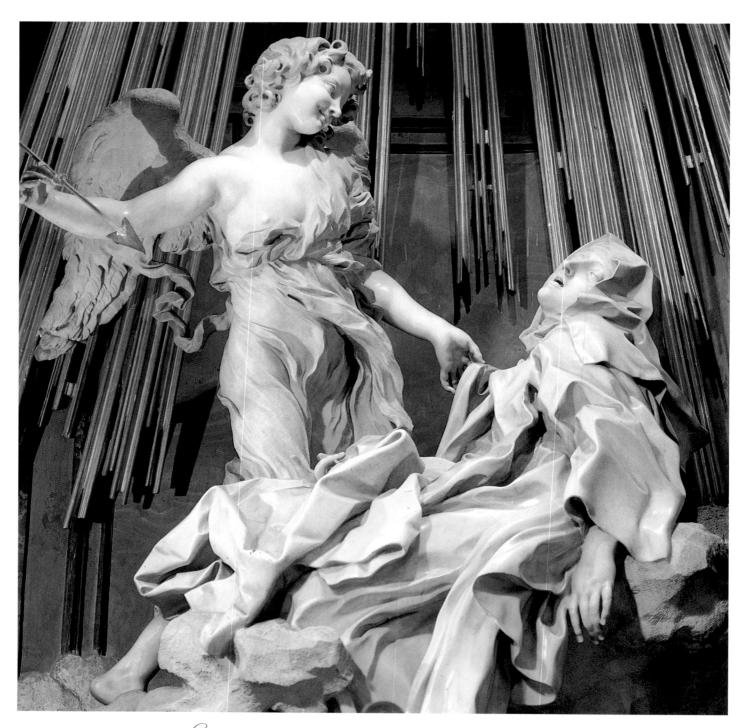

GIANLORENZO BERNINI (1598–1680). *The Ecstasy of Saint Teresa*, 1645–52. Marble, life-size. Santa Maria della Vittoria, Rome.

 $\int OHN \ WILLIAM \ GODWARD \ (1861-1922). \ The \ Betrothed, n.d.$ Oil on canvas, $17^{3/4} \ x \ 31^{1/2}$ in. (45 x 80 cm). Guildhall Art Gallery, London.

Evelyn De Morgan (1855–1919). Port after Stormy Seas: Spenser's Faerie Queene, n.d. Oil on canvas. De Morgan Foundation, London.

(JOROTHEA TANNING (b. 1912). *Guardian Angels*, 1946. Oil on canvas, 48 x 36 in. (122 x 91.4 cm). New Orleans Museum of Art; Kate P. Jourdan Fund.

INDEX OF ILLUSTRATIONS

Annunciation to the Shepherds, The (Bassano), 47

Abraham, Sarah, and the Angel (Provost), 35 Abraham Sacrificing Isaac (La Hyre), 128 Adam and Eve (Giusto de Menabuoi), 105 Adoration of an Angel (workshop of Fra Angelico), 6 Adoration of the Magi, The (D. Ghirlandaio), 56 Adoration of the Shepherds, The (Zurbarán), 47 Adoring Angels (Gozzoli; detail of The Journey of the Magi), 48 Altdorfer, Albrecht, 94 Andrea del Sarto, 41, 76-77 Angel (Antonio del Pollaiolo), 89 Angel (Guariento di Arpo), 124 Angel (Smith), 27 Angel (two panels) (Guariento di Arpo), 14 Angel Dictating to Saint Matthew the Evangelist (French sculpture), 134 Angelico, Fra, 6, 32-33, 53, 65 Angel Musicians (Perugino; detail of The Vallombrosa Altar), 66 Angel of Grief (Story), 25 Angel of the Waters (Stebbins), 24 Angels (French stained glass), 17 Angels Dancing in Front of the Sun (Italian painting), 64 Angels' Kitchen, The (Murillo), 60-61 Angel Standing in a Storm (Turner), 100 Angel with Millstone (German illuminated manuscript), 15 Annunciation, The (Andrea del Sarto), 41 Annunciation, The (Fra Angelico), 32 Annunciation, The (Fra Angelico; detail of Panel with Nine Scenes from the Silver Chest of Santissima), 33 Annunciation, The (Fra Angelico, and workshop), 33 Annunciation, The (Benvenuto di Giovanni Guasta), 18 Annunciation, The (Botticelli), 28, 37 Annunciation, The (Braccesco), 92 Annunciation, The (Donatello), 31 Annunciation, The (Filippo Lippi), 36 Annunciation, The (Giovanni di Paolo di Grazia), 104 Annunciation, The (Komar and Melamid), 43 Annunciation, The (Leonardo da Vinci and others), 38-39 Annunciation, The (Pontormo), 19 Annunciation, The (Tissot), 43 Annunciation, The (two paintings) (Garofalo), 40 Annunciation, The (Weyden), 34 Annunciation, The Archangel Gabriel (French illuminated manuscript), 59 Annunciation, The, with Saints Catherine, Anthony Abbot, Procolo, and Francis (Lorenzo

Monaco), 30 Annunciation and Two Saints, The (Simone Martini and Lippo Memmi), 30 Apocalypse, The (Norman illuminated manuscript), 102 Apocalypse of Angers, The (French tapestry), 119 Apotheosis of Homer (Ingres), 11 Apparition of Saint Michael, The (Pacino di Bonaguida), 111 Archangel Gabriel (Masolino da Panicale), 18 Archangel Michael (Greek icon), 21 Archangel Raphael (Italian wood sculpture), 12 Archangel Raphael Leaving Tobias's Family, The (Rembrandt van Rijn), 96 Armenian art, 21 Ascension, The (Giotto), 51 Ascension of Elijah, The (School of Pskov), 130 Ascension of Mohammed on Buraq, His Mule, Guided by the Angel Gabriel, The (Persian illuminated manuscript), 130 Assumption of the Virgin, The (Andrea del Sarto), 76-77 Assumption of the Virgin, The (El Greco), 97 Assumption of the Virgin, The (Piazzetta), 98 Baker, Bill, 110 Barocci, Federico, 95 Bassano, Jacopo, 47 Benvenuto di Giovanni Guasta, 18 Bernini, Gianlorenzo, 140 Betrothed, The (Godward), 141 Birth of Mary, The (Altdorfer), 94 Botticelli, Sandro, 28, 37, 46 Botticini, Francesco, 139 Boucher, François, 82 Bouguereau, William, 62, 83 Bouts, Dieric, 122 Braccesco, Carlo di, 92 Bronzino, Agnolo, 76 Bruegel, Pieter, I, 109 Brunelleschi, Filippo, 128, 134 Burne-Jones, Edward, 133 Champaigne, Philippe de, 80-81 Charity (Saint-Gaudens), 25 Choir of Angels, A (Marmion), 65 Christ and Saint John with Angels (Rubens), 79 Christ in Glory (D. Ghirlandaio), 90 Christ Served by the Angels (Jacques de Stella), 133 Christ Surrounded by Cherubim, Carrying His Mother's Soul (French sculpture), 58 Christ with Angels (Manet), 10 Cimabue, 50 Circumcision, The (Barocci), 95 Commentary on the Apocalypse (Beatus de Liébana): Daniel in the Lion's Den, 127; Fifth Trumpet: The Plague of Locusts, 117; Mission of the Seven Angels with the Seven Cups, The, 118; Seventh Angel of the Apocalypse Proclaiming the Reign of the Lord, The, 119; Sixth

Angel Delivers the Four Angels That Had Been

Enchained in the Euphrates, The, 116; Theophany: Adoration of God in Heaven, 121 Coronation of the Virgin, The (R. Ghirlandaio), 67 Coronation of the Virgin, The (Neri di Bicci), 64 Coronation of the Virgin, The (Reni), 80 Cranach, Lucas, I, 78 Creation of the World, The (Giusto de Menabuoi), 51 Creation of the World, The, and the Expulsion from Paradise (Giovanni di Paolo di Grazia), 105 De Morgan, Evelyn, 63, 141 Deposition of Christ, The (Bronzino), 76 Donatello, 31 Dream of Heraclius, The (A. Gaddi), 88 Dweller in the Innermost (Watts), 22 Dyck, Anthony Van, 79 "Ecce Ancilla Domini!" (The Annunciation) (Rossetti), 42 Ecstasy of Saint Teresa, The (Bernini), 140 Esiguo, Maestro, 45 Fall of the Damned, The (Bouts), 122 Fall of the Rebel Angels, The (Master of the Rebel Angels), 108 Fall of the Rebel Angels, The (Pieter Bruegel I), 100 Feuchère, Jean-Jacques, 115 Flight into Egypt, The (Giotto), 86 Florence Baptistery, interior of dome (Italian mosaic), 54-55 Flying Angel (French sculpture), 88 Fremiet, Emmanuel, 114 French illuminated manuscripts, 59, 120 French sculpture, 58, 88, 110, 134 French stained glass, 17, 52 French tapestry, 119 Gaddi, Agnolo, 88 Garofalo, 40 Gauguin, Paul, 107 German illuminated manuscript, 15 Ghirlandaio, Domenico, 56, 90 Ghirlandaio, Ridolfo, 67 Giotto, 51, 86-87, 121 Giovanni di Paolo di Grazia, 104-5 Giusto de Menabuoi, 51, 105 Godward, John William, 141 Goes, Hugo van der, 44 Gozzoli, Benozzo, 48 Greco, El, 97 Greek icon, 21 Guardian Angels (Tanning), 142 Guariento di Arpo, 14, 124 Hagar and the Angel in the Desert (Tissot), 126 Haring, Keith, 26 Hellenistic sculptor, 9 Hours of Charles of France, The (French illuminated manuscript), 59 Ingres, Jean-Auguste-Dominique, 11

Innocence (Bouguereau), 83 Italian mosaic, 54–55 Italian painting, 64 Italian sculpture, 12 Jacob Wrestling with the Angel (Steinle), 106 Joachim's Dream (Giotto), 87 Journey of the Magi, The (Gozzoli), 48 Komar and Melamid, 43 La Hyre, Laurent de, 128 Lamentation, The (Giotto), 87 Last Judgment, The (Giotto), 121 Last Judgment, The (Memling), 123 Leonardo da Vinci, 38–39 Linaiuoli Triptych, The (Fra Angelico), 65 Lippi, Filippino, 136-37 Lippi, Fra Filippo, 36 Lochner, Stefan, 69 Lorenzo Monaco, 30 Lotto, Lorenzo, 132 Madonna and Child in Majesty Surrounded by Angels (Cimabue), 50 Madonna and Child with Angels (Memling), 68 Madonna and Child with Cherubs (Mantegna), 73 Madonna and Child with Saints Catherine and James (Lotto), 132 Madonna del Baldacchino (Raphael), 70, 84, 93 Madonna della Stella (workshop of Fra Angelico), 53 Manet, Edouard, 10 Mantegna, Andrea, 72–73 Mantua, Palazzo Ducale, ceiling fresco (Mantegna), 72 Marmion, Simon, 65 Martini, Simone, 30 Martyrdom of Saint John of Bergamo, The (Tiepolo), 99 Masolino da Panicale, 18 Master of the Rebel Angels, 108 Melamid. See Komar and Melamid Memling, Hans, 68, 123 Memmi, Lippo, 30 Morning of the Resurrection, The (Burne-Jones), 133 Murillo, Bartolomé Estebán, 60-61 Musical Angel (Rosso Fiorentino), 75 Mystic Nativity (Botticelli), 46 Nativity, The (Champaigne), 80-81 Nativity, The (Maestro Esiguo), 45 Neri di Bicci, 64 Norman illuminated manuscript, 102 Notre Dame de la Belle Verrière (French stained glass), 52 Our Lady of Peace (De Morgan), 63 Pacino di Bonaguida, 111 Panel with Nine Scenes from the Silver Chest of Santissima Annunziata (Fra Angelico), 33 Persian illuminated manuscript, 130 Perugino, 66, 91 Piazzetta, Giambattista, 98 Pollaiolo, Antonio del, 89 Pontormo, Jacopo da, 19, 135 Port after Stormy Seas: Spenser's Faerie Queene (De Morgan), 141 Portinari Altarpiece (Goes), 44 Presentation at the Temple, The (Giotto), 86

Prophet Elijah Receiving Bread and Water from an Angel, The (Rubens), 131 Provost, Jan, 35 Pskov, School of, 130 Putti Holding Dedicatory Tablet (Mantegna), 72 Raphael, 16, 70, 74, 84, 93, 112–13 Redon, Odilon, 101 Rembrandt van Rijn, 96, 129 Reni, Guido, 80 Rest on the Flight to Egypt, The (Boucher), 82 Rest on the Flight to Egypt, The (Virgin with Partridges) (Dyck), 79 Roman muralist, 8 Rossetti, Dante Gabriel, 42 Rosso Fiorentino, 75 Rubens, Peter Paul, 79, 131 Sacrifice of Isaac, The (Brunelleschi), 128 Sacrifice of Isaac, The (Rembrandt van Rijn), 129 Saint Augustine Polyptych, The (Perugino), 91 Saint-Gaudens, Augustus, 25 Saint John Takes the Book from the Seventh Angel (from The Apocalypse of Angers, French tapestry), 119 Saint Matthew (Brunelleschi), 134 Saint Matthew (Pontormo), 135 Saint Michael (Armenian silverwork), 21 Saint Michael (Fremiet), 114 Saint Michael (Schoengauer, tattoo by Baker), IIO Saint Michael Slaying the Dragon (French sculpture), 110 Saint Michael Trampling the Dragon (Raphael), 112-13 Saint Michael Weighing Souls (Weyden), 20 Saint Nicholas Altarpiece, The (Raphael), 16 Satan (Feuchère), 115 Schoengauer, Martin, 110 Sistine Madonna, The (Raphael), 74 Smith, Fred, 27 Spanish illuminated manuscripts, 116-19, 121, 127 Stebbins, Emma, 24 Steinle, Edward, 106 Stella, Jacques de, 133 Story, William Wetmore, 25 Superstitions, Les (French illuminated manuscript), 120 Tanning, Dorothea, 142 Thayer, Abbott Handerson, 23 Three Archangels and Tobias, The (Botticini), 139 Tiepolo, Giambattista, 99 Tissot, James, 43, 126 Tobias and the Angel (follower of Verocchio), 138 Trinity, The (Cranach), 78 Turner, Joseph Mallord William, 100 Unknown artist (English or French), 57 Untitled (Haring), 26 Vallombrosa Altar, The (Perugino), 66 Verocchio, Andrea del, follower of, 138 Veronese, Paolo, 95 Victoria (Ingres; detail of Apotheosis of Homer), II Virgin and Child, The (Perugino), 91 Virgin in a Rose Arbor, The (Lochner), 69 Virgin with Angels, The (Bouguereau), 62

Vision after the Sermon: Jacob Wrestling with the Angel (Gauguin), 107 Vision of Saint Bernard, The (Filippino Lippi), 136-37 War in Heaven (from The Apocalypse, Norman illuminated manuscript), 102 Watts, George Frederic, 22 Way to Paradise, The (Bouts), 122 Weyden, Rogier van der, 20, 34 Wife of Zebedee Interceding with Christ over Her Sons, The (Veronese), 95 Wilton Diptych, The (unknown English or French artist), 57 Winged Figure (Thayer), 23 Winged Man or the Fallen Angel, The (Redon), IOI Winged Spirit (Roman muralist), 8 Winged Victory of Samothrace, The (Hellenistic sculptor), 9 Zurbarán, Francisco, 47 PHOTO CREDITS Robert Amft, Chicago: 27. Archiv für Kunst und Geschichtes, Berlin/ Superstock: 11, 15–16, 21 left, 28, 30 top, 37, 47 top, 69, 78, 101. Copyright © 1994 The Art Institute of Chicago, all rights reserved: 23. Art Resource, New York: 42, 117. Vicki Berndt: 110 right. Bridgeman Art Library, London/Superstock: 4, 6, 20, 22, 40 bottom, 44, 63, 66, 74, 75 top, 79 top, 82-83, 95 bottom, 130 right, 133 both, 139, 141 both. James Dee: 43 top left and right.

et Archive, London/Superstock: 94, 100.

David Finn: 140.

William H. Gerdts: 25 bottom left.

Hubert Josse: 17, 21 right, 32, 35, 45, 47 bottom, 52, 58, 60–62, 64 both, 67, 80–81, 88 top, 92, 96, 108, 112–13, 120, 122 both, 128 bottom, 131–32.

Museum Associates, Los Angeles County Museum of Art: 12 (copyright © 1991), 115 (copyright © 1995).

- The Metropolitan Museum of Art, New York: 59 (copyright © 1993), 102 (copyright © 1987), 105 bottom (copyright © 1992), 116 (copyright © 1992), 119 top (copyright © 1992).
- Sara Cedar Miller, Central Park Conservancy, New York: 24.
- Takashi Okamura: 19, 30 bottom, 31, 33 both, 36, 38–39, 41, 48, 53–56, 65 left, 70, 76–77, 84, 88 bottom, 89, 93, 128 top, 134 bottom right, 135–37.

Courtesy Tony Shafrazi Gallery, New York: 26. Speltdoorn & Fils: 109.

Superstock: 1, 3, 5, 14 both, 18 both, 40 top, 43 bottom, 51 both, 68, 72–73, 75 bottom, 79 bottom, 86–87, 90–91, 97, 99, 104, 105 top, 106, 119 bottom, 121 top, 123–24, 126, 129, 130 left.